The North Carolina Museum of Art

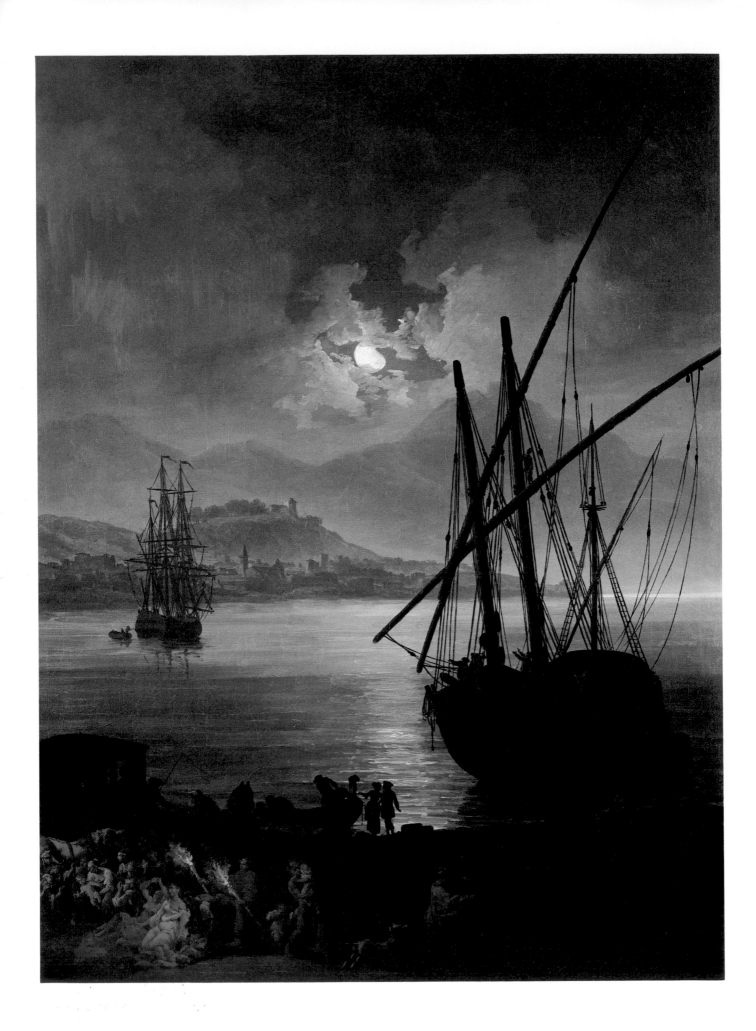

The North Carolina Museum of Art

Introduction to the Collections

Edited by Edgar Peters Bowron

Published for The North Carolina Museum of Art, Raleigh, North Carolina
by The University of North Carolina Press, Chapel Hill

This publication is supported by a grant from the
National Endowment for the Arts, Washington, D.C., a federal agency,
and by funds from the North Carolina Art Society.

Cover: Bernardo Bellotto
Italian, 1720–80
View of Dresden with the Frauenkirche at Left, 1747 (detail of no. 216)
Oil on canvas, 59 x 93 in. (149.9 x 236.2 cm.)
52.9.145

Frontispiece: Pierre Jacques Volaire
French, 1727–before 1802
The Eruption of Mt. Vesuvius, 1777 (detail of no. 154)
Oil on canvas, 53¼ x 89 in. (135.2 x 226.2 cm.)
Alcy C. Kendrick Funds and Museum Purchase Fund, by exchange, 82.1

First Printing, May 1983
Second printing, August 1984

Library of Congress Cataloging in Publication Data

North Carolina Museum of Art.
 The North Carolina Museum of Art.

 Includes Index.
 1. Art—North Carolina—Raleigh—Catalogs.
2. North Carolina Museum of Art—Catalogs. I. Bowron,
Edgar Peters. II. Title.
N715.R2A58 1983 708.156'55 82-21982
ISBN 0-8078-4097-1

Contents

The North Carolina Museum of Art is an agency of the State of North Carolina, James B. Hunt, Jr., Governor, and of the Department of Cultural Resources, Sara W. Hodgkins, Secretary

Preface and Acknowledgments

The collections of the North Carolina Museum of Art have grown from a nucleus of 201 European and American paintings purchased in 1952 to more than 6,000 works of art from all cultures and media. The original catalog of the Museum's collections by W. R. Valentiner (1956) as well as the Kress catalogs (1960 and 1965) have been out of print for years. The last published checklist (*Exhibition Number One from the Permanent Collection*, 1970) is now seriously outdated, retaining as it does the old attributions of various paintings to Rembrandt, Rubens, Frans Hals, and others. The present volume is the first published survey of the Museum's collections in thirteen years and is intended to reflect more accurately their strengths and weaknesses at this point in the Museum's rapid evolution. Although many of the approximately 300 works of art reproduced here were acquired with the original legislative appropriation of funds that brought the Museum into existence, many others have been acquired very recently and, as such, underscore the vitality of an institution so new on the American museum scene that, when compared with those in Boston, New York, Philadelphia, and Washington, it can hardly be considered to have attained its majority.

The publication of this illustrated survey on the occasion of the opening of the Museum's new building heralds a new era in the preservation, exhibition, and interpretation of the collections. For twenty-six years these works of art have been contained within an aging, remodeled state office building that has long resisted the efforts of the staff to maintain proper levels of temperature and relative humidity and has proven inadequate in numerous other ways. The transfer of the collections in 1982 to a modern, climate-controlled building; the appointment of professionally trained, experienced conservators; and the deployment of a new 3,000 square-foot conservation laboratory equipped with the latest scientific equipment should quickly raise the level of care of the collections to the prevailing standards of the profession.

One of the ironies of the Museum's situation in recent years is that although nearly two-thirds of its collections have remained in storage, owing to serious shortages of exhibition space in Raleigh, many of its finest works have been viewed and admired by visitors to exhibitions in Washington, New York, Los Angeles, London, Paris, and Amsterdam. The doubling of exhibition space in the new building will permit the Museum's most important works to be again displayed. Perhaps more significantly, the conditions under which the collections will be presented—their arrangement, installation, lighting, and labeling—will be in accordance with modern museum practices.

As a result of appropriations by the 1979 General Assembly, the Museum was able to appoint in 1982, for the first time in its history, a sufficient number of curators experienced and trained in a particular academic discipline relevant to the collections. One of the primary responsibilities of the new curators is research on the collections and the publication of the results in guides for the general visitors, brochures, and scholarly catalogs. Their efforts will be substantially aided by a $100,000 grant from the Andrew W. Mellon Foundation in support of the early planning costs of exhibitions and publications linked to the Museum's permanent holdings. This publication is itself a reflection of the new strength of the Museum's professional staff. Changes in attribution, accurate spelling of artists' names, their correct birth and death dates, and other basic matters have been neglected for many years because of insufficient curatorial personnel, and I am gratified to record the dedication and hard work in these areas by William J. Chiego, chief curator, and his staff: Mitchell D. Kahan, curator of American and Contemporary Art; Mary Ellen Soles, curator of Ancient Art; David H. Steel, Jr., associate curator of European Art; and Huston Paschal, assistant curator. This book would not have been possible at all without the assistance of Peggy Jo Kirby, registrar, and her expedient and very capable staff, including Bill DePalma, the Museum's new photographer. The complexities of the project involved the talents of many people, including Gay Mahaffy Hertzman, assistant director; Patrick H. Sears, chief designer; Nancy G. Brantley, my administrative secretary; and Gayle Lane Fitzgerald.

The design and production of the handbook was a col-

laborative effort between Pat Sears, Lida Lowrey, and Richard Hendel, assistant director of the University of North Carolina Press. I am grateful as well to Matthew N. Hodgson, director of the University of North Carolina Press, for his initiatives in bringing together the University of North Carolina Press and the North Carolina Museum of Art. We hope this initial venture will lead to further cooperation in our efforts to make available to a wider audience what is such a significant part of North Carolina's cultural patrimony—the Museum's collections.

Finally, in behalf of the North Carolina Museum of Art, I would like to record my gratitude to the National Endowment for the Arts and to the North Carolina Art Society for the funds that have made this publication possible.

Edgar Peters Bowron
Director

The North Carolina Museum of Art and Its Collections

When its General Assembly appropriated a million dollars in 1947 for the purchase of Old Master paintings, North Carolina became the first state in the nation to set aside public funds to create an art collection for its people. That the funds were available at all was due to the unprecedented surplus accumulated in the state treasury during World War II, when the economy flourished and substantial tax revenues were raised but limited building materials and manpower prevented expenditures for major public works projects. Even so, that a relatively small, agrarian southern state liberated such an enormous sum for the foundation of an art collection assures a unique place for the North Carolina Museum of Art in the history of American art museums.

The story of the Museum's founding has been recorded on numerous occasions.[1] The organized effort to create an art museum for the state can be traced to 1924, when the North Carolina State Art Society was formed with the intention "to promote an interest in providing a State Art Museum in Raleigh." Lacking a permanent collection of its own, the Art Society organized exhibitions of loans from M. Knoedler and Company, Grand Central Galleries, and Robert Vose Gallery, including works by El Greco, Rembrandt, Albert Pinkham Ryder, and Thomas Eakins. The Art Society also brought speakers and critics to the state and promoted educational activities, and after it received its charter of incorporation on 7 October 1927, efforts were redoubled to establish a state museum of art. In 1928, the Art Society received by bequest a collection of approximately seventy-five paintings assembled by Robert F. Phifer (1849–1928), a native of Concord, North Carolina, who had lived in New York for many years. Although Phifer's collection consisted largely of minor works by members of the Salmagundi Club,[2] it contained a few notable pictures (William Merritt Chase, *The Artist's Daughter*, no. 255) and remained for many years the principal art collection on view in Raleigh. In 1929, the year in which the General Assembly placed the Art Society under state patronage and control, a temporary art museum was provided in the Agricultural Building for the exhibition of forty-eight paintings from the Phifer bequest and a few others that the society had acquired.

Of greater significance than Phifer's personal art collection was his monetary bequest to the society, which, although it became available only at intervals on the death of his heirs, sustained the organization through the Depression and provided additional leverage in support of efforts to create what was to become a museum for the state. In the past thirty years, the Phifer funds have been substantially increased through sound financial investment and have enabled the Art Society to provide the Museum with the resources to acquire a number of significant works for its collections.

The Depression effectively stifled subsequent attempts to create a permanent, public art museum for North Carolina, but in the late 1930s the state provided improvised quarters in the former Supreme Court building for exhibition galleries and Art Society offices. The State Art Society Gallery, which was partly financed by the Federal Art Project, opened in 1939 with an exhibition of American paintings assembled from New York galleries and organized during the next fourteen years more than 125 special exhibitions. These included many exhibitions of work by North Carolina artists but also encompassed medieval manuscripts and Matisse lithographs; paintings by Rubens, Picasso, and John Marin; and drawings, photographs, furniture, and textiles. The activity and success of the State Art Gallery were due in great measure to the initiatives of its director, Miss Lucy Cherry Crisp (1899–1977), who sought to establish, "even though in miniature, as many as possible of the major functions and services of a public Art Museum, in order that [the] beginnings, at least, of all these things might have been made when the goal of a great Museum of Art should finally be achieved."[3] In these same years, the Art Society's efforts were boosted by Governor J. Melville Broughton's appointment in 1943 of a Citizens Committee for a State Art Gallery, which voted unanimously to launch a movement for the construction of a North Carolina State Art Gallery in Raleigh as a memorial to North Carolinians who had served in the first and

1. The basic published sources are Betty Chamberlain, "How to Get and Spend a Million Dollars for Art," *Art News* 55 (April 1956): 37–44, 95–97; Ola Maie Foushee, *Art in North Carolina: Episodes and Developments, 1585–1970* (Chapel Hill, 1972), pp. 21–43, 104–30; and Margaret Sterne, *The Passionate Eye: The Life of William R. Valentiner* (Detroit, 1980), pp. 334–56.

2. North Carolina Museum of Art, *Robert F. Phifer Collection* [exhibition catalog] (Raleigh, 1973), p. 94.
3. Foushee, *Art in North Carolina*, p. 32.

second world wars. However, the committee could not raise the $50,000 in private donations thought to be sufficient and the project was abandoned.

The individual to whom is owed the largest measure of credit for the founding of the North Carolina Museum of Art is Robert Lee Humber (1898–1970),[4] a former Rhodes scholar, international lawyer, cofounder of the United World Federalists, and state senator. Upon his return from Paris to his native Greenville in 1940, Humber immediately became active in the Art Society and began to explore the possibilities of establishing an art museum in Raleigh. Convinced that at least $1,000,000 would be required for the project, he went to New York in search of possible sources of support. Through Carl Hamilton, a New York dealer and collector, Humber met Stephen S. Pichetto, conservator to Samuel H. Kress, the merchant and collector.[5] In 1943, Humber approached Kress to assist with the efforts being made in North Carolina to found an art museum for the state, and in 1947 Kress agreed to provide a million dollars on the condition that neither his name nor that of the Samuel H. Kress Foundation would be disclosed and that his commitment remain verbal in order to avoid solicitation from other states in which he operated S. H. Kress & Company stores.[6] Humber accepted these terms, and the agreement served as the basis for the legislative action of 1947, when the General Assembly conditionally appropriated a million dollars to the North Carolina State Art Society for the purchase of Old Master paintings, contingent upon the sum being matched by private donations.

In 1950, Governor W. Kerr Scott appointed a State Art Commission to acquire works of art with the appropriated revenues. Joining the representatives of the Art Society— Mrs. Katherine Pendleton Arrington (1876–1955), its president since 1927; Clarence Poe (1881–1969), editor of *The Progressive Farmer*, the most widely read agricultural magazine in the south; and Humber—were Clemens Sommer (1891–1962), a professor of the history of art at the University of North Carolina in Chapel Hill, and Edwin Gill (1899–1978), formerly federal collector of the Department of Internal Revenue, then treasurer of North Caro-

lina, and a strong advocate for the foundation of a state art collection. With the exception of Sommer, a former curator with the city museum in Freiburg, Germany, and a specialist in late medieval and early Italian Renaissance sculpture, none of the members of the Art Commission was particularly knowledgeable about the history of art or, for that matter, the museum profession or the art market. The commission therefore appointed Carl Hamilton (1886–1967) as its consultant and adviser. A curious, and at times controversial, figure on the American art scene since the 1920s,[7] Hamilton has never received sufficient credit for the critical role he played in the formation of the collections of the North Carolina Museum of Art. In the early 1950s, it was he who directed the Art Commission to the nucleus of dealers who provided the bulk of the works of art purchased from the original million-dollar appropriation, at prices ranging from a few hundred dollars to a maximum of about $65,000. They were acquired from a handful of New York dealers, the majority from David M. Koetser Gallery, Newhouse Galleries, M. Knoedler and Company, E. and A. Silberman Galleries, Schaeffer Galleries, Victor Spark, and Julius Weitzner.

The goal of the Art Commission was to assemble a complete survey of Western painting from its origins in the fourteenth century to the end of the nineteenth century. In forming a collection of paintings from the hundreds available on the art market, the members of the Art Commission were confronted immediately with the choice of spending all of the funds at their disposal on a relatively few "masterpieces" or providing a more balanced survey of the history of art with works by artists of lesser rank. As W. R. Valentiner put it in the introduction to the Museum's first catalog, "In representing the great period of Dutch seventeenth-century art, should they spend all their funds to acquire one famous portrait by Rembrandt at an exorbitant price or should they try to find one of his lesser-known paintings with a historical subject and add to it a collection of paintings which represent the main fields of Dutch art and give an idea of the wealth of new thoughts expressed in this period, in Holland, by innumerable lesser-

4. For a brief biography, see *North Carolina Museum of Art Bulletin* 10 (June 1971): 16–20.

5. For a concise account of the Samuel H. Kress Foundation and the regional galleries of paintings it established in the United States in the 1940s and 1950s, see the introduction by Guy Emerson in *Art Treasures for America: An Anthology of Paintings and Sculpture in The Samuel H. Kress Collection* (London, 1961), pp. vii–xviii.

6. Foushee, *Art in North Carolina*, p. 108, quoting a letter from Humber of 29 June 1967.

7. For an account of Hamilton, whom Mary Berenson thought "a mixture of Dionysus and St. Francis, a mysterious awe-inspiring and love-compelling force and a kind of mystic genius," see Meryle Secrest, *Being Bernard Berenson* (Harmondsworth, England, 1979), pp. 320–23; see also Sterne, *The Passionate Eye*, pp. 338–40.

known artists?"[8] They chose the latter course and acquired the dramatic and provocative *Feast of Esther* (no. 97), which came on the market in 1936 as an unknown Rembrandt painting, as the pivotal work in a selection of twenty-three Dutch pictures that would give the public a well-rounded view of the period and possess "greater popular appeal in their many story-telling subjects than one portrait by Rembrandt alone." Although most recent opinions have supported an attribution of the *Feast of Esther* to Jan Lievens,[9] who was, together with Rembrandt, one of the foremost artists in Leiden in the 1620s, the painting provided the rationale for the acquisition of a group of excellent pictures (nos. 94–112) representing the specialties of Dutch painting of the period—portraiture, genre, landscape, still life, and history painting.

The Art Commission purchased 139 paintings from the original million-dollar appropriation, divided among schools as follows: American (sixteen), Flemish (twenty-three), Dutch (twenty-three), Italian (seventeen), British (twenty-one), Spanish (nineteen), French (ten), and German (ten). In part as the result of the inflated prices of the seven pictures acquired as by Rubens and two others as by Rembrandt and Frans Hals, the bulk of the funds was spent on Flemish ($300,300) and Dutch paintings ($190,600).[10] On the other hand, a number of paintings were acquired relatively inexpensively, even allowing for the extraordinary inflation of art prices since 1950; among these acquisitions were Jan Brueghel's *Harbor Scene with St. Paul's Departure from Caesarea* (no. 10; $3,000) and Balthasar van der Ast's *Still Life with Grasshopper* (no. 96; $2,000). In spite of the inevitable changes of attribution of several well-known paintings during the past thirty years, the collection of Old Master paintings acquired with the original state appropriation remains, by any standard, one of the finest in the United States. Its nucleus is formed by the works of Memling (no. 128), Rubens (no. 11), Snyders (nos. 134, 139), Claude (no. 145), Mignard (no. 147), Bellotto (nos. 216, 217), Ribera (no. 220), Murillo (no. 221), Beechey (no. 122), Lawrence (nos. 123, 125), Copley (nos. 18, 230), and Homer (no. 22).

The acquisition funds available to the Art Commission were not restricted, however, to the 1947 legislative appropriation. In 1952, one of the Phifer heirs died and approximately $300,000 from the Phifer trust fund became available for the purchase of works of art; among the paintings acquired with these funds were: Stefan Lochner's *St. Jerome in His Study* (no. 163); Peter Paul Rubens's *Joan of Arc* (no. 132); Jacob Jordaens's *The Holy Family* (no. 133); Jean-Baptiste Oudry's *Swan Frightened by a Dog* (no. 149); John Hoppner's *Portrait of a Family* (no. 120); Thomas Gainsborough's *Portrait of a Gentleman, said to be John Scrimgeour* (no. 121); and Jean Millet's *Peasant Spreading Manure* (no. 157). In recent years, the North Carolina Art Society has further enriched the Museum's collections by making available funds from the Phifer bequest for the purchase of such significant works as the Hellenistic Greek marble *Aphrodite* (no. 56); Tilmann Riemenschneider's *St. Catherine* (no. 9); Georgia O'Keeffe's *Cebolla Church* (no. 27); and Severin Roesen's *Still Life with Fruit* (no. 239).

The original purchase funds were augmented in the early 1950s with contributions from foundations and private citizens. In 1956 alone, the total of these gifts amounted to approximately one-third of the capital invested in the collection by the state, and this total, if added to donations received before the opening of the Museum, amounted to about 40 percent more than the original investment. Even in 1959, three years after the Museum had opened to the public, gifts worth more than half a million dollars were granted or promised to it—$200,000 in promised gifts and $300,462 in actual works of art, an amount equal to twice the Museum's annual budget.

In 1953, the General Assembly had appropriated funds to transform the former State Highway Building into a facility for the exhibition of the collections. The renovation proceeded under the direction of the Art Commission and Carl Hamilton until the appointment in 1955 of the Museum's first director, William R. Valentiner (1880–1958).[11] Valentiner, an internationally known scholar in the fields of Italian Renaissance sculpture, Dutch seventeenth-century

8. W. R. Valentiner, *Catalogue of Paintings including Three sets of Tapestries* (Raleigh, 1956), p. 12.

9. National Gallery of Art, *Gods, Saints and Heroes: Dutch Painting in the Age of Rembrandt* [exhibition catalog] (Washington, D.C., 1980–81), no. 31, as by Jan Lievens.

10. The original list of purchases and prices, compiled from records of the state auditor, was published in the Raleigh *News and Observer*, 28 November 1954, sec. 4, p. 2.

11. In addition to Sterne, *The Passionate Eye*, pp. 334–56, see North Carolina Museum of Art, *Masterpieces of Art* [exhibition catalog] (Raleigh, 1959), an exhibition organized to honor Valentiner's achievements during fifty years of activity in American museums, and a supplement published in the *North Carolina Museum of Art Bulletin* 3 (1959): 1–52.

painting, and German expressionist art, had served from 1924 to 1945 as director of the Detroit Institute of Arts, where he assembled one of the significant art collections in the United States. He had also been codirector of the Los Angeles County Museum from 1946 to 1949 and consultant to the Board of Trustees of that museum from 1949 to 1953 and, shortly before coming to Raleigh, director of the J. Paul Getty Museum in Malibu. Valentiner's reputation, connoisseurship, experience, and knowledge of modern professional practices instantly legitimized North Carolina's efforts to establish a credible museum. To the fledgling institution, Valentiner brought a high level of scholarship as well as a trained eye, and through his writings and example, he elevated the community's standards of connoisseurship. Contrary to widely held belief, Valentiner did not play a major role in the selection of the original purchases in the early 1950s, for after his arrival in Raleigh on 1 November 1955, less than 10 percent of the collection acquired with the original legislative appropriation was changed.[12] Nonetheless, he was instrumental in the acquisition of many private gifts to the Museum, and it was because of his presence in Raleigh that others came to the Museum after his death (Berlinghiero, *Madonna and Child*, no. 171; Lodovico Carracci, *The Assumption of the Virgin*, no. 195; Antonis Mor, *Portrait of a Gentleman*, no. 93; Theodor Rombouts, *The Backgammon Players*, no. 137; Goya, *The Topers*, no. 226; Hans Thoma, *Sunset*, no. 265; Lyonel Feininger, *The Green Bridge II*, no. 261; and Milton Avery, *Blue Landscape*, no. 270).

Valentiner sought to shape the nascent museum—which was actually a picture gallery in the traditional European sense of the term—into "an educational institution destined to teach the complete art history of the world."[13] He installed the collections in the new museum building in the manner of the great European collections with which he was familiar—chronologically, according to schools. Immediately following the inauguration of the North Carolina Museum of Art and the opening of the Morgan Street building on 6 April 1956, he initiated an assessment of the strengths of the collections and established a policy for

expansion that in one way or another has guided the Museum's growth until the present. "Still missing," he wrote at the time to Robert Lee Humber, "are the great painters of the nineteenth century (Romantics, Realists, Impressionists, Post-impressionists, Expressionists) and the best painters of our time. We hope to show their works in forthcoming loan exhibitions. Perhaps donors could be found to buy for our collection one or more outstanding paintings from these exhibitions. In order to silence the constant and justifiable claim of artists in our state that modern art should be represented, a small amount should be set aside each year (about $5,000) for the acquisition of contemporary paintings."[14]

In the same letter Valentiner outlined a proposal to establish, in an adjacent building, "a *museum of sculpture* to which should be added a walled garden with lawns, pool and shrubbery to contain outdoor sculptures. . . . The advantage of such a museum would be that it would enable us to extend our educational program far beyond the limits of our present collection. We could then teach the whole history of the art of mankind from its beginning in prehistoric times to the comparatively late epoch when panel paintings started (about 1400). The contents of this museum of sculpture should, to a great extent, precede in date the art represented in our museum of painting." In the two separate buildings devoted to painting and sculpture, Valentiner envisioned adding decorative arts; those that are allied with two-dimensional design—textiles, rugs, and tapestries—would be placed with the paintings and those that have plastic form like pottery and porcelain would be exhibited with the sculpture. Valentiner's scheme was never realized, but he did manage to expand the Museum's collections and collecting policies and in July 1957 opened five additional galleries devoted to Egyptian art, Greek and Roman art, Coptic textiles, and Renaissance bronzes. In his brief but influential tenure as director of the North Carolina Museum of Art, Valentiner also aggrandized the institution's position among American art museums by the exhibitions he organized. In 1956, the Museum was the focus of international attention as a result of a loan ex-

12. In 1951, North Carolina Attorney General Harry McMullan persuaded the General Assembly to add two amendments to the bill authorizing acceptance of the gift by Kress of works of art in lieu of cash as a compliance with the terms of the 1947 appropriation for the purchase of works of art. One of these specified that every purchase be approved by, among others, the director or chief curator of the National Gallery of Art in Washington. The National Gallery, however, declined the responsibility of passing on the acquisitions. This refusal, under the laws that stood, made any purchase impossible. Valentiner was eventually approved as a substitute authority to pass on the prospective purchases and he was paid $2,050 for his appraisal late in that year of the purchases made to date. (The other amendment required "dominant emphasis" on acquiring "masterpieces of the American, British, French, Spanish, Flemish and Dutch Schools" in spending the state's $1,000,000.)

hibition of paintings by Rembrandt and his pupils, and, in 1958, for an exhibition of oil paintings, watercolors, and prints of the German expressionist, Ernst Ludwig Kirchner. In 1957, Valentiner initiated *The North Carolina Museum of Art Bulletin*, and in its early issues he himself supplied most of the articles, focusing on major works in the collection.

Before his death in 1958, Valentiner prepared a report for the Art Commission recommending the acceptance of forty-seven paintings from the Samuel H. Kress Foundation. Seven years earlier, in 1951, the 1947 statute had been modified to permit the required matching gift to be made in works of art, and the Samuel H. Kress Foundation had agreed to include Raleigh in its program for endowing regional museums throughout the United States with paintings from the Kress Collection and to present the state Art Society with "outstanding Italian Renaissance Art and other similar paintings of a value of at least one million dollars."[15] Between 1958 and 1961, following negotiations and exchanges, the number of paintings was increased to sixty-nine and two sculptures were added, making the Kress gift to North Carolina the largest and most important of any except that given to the National Gallery of Art in Washington, D.C. The advantage of having had the promise of the Kress gift before the purchase of the Museum's original collection was the assurance that the field of early Italian painting would be eventually well represented. Funds that ordinarily would have been used to acquire Italian paintings from the fourteenth and fifteenth centuries were thus freed for the purchase of other works. The Kress Collection at Raleigh[16] has given the Museum a particularly prestigious position among American museums for its collection of early Italian paintings that is centered around one of the monuments of Trecento painting, the so-called Peruzzi altarpiece by Giotto and assistants (nos. 6, 7, 173), believed to have been painted for the Franciscan church of Santa Croce in Florence about 1322. In addition to a splendid survey of Italian Trecento and Quattrocento pictures that includes such notable pictures as the tondo by Botticelli and assistants (no. 184), the

Francia *Madonna and Child with Two Angels* (no. 185), the cassone panels by Neroccio de' Landi (nos. 180, 181), and the marriage salver from the workshop of Apollonio di Giovanni (no. 179), the Kress gift added major works from the sixteenth, seventeenth, and eighteenth centuries. The large altarpiece of 1552 painted for a Dominican confraternity by Bernardino Lanino (no. 190) and that by Domenichino (no. 196) for Fano, a town on the east coast of Italy where the artist worked in 1618–19, are but two works in a sequence that leads through Massimo Stanzione's powerful and arresting *Assumption of the Virgin* (no. 197), one of the most important Neapolitan baroque paintings in America; includes the two very different canvases by Magnasco (nos. 203, 213), each of unusually fine quality; and culminates in Batoni's large and ambitious *Triumph of Venice* (no. 211), his first nonreligious commission, painted in 1737 for Marco Foscarini, the Venetian ambassador to the Holy See. In addition, ten paintings from the French, Dutch, Flemish, and German schools further enriched the Museum's collections, notably the exceptionally rare triptych from a fifteenth-century French atelier, assigned to the Master of the Latour d'Auvergne Triptych (no. 143), the double portrait of Martin Luther and Philipp Melanchthon by Lucas Cranach the Younger (no. 168), Terbrugghen's *David Praised by the Israelite Women* (no. 95), with its strongly Caravaggesque features, and the brilliantly executed *Portrait of a Man* (no. 104), thought to be the painter Ferdinand Bol, by an anonymous member of Rembrandt's circle working around 1660.

The first phase of growth of the North Carolina Museum of Art, during which it accumulated very rapidly an impressive basic collection by means of the original state appropriation, the Robert F. Phifer bequest, and the Samuel H. Kress Foundation gift, ended in 1960. In 1961, the General Assembly separated the Museum from the North Carolina State Art Society, conferred upon it the status of a state agency, and transferred to it title of the works of art and all other property of the Museum.[17] In that same year, Justus Bier (1899–),[18] was appointed the Museum's director. The collections continued to expand in

13. *North Carolina Museum of Art Bulletin* 1 (Spring 1957): 21.

14. Letter to Robert Lee Humber, 26 April 1956, North Carolina State Archives, Raleigh, N.C.

15. N.C. General Assembly, *Session Laws and Resolutions of 1951 Passed by the General Assembly . . . , Chapter 1168*, p. 1212.

16. See North Carolina Museum of Art, *The Samuel H. Kress Collection* (Raleigh, 1960), the revision by Fern Rusk Shapley, *Paintings from*

the Samuel H. Kress Collection: Italian Schools XIII–XV Century (London, 1966), and subsequent volumes in this series.

17. Under the Executive Organization Act of 1971, the Museum became an agency of what is now the Department of Cultural Resources.

18. For a biography and bibliography of the writings of Justus Bier, see *North Carolina Museum of Art Bulletin* 12, no. 4 (1974): 9–41.

the 1960s, but certainly not at the dizzying pace of the previous decade. The major acquisitions included an important document of the work of the young Raphael, *St. Jerome Punishing the Heretic Sabinian* (no. 8), a scene from the predella of the Mond Crucifixion in the National Gallery, London; Chardin's *Still Life with Ray Fish and a Basket of Onions* (no. 16); and Raeburn's *Thomas Robert Hay, 11th Earl of Kinnoull* (no. 126). Dr. Bier's profound knowledge of late gothic German sculpture is reflected in his acquisition of the beautiful *St. Catherine* by Tilmann Riemenschneider (no. 9) and *Madonna of the Protective Cloak* (no. 170) by Peter Koellin, although his catholic tastes and love of the plastic arts in general led him also to the acquisition of other sculptures of a very different kind, such as the mobile by Alexander Calder, *Tricolor on Pyramid* (no. 29). Before coming to Raleigh, Bier had been a distinguished scholar and art historian for many years at the Allen R. Hite Art Institute, which he founded at the University of Louisville; so it was inevitable that he would follow Valentiner's example and work to raise the status of the North Carolina Museum of Art as an educational institution. The *Bulletin* was revived with important contributions from recognized scholars focusing on the Museum's holdings;[19] the Mary Duke Biddle Gallery for the Blind was inaugurated in 1965; and educational programs of tours, lectures, and concerts were greatly expanded.

The development of the Museum's collections in the 1970s depended primarily upon purchase funds allocated by the General Assembly (ranging from $10,000 in 1958 to $200,000 in 1973 to $25,000 in 1982), the support of the North Carolina Art Society, and the generosity of corporations and private donors. In this decade, Moussa M. Domit, director from 1974 to 1980, aggressively pursued the expansion of the Egyptian, Greek, and Roman (nos. 36–60), and African, Oceanic, and New World collections (nos. 63–90),[20] following Valentiner's conception of the Museum as an encyclopedia of diverse world cultures and historical periods. This period in the Museum's history was marked by the emergence of major new patrons in Mr. and Mrs. Gordon Hanes and the James G. Hanes

Foundation of Winston-Salem, by whose benefaction the Egyptian, Greek, Roman, and non-Western collections were measurably enriched. In these same years, the new emphasis on nontraditional areas of collecting also led to the formation of a collection of Jewish ceremonial artifacts under the auspices of Dr. Abram Kanof.

Another major area of the collections strengthened in the 1970s was twentieth-century American painting. The acquisitions included Andrew Wyeth's *Winter, 1946* (no. 272); Georgia O'Keeffe's *Cebolla Church* (no. 27); a bequest of 2,054 oil paintings, pastels, watercolors, drawings, and sketches from the estate of the late Hobson Pittman, a beloved North Carolina artist (no. 289); Marsden Hartley's *Indian Fantasy* (no. 26); Frederick Carl Frieseke's *The Garden Parasol* (no. 23); and William Merritt Chase's group portrait, *Dorothy, Helen and Bob*. Notable acquisitions of European art in the 1970s included paintings by Bonnard (no. 21), Boudin (no. 20), and Pissarro (no. 161), the latter two paintings gifts of the North Carolina National Bank and the Wachovia Bank and Trust Company, respectively.

The Art Commission, appointed in 1950 to acquire an art collection for North Carolina with legislatively approved funds, selected exclusively American and European paintings from the fifteenth through the late nineteenth centuries. It explicitly avoided the "controversial subject of modern art,"[21] and, as a result, the twentieth-century collections of the Museum consisted for many years largely of the work of North Carolina artists who have participated in the exhibitions cosponsored by the North Carolina Art Society. There have been exceptions, of course, and the collections have been enriched with occasional gifts of the work of artists of national importance such as the paintings by Milton Avery (no. 270), Franz Kline (no. 275), Josef Albers (no. 290), Richard Diebenkorn (no. 30), and Neil Welliver (no. 281). The enlightened patronage of Gordon Hanes and his understanding of the Museum's needs in representing the art of postwar America with choice individual works has resulted in the acquisition of paintings by Kenneth Noland, Thomas Downing,

19. For example, Anthony M. Clark, "Batoni's *Triumph of Venice*," *North Carolina Museum of Art Bulletin* 4, no. 1 (1963): 5–11, and Creighton Gilbert, "A Miracle by Raphael," *ibid.* 6, no. 1 (1965): 3–35.

20. Most of the Ancient, African, Oceanic, and New World collections are described in the *North Carolina Museum of Art Bulletin* 12, no. 3 (1974): 31–38, 42–77; 13, no. 1 (1975): 92–269; 13, no. 2 (1975): 32–38.

21. For the dispute over possible purchases of modern art with legislatively appropriated funds, see Chamberlain, "How to Get and Spend a Million Dollars for Art," p. 96.

Frank Stella (no. 279), and Morris Louis (no. 31), among others.

In 1967, the North Carolina General Assembly authorized the creation of a State Art Museum Building Commission to select a site and architect for a new museum building to replace the renovated office building that had long since proved inadequate. In 1973, the Building Commission, under the direction of Senator Thomas J. White, recommended a 164-acre tract on Blue Ridge Boulevard in west Raleigh and selected Edward Durell Stone and Associates, New York, and Holloway-Reeves, Raleigh, as the architects for the new building.[22] The General Assembly appropriated $10.75 million for the construction of the new building, and this was supplemented by a statewide fund-raising campaign chaired by Louis C. Stephens, Jr., and administered by the North Carolina Art Society, which raised an additional $5 million from nonpublic sources, including a $1.5 million challenge grant from the Z. Smith Reynolds Foundation of Winston-Salem. Bids for the project were received in July 1977 and construction began the same month. The building was dedicated on 28 May 1981 and is expected to be opened to the public in April 1983. The 181,000 square-foot facility includes exhibition galleries of approximately 50,000 square feet (against approximately 28,000 square feet in the Morgan Street building); a conservation laboratory of 3,000 square feet; expanded educational facilities, including a 272-seat auditorium; improved facilities for photography, technical workshops, offices, art storage, an art reference library, and a museum sales shop; and exhibition galleries accessible to the handicapped.

The major result of the opening of the new North Carolina Museum of Art is that its most important possessions may once again be seen by the public. For years, whole collections have been in storage or only partially visible owing to the limitations of the original quarters. These include the fine group of American nineteenth-century landscapes by William Keith, Thomas Doughty, Thomas Cole, Jasper Cropsey, and Ralph Blakelock (nos. 234, 241, 244) acquired with the original state appropriation;[23] the important bequest of William R. Valentiner, which included Wilhelm Lehmbruck's *Head of a Woman* (no. 264); Barbara Hepworth's *Curlew II—String Figure*; drawings by Max Beckmann, Henry Moore, Graham Sutherland, Paul Klee, and Wassily Kandinsky (no. 268); as well as a number of German expressionist paintings (nos. 24, 25, 262). The fine collection of British eighteenth-century portraits acquired with the original state appropriation (nos. 118, 120–123, 125) has not been adequately exhibited in recent years nor has the collection of African, Oceanic, and pre-Columbian art and artifacts, which comprises 25 percent of the Museum's holdings. Moreover, many recent acquisitions have never been placed on view since entering the collections. This illustrated survey of the collections therefore fulfills an important responsibility of the Museum to make available its collections to a wider audience. The success of every art museum greatly depends on its community's belief in the significance of the paintings, sculpture, decorative arts, and other objects that it collects, and the North Carolina Museum of Art is no exception. Everything shown in these pages belongs to the people of North Carolina and reflects their commitment to the quality and vitality of artistic life in this state. What has been accomplished in the years during which the North Carolina Museum of Art was founded and developed is exciting; even more so is the prospect of the Museum's future as one of the major cultural resources of this state and region.

Edgar Peters Bowron

22. An official synopsis of the State Art Museum Building Commission's activities was compiled by its chairman, Thomas J. White, and published in the program issued on the occasion of the new building dedication, 28 May 1981; see, however, Karl E. Meyer, *The Art Museum: Power, Money, Ethics* (New York, 1979), pp. 144–47, and Phil Patton, "North Carolina's museum with a 'checkered history,'" *Artnews* 81 (October 1982: 84–88).

23. Nina Kasanof, "American Landscapes of the 19th century in the North Carolina Museum of Art," *North Carolina Museum of Art Bulletin* 8, no. 4 (June 1969): 2–15.

Editorial Note

The works of art included here have been listed in approximate chronological order. The selections of European art, however, have been grouped according to country, listed alphabetically, and arranged in approximate chronological order based on the date of the work. When dates are not documented a general period is designated or an approximate date is indicated by *c.* Measurements throughout are in inches, with their metric equivalents following in parentheses. Height precedes width; depth, where it is indicated, follows width.

The first two digits of the accession number represent the year of acquisition. The paintings acquired with the original legislative appropriation were purchased in 1952. Other accessions without a specific credit line have been acquired with the Museum Purchase Fund, an annual legislative appropriation for the purchase of works of art.

Color Plates

Sicilian, Centuripe, c. 250–225 B.C.

Funerary Vase

Polychrome ceramic, h. 35 in. (88.9 cm.)
75.1.9

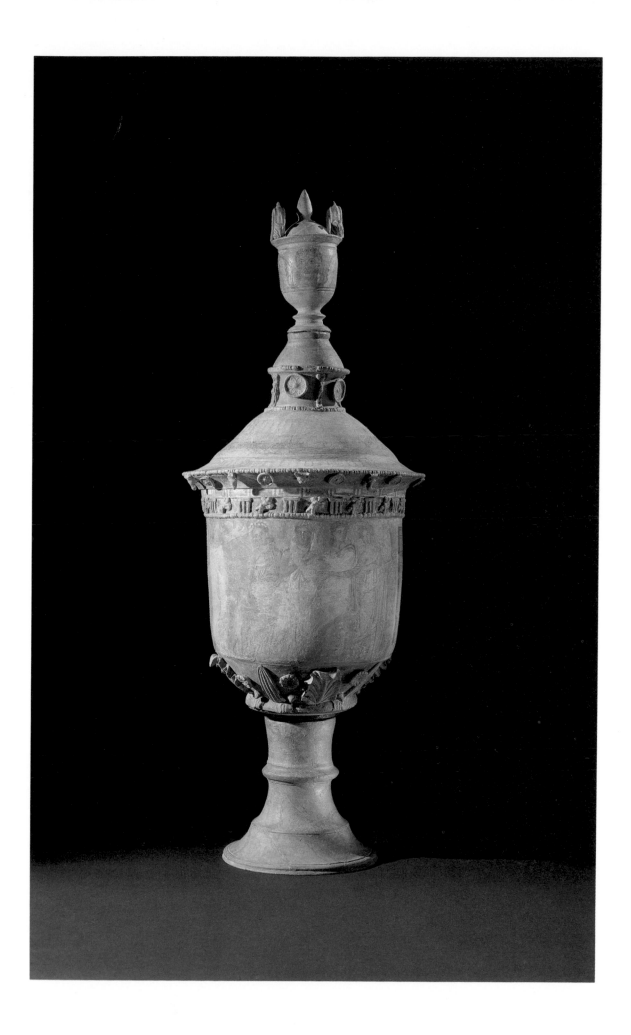

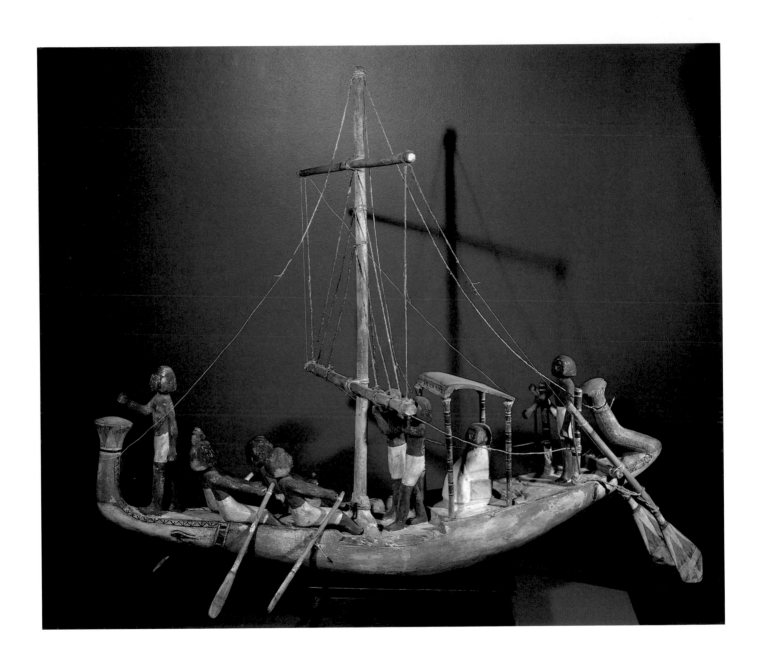

Egyptian, Middle Kingdom, Dynasty XII–XIII, 2052–1778 B.C.

African, Ghana, Ashanti

Model Boat with Figures

Wood with gesso and paint, 30½ x 41 in. (77.5 x 104 cm.)
Gift of Mr. and Mrs. Gordon Hanes, 82.12

Fertility Figure (Akua Ba)

Wood, beads, h. 13½ in. (34.3 cm.)
Gift of Mr. and Mrs. Gordon Hanes, 72.19.42

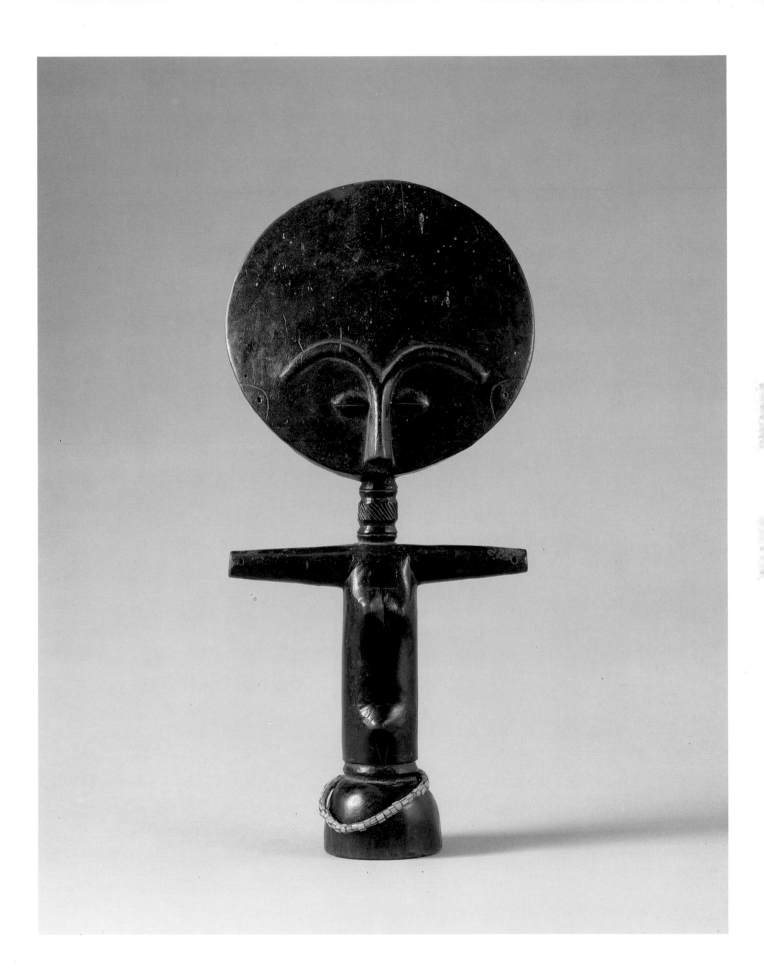

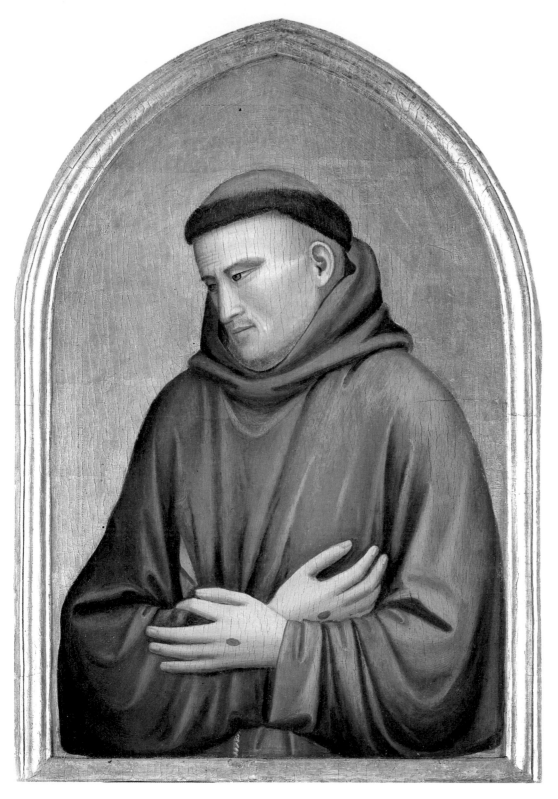

Giotto di Bondone and assistants
Italian, c. 1266–1336

St. Francis, from the *Peruzzi Altarpiece* (no. 173), c. 1322

Tempera and gold leaf on panel, 24½ x 16½ in. (62.3 x 42 cm.)
Gift of the Samuel H. Kress Foundation, 60.17.7

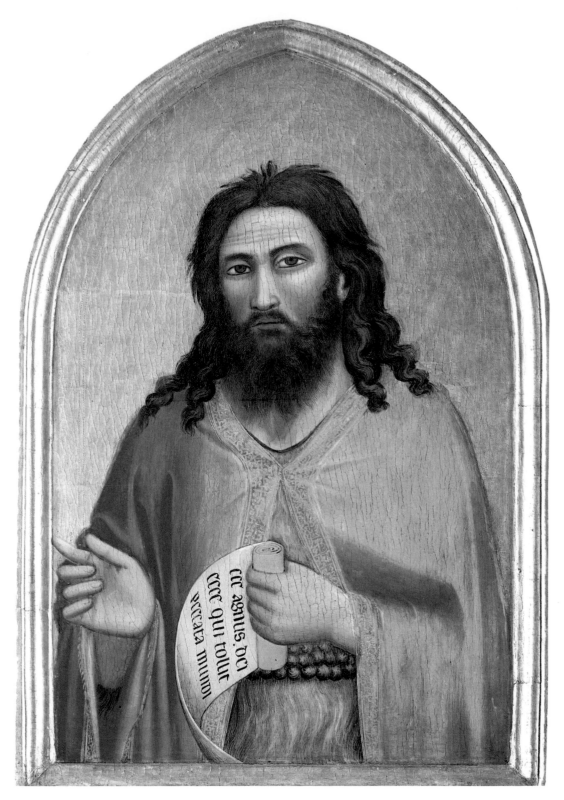

Giotto di Bondone and assistants
Italian, c. 1266–1336

St. John the Baptist, from the *Peruzzi Altarpiece* (no. 173), c. 1322

Tempera and gold leaf on panel, 24½ x 16½ in. (62.3 x 42 cm.)
Gift of the Samuel H. Kress Foundation, 60.17.7

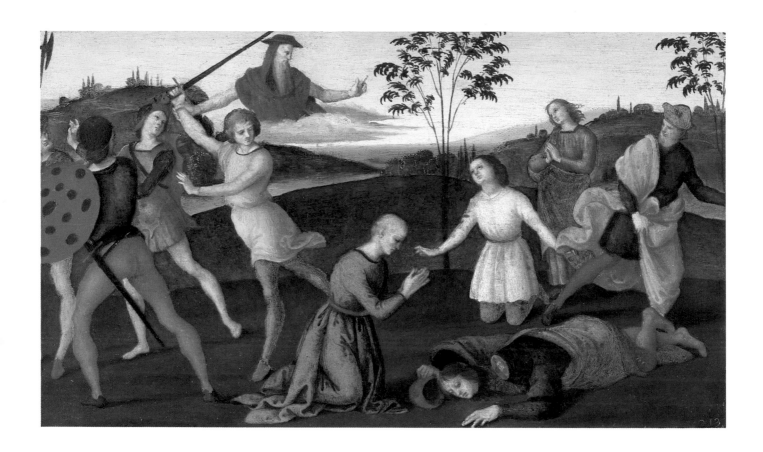

Raphael (Raffaello Sanzio)
Italian, 1483–1520

St. Jerome Punishing the Heretic Sabinian, c. 1503

Oil on panel, 10⅛ x 16½ in. (25.7 x 41.8 cm.)
Gift of Mrs. Nancy Susan Reynolds, the Sarah Graham Kenan Foundation, Julius H. Weitzner,
and Museum Purchase Fund, 65.21.1

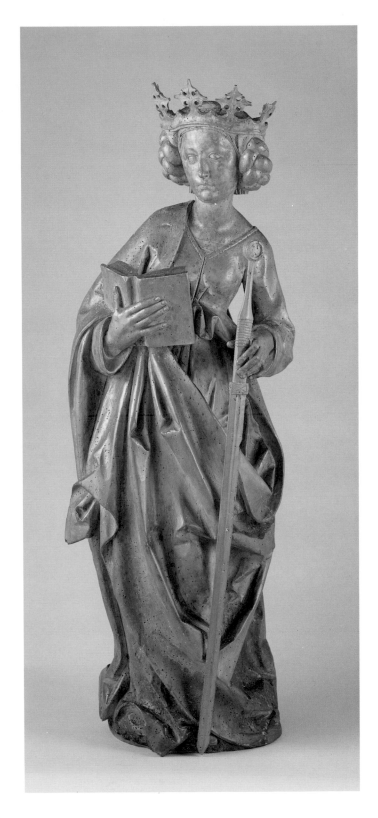

Tilmann Riemenschneider
German, c. 1460–1531

St. Catherine, c. 1505–10

Lindenwood, traces of pigment, h. 37¾ in. (96 cm.)
68.33.1

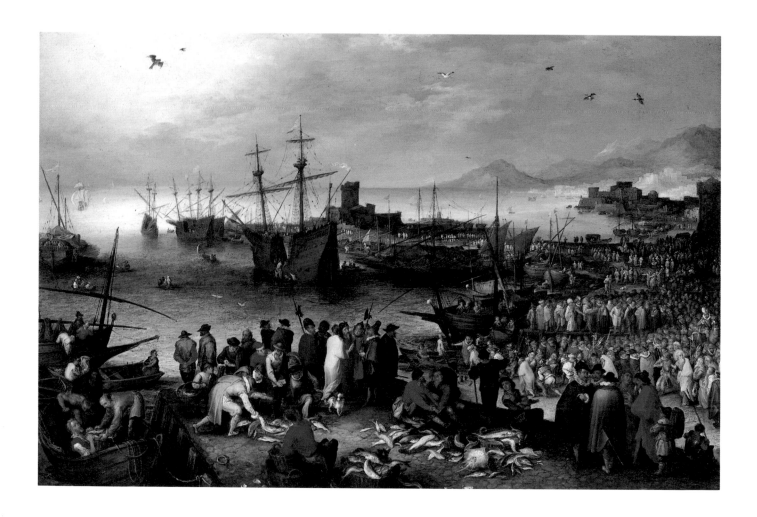

Jan Brueghel the Elder
Flemish, 1568–1625

Harbor Scene with St. Paul's Departure from Caesarea, 1596

Oil on copper, 14 x 21 in. (35.5 x 53.5 cm.)
52.9.92

Peter Paul Rubens
Flemish, 1577–1640

The Holy Family, c. 1633

Oil on canvas, 68¾ x 56 in. (174.6 x 142.2 cm.)
52.9.107

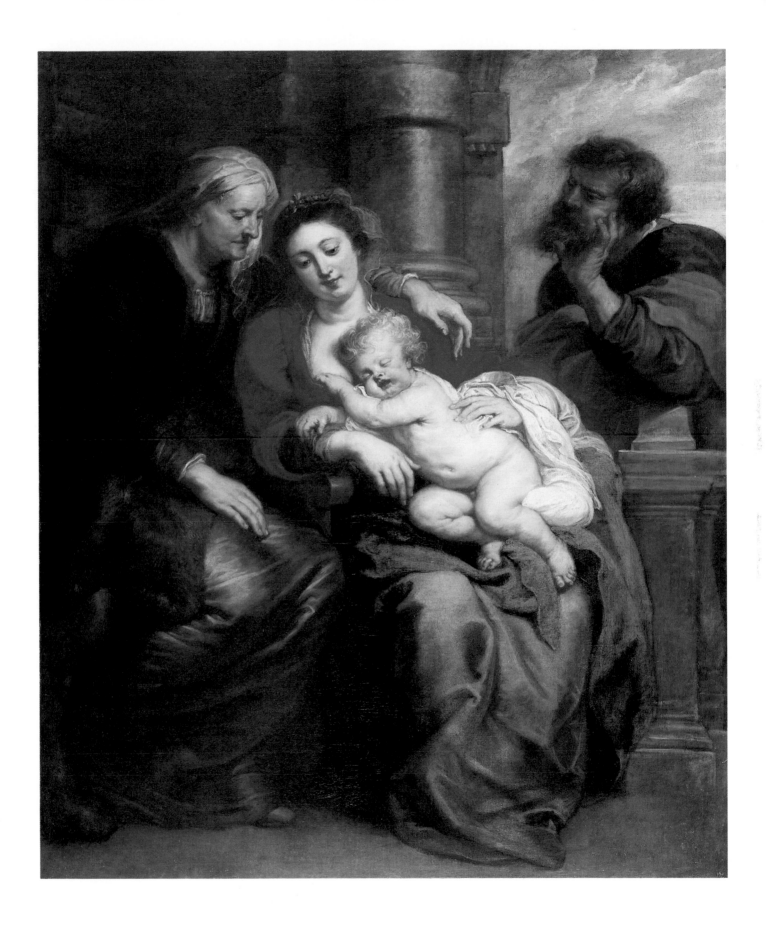

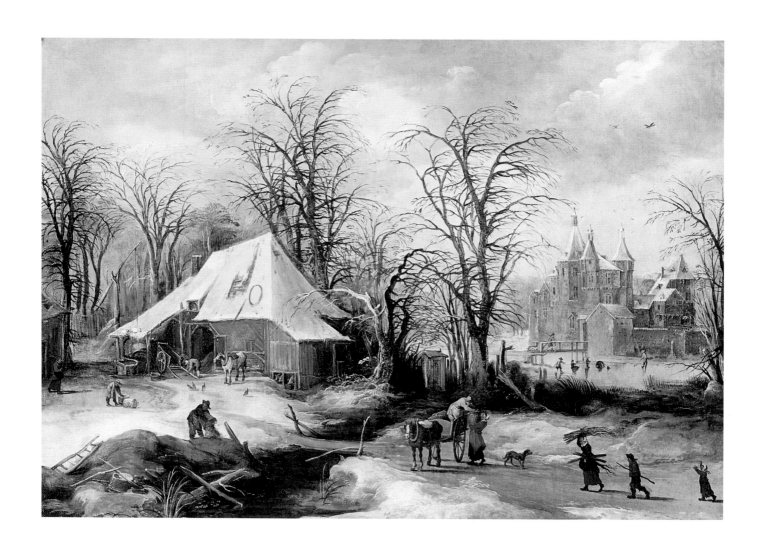

Joos de Momper
Flemish, 1564–1635

Winter Landscape

Oil on canvas, 46¹/₂ x 65⁵/₁₆ in. (118.1 x 165.9 cm.)
52.9.104

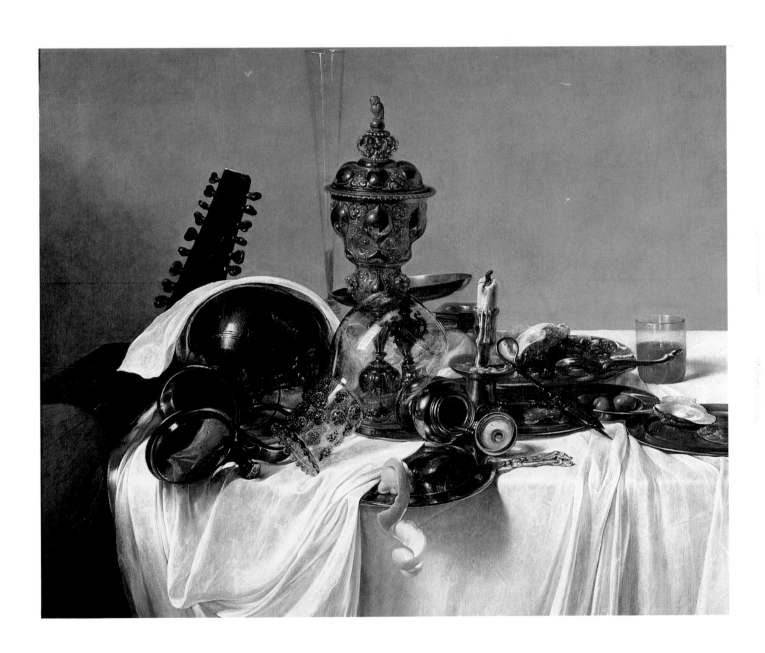

Jan Jansz. den Uyl
Dutch, 1595–1640

Vanitas Still Life, c. 1635

Oil on panel, 31⅜ x 37 in. (79.9 x 94 cm.)
52.9.43

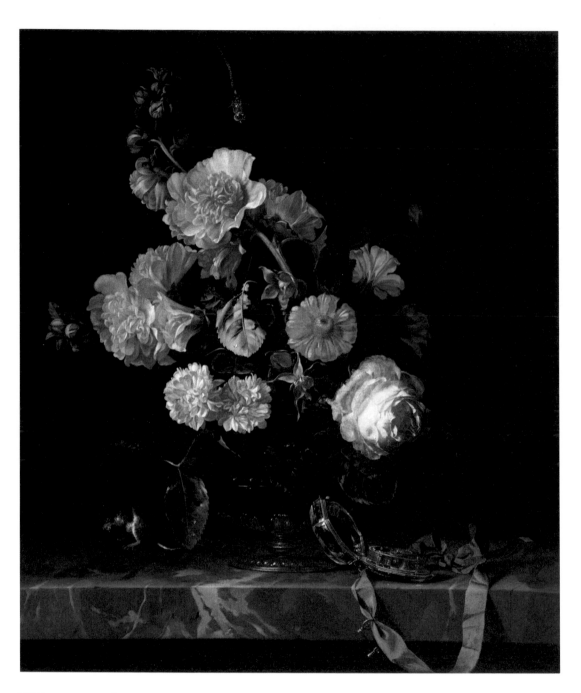

Willem van Aelst
Dutch, 1625/26–after 1682

Guido Reni
Italian, 1575–1642

Vanitas Flower Piece

Madonna and Child, c. 1628–30

Oil on canvas, 22 x 18¼ in. (55.9 x 46.7 cm.)
52.9.57

Oil on canvas, 45 x 36 in. (114.3 x 91.4 cm.)
Gift of Mr. and Mrs. Robert Lee Humber, 55.12.1

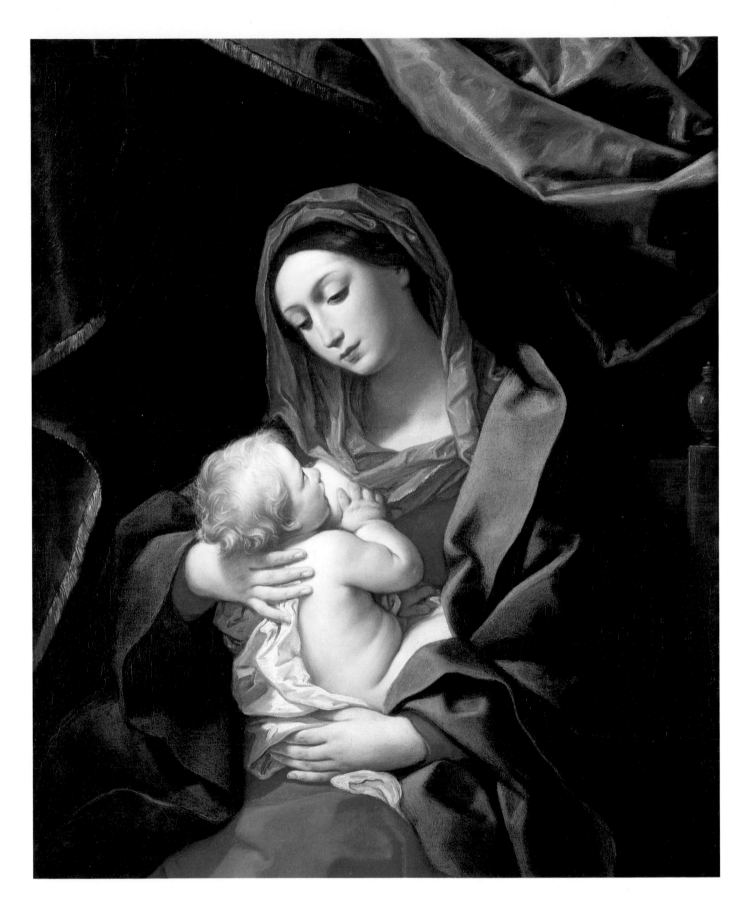

15

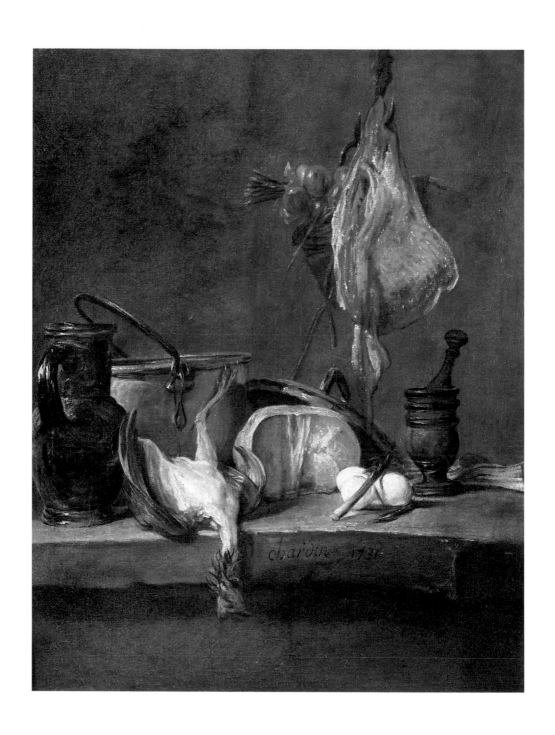

Jean Siméon Chardin
French, 1699–1779

Still Life with Ray Fish and a Basket of Onions, 1731

Oil on canvas, 16 x 12⅝ in. (40.6 x 32 cm.)
63.29.1

16

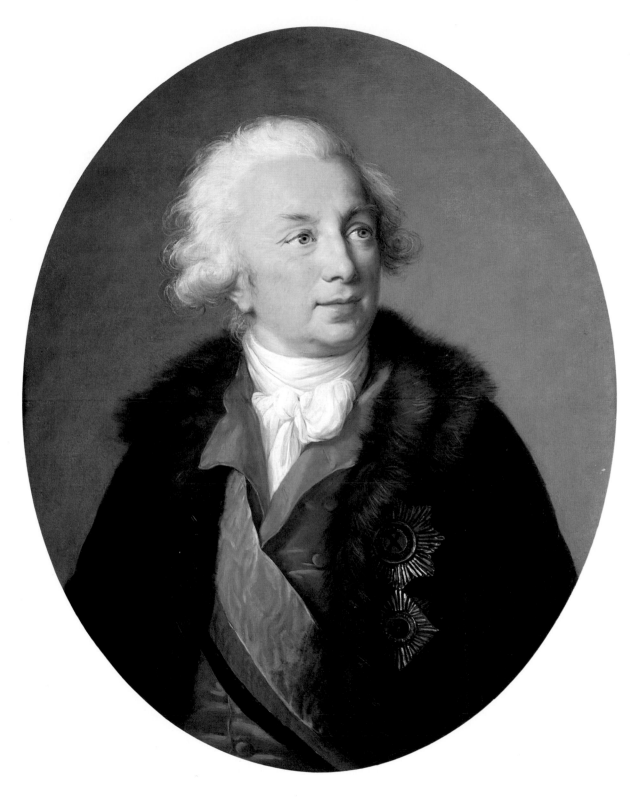

Elisabeth Louise Vigée LeBrun
French, 1755–1842

Count Ivan Ivanovitch Chouvaloff (1727–1797), c. 1795–97

Oil on canvas, 33 x 24 in. (83.8 x 61 cm.)
52.9.224

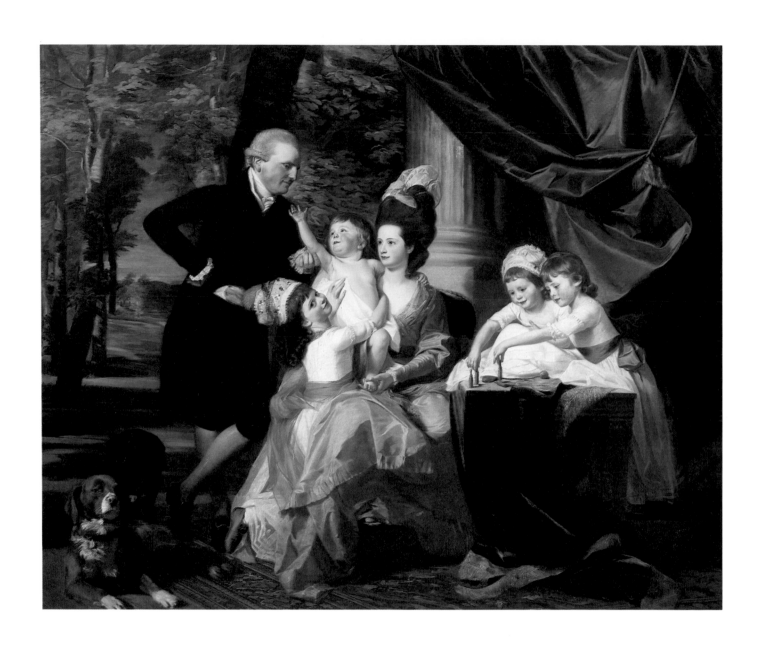

John Singleton Copley
American, 1738–1815

Sir William Pepperrell (1746–1816) and His Family, 1778

Oil on canvas, 90 x 108 in. (228.6 x 274.3 cm.)
52.9.8

Anton von Maron
Austrian, 1733–1808, active in Rome

Cardinal Muzio Gallo (1721–1801), 1785

Oil on canvas, 82½ x 46½ in. (209 x 118 cm.)
George and Lucy Finch Trust Fund, North Carolina Art Society funds, and Museum Purchase Fund, 82.2

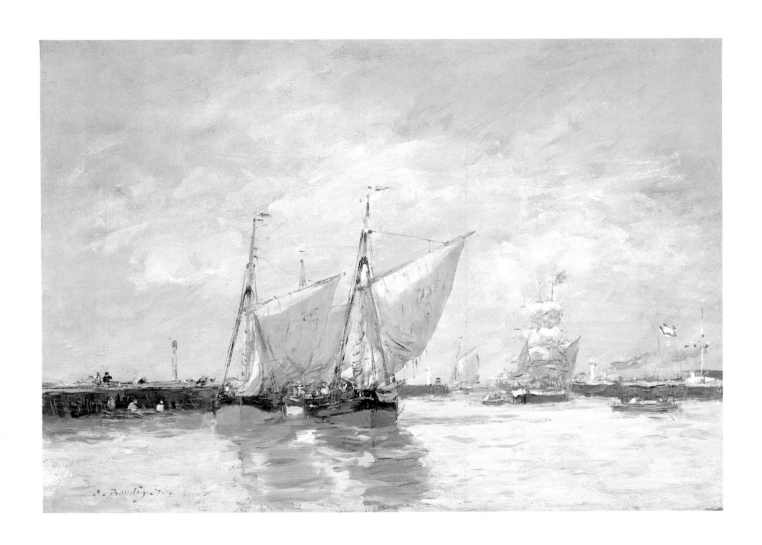

Eugène Boudin
French, 1824–1898

Trouville, The Jetties, High Tide, 1876

Oil on canvas, 12¾ x 18¼ in. (32.4 x 46.4 cm.)
Gift of the North Carolina National Bank, 67.12.1

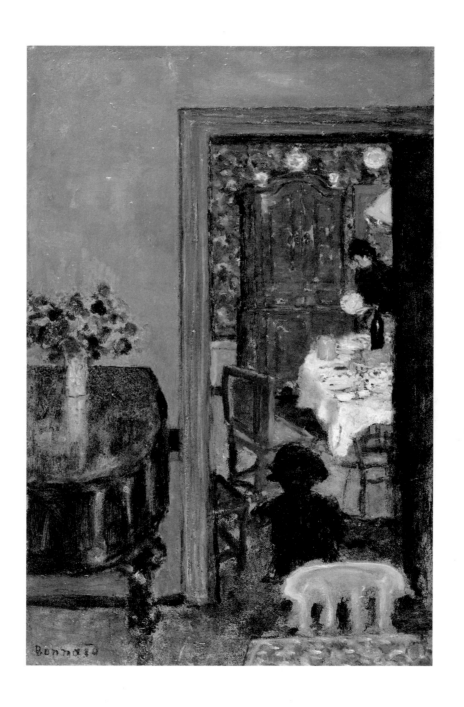

Pierre Bonnard
French, 1867–1947

The Lessons, 1898

Oil on board, 20¼ x 13¼ in. (51.43 x 33.65 cm.)
72.1.3

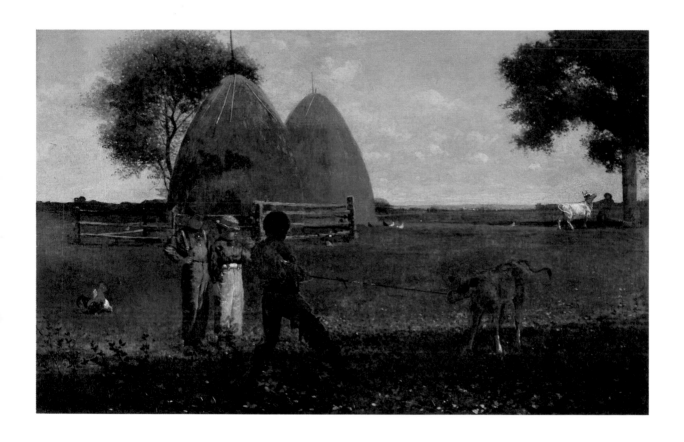

Winslow Homer
American, 1836–1910

Weaning the Calf, 1875

Oil on canvas, 23 ⅞ x 38 in. (60.8 x 96.5 cm.)
52.9.16

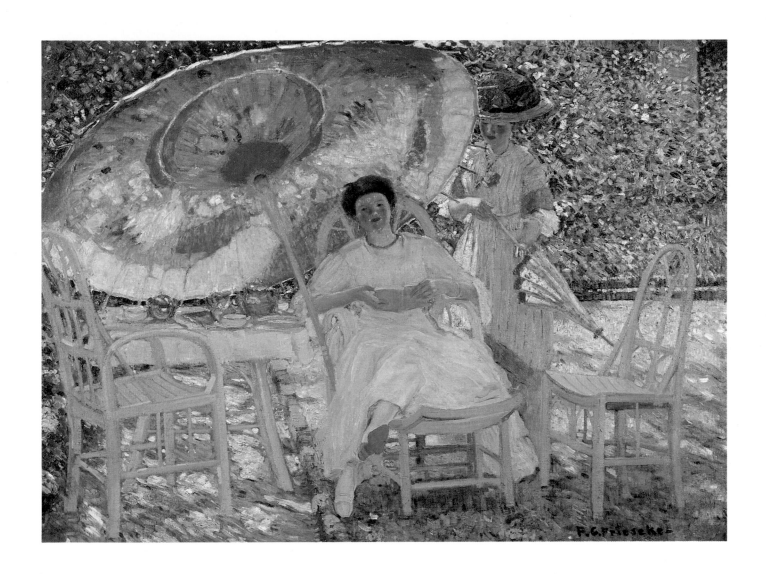

Frederick Carl Frieseke
American, 1874–1939

The Garden Parasol, c. 1909

Oil on canvas, 57⅛ x 77 in. (145.1 x 195.5 cm.)
73.1.4

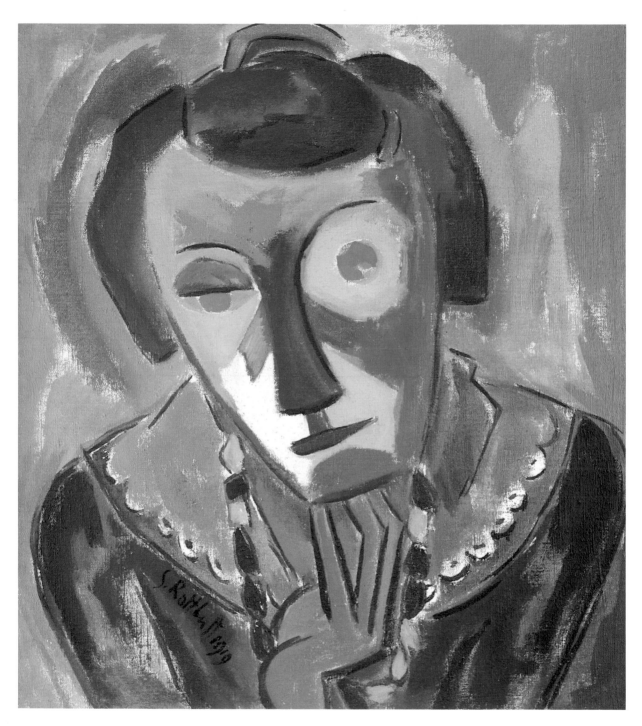

Karl Schmidt-Rottluff
German, 1884–1976

Portrait of Emy, 1919

Oil on canvas, 28 15/16 x 25 3/4 in. (73.5 x 65.5 cm.)
Bequest of W. R. Valentiner, 65.10.58

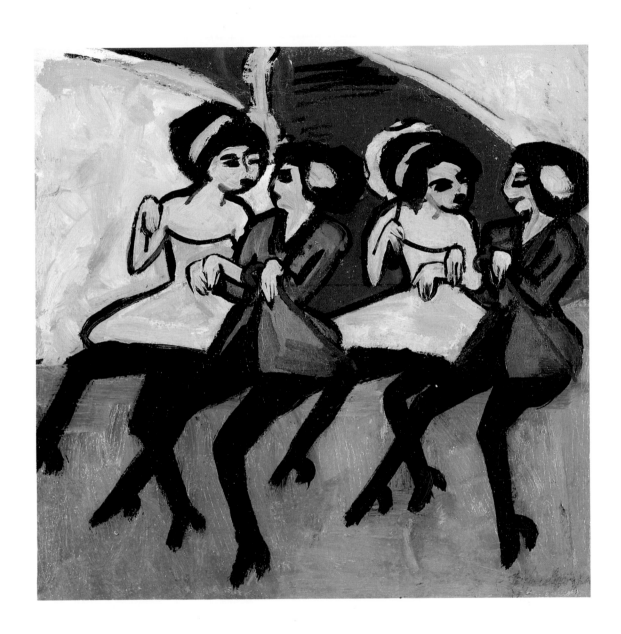

Ernst Ludwig Kirchner
German, 1880–1938

Panama Girls, c. 1910

Oil on canvas, 19⅞ x 19⅞ in. (50.5 x 50.5 cm.)
Bequest of W. R. Valentiner, 65.10.30

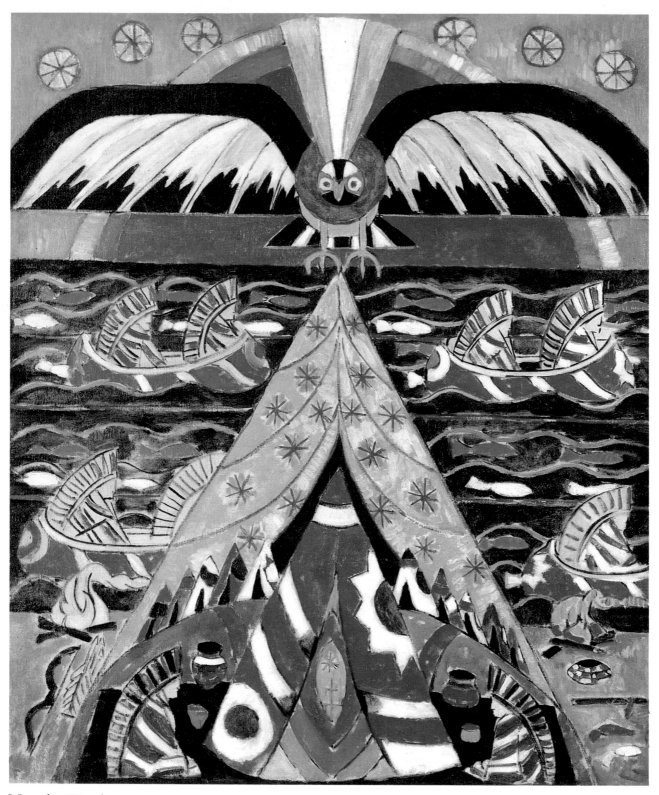

Marsden Hartley
American, 1877–1943

Indian Fantasy, 1914

Oil on canvas, 46 11/16 x 39 5/16 in. (118.6 x 99.7 cm.)
75.1.4

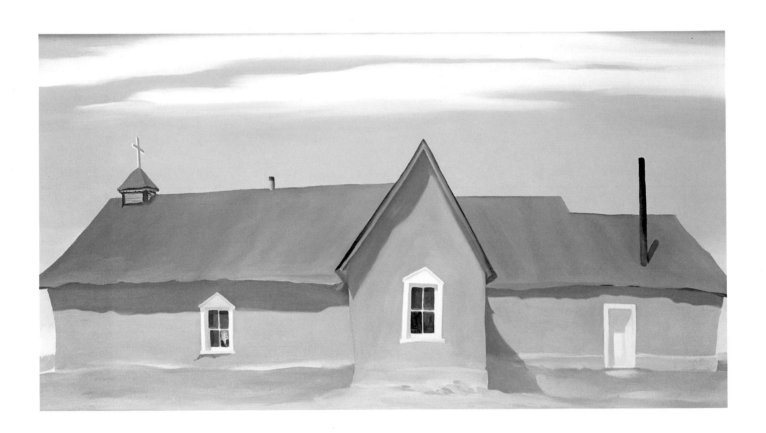

Georgia O'Keeffe
American, born 1887

Cebolla Church, 1945

Oil on canvas, 20¹/₁₆ x 36¹/₄ in. (51.1 x 92 cm.)
Purchased with funds from the North Carolina Art Society (Robert F. Phifer Funds)
in honor of Dr. Joseph C. Sloane, 72.18.1

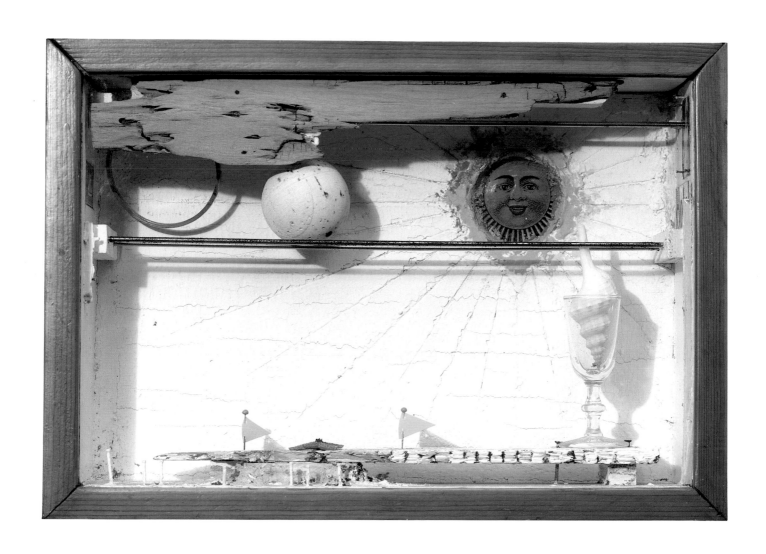

Joseph Cornell
American, 1903–1972

Suzy's Sun (for Judy Tyler), 1957

Mixed media, 10¾ x 15 x 4 in. (27.3 x 38.1 x 10.2 cm.)
78.1.1

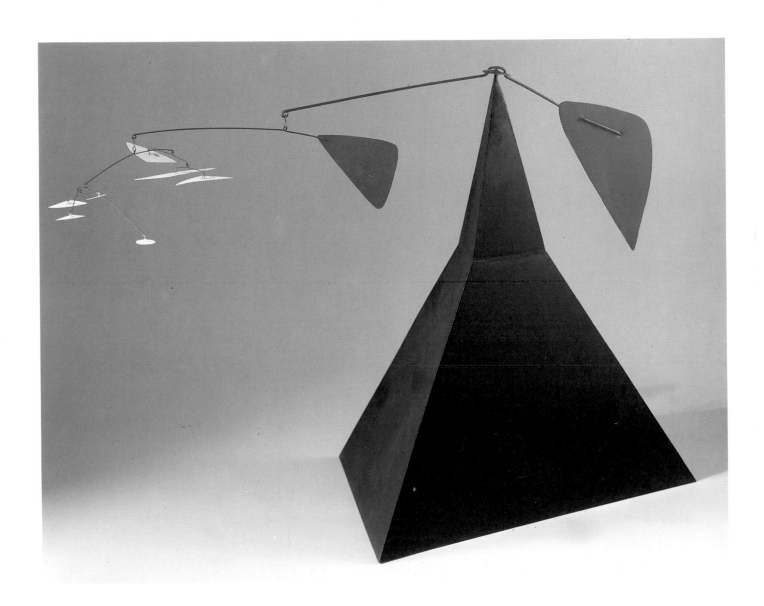

Alexander Calder
American, 1898–1976

Tricolor on Pyramid, 1965

Painted sheet metal and steel wire, 48 x 78 in. (121.92 x 198.12 cm.)
Purchased with funds from the National Endowment for the Arts and the North Carolina Art Society
(Robert F. Phifer Funds), 69.12.1

Richard Diebenkorn
American, born 1922

Berkeley No. 8, 1954

Oil on canvas, 68⅞ x 45¼ in. (175 x 150 cm.)
Gift of W. R. Valentiner, 57.34.3

Morris Louis
American, 1912–1962

Pi, 1960

Acrylic on canvas, 103 x 175 in. (261.6 x 444.5 cm.)
Gift of Mr. and Mrs. Gordon Hanes, 82.15

Robert Rauschenberg
American, born 1925

Credit Blossom, 1978

Solvent transfer on fabric applied to wooden panels, 84 x 108 in. (213.4 x 274.3 cm.)
Purchased with funds from the National Endowment for the Arts, the North Carolina Art Society
(Robert F. Phifer Funds), and Museum Purchase Fund, 79.2.6

Ancient Art

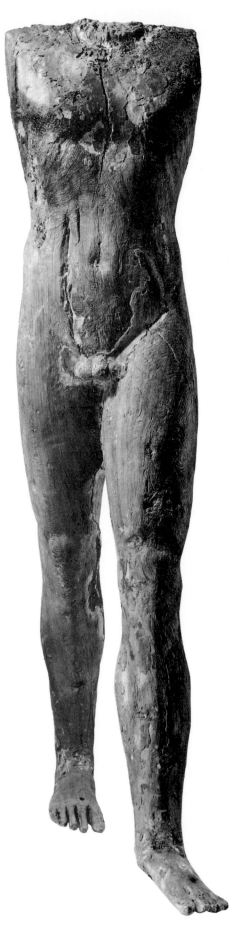

Egyptian, Old Kingdom, Dynasty V, 2494–2345 B.C.

Male Striding Figure

Wood with traces of gesso and paint, h. 52¼ in. (132.7 cm.)
Gift of Mr. and Mrs. Gordon Hanes, 79.6.3

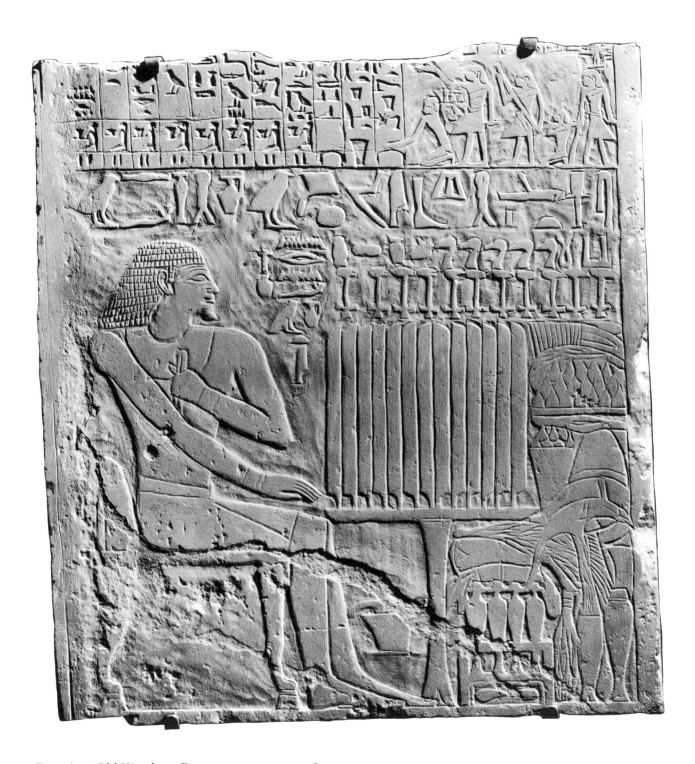

Egyptian, Old Kingdom, Dynasty VI, 2420–2258 B.C.

Relief from the Tomb of Khnumti in Saqqarah

Limestone, 21 1/2 x 18 15/16 in. (54.4 x 48 cm.)
The James G. Hanes Memorial Fund, 72.2.2

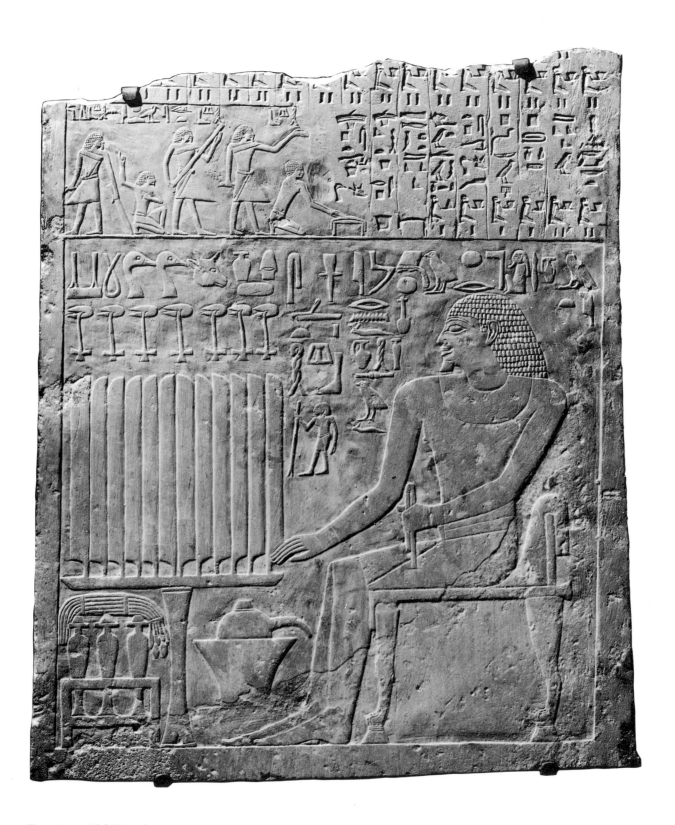

Egyptian, Old Kingdom, Dynasty VI, 2420–2258 B.C.

Relief from the Tomb of Khnumti in Saqqarah

Limestone, 23 ⅞ x 19 ⅝ in. (60.5 x 50 cm.)
The James G. Hanes Memorial Fund, 72.2.1

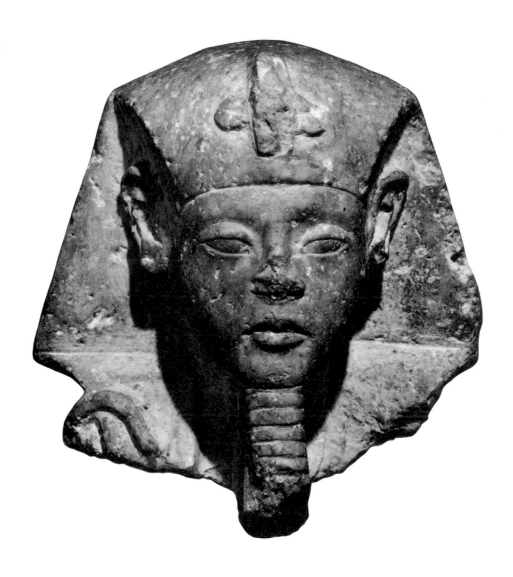

Egyptian, New Kingdom, Dynasty XVIII, 1372–1355 B.C.

Head from a Shawabti Figure of Akhenaten

Quartzite, h. 2¾ in. (6.98 cm.)
The James G. Hanes Memorial Fund, 74.2.8

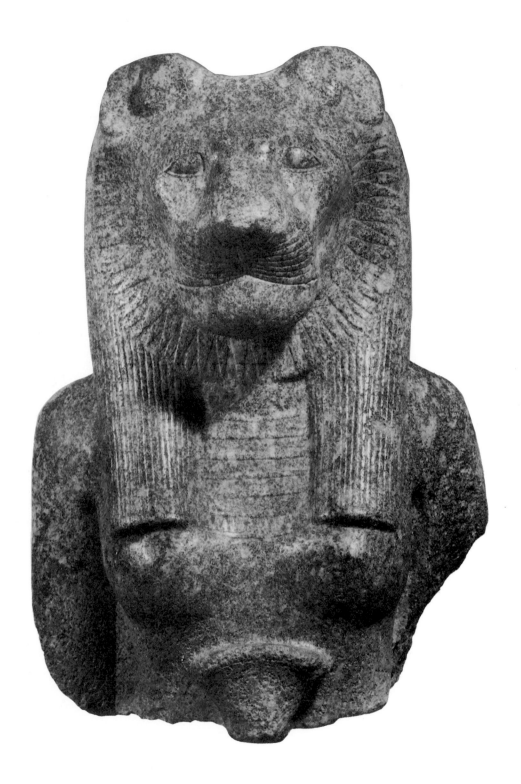

Egyptian, New Kingdom, Dynasty XVIII, 1570–1314 B.C.

Bust of the Goddess Sekhmet

Black granite, h. 23 in. (58.5 cm.)
Gift of Mr. and Mrs. Gordon Hanes, 82.11

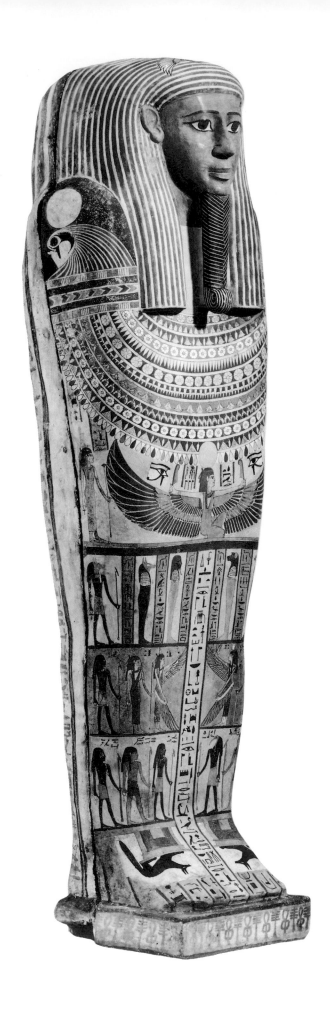

Egyptian, Late Period, Dynasty XXV–XXXI, 730–330 B.C.

Male Mummy Case

Wood with gesso and polychrome, h. 71 in. (180.3 cm.)
The James G. Hanes Memorial Fund, 73.8.5

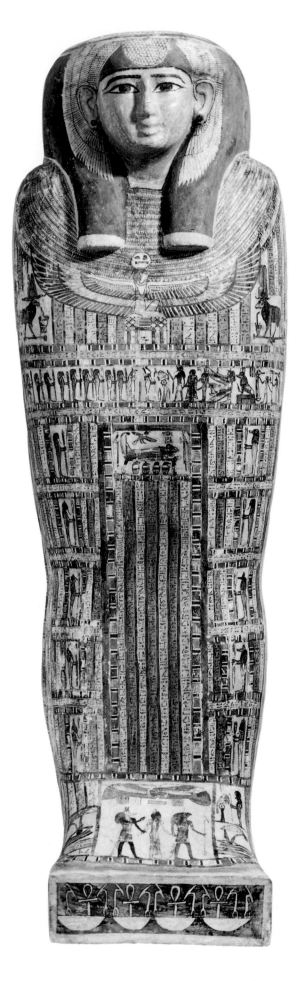

Egyptian, Late Period, Dynasty XXV–XXXI, 730–330 B.C.

Female Mummy Case

Wood with gesso and polychrome, h. 71 in. (180.3 cm.)
The James G. Hanes Memorial Fund, 73.8.4

Egyptian, Ptolemaic Period, 285–246 B.C.

Corner Relief with Offering Scene (front)

Red granite, 29 x 18¼ in. (73.66 x 46.35 cm.)
The James G. Hanes Memorial Fund, 72.2.3a

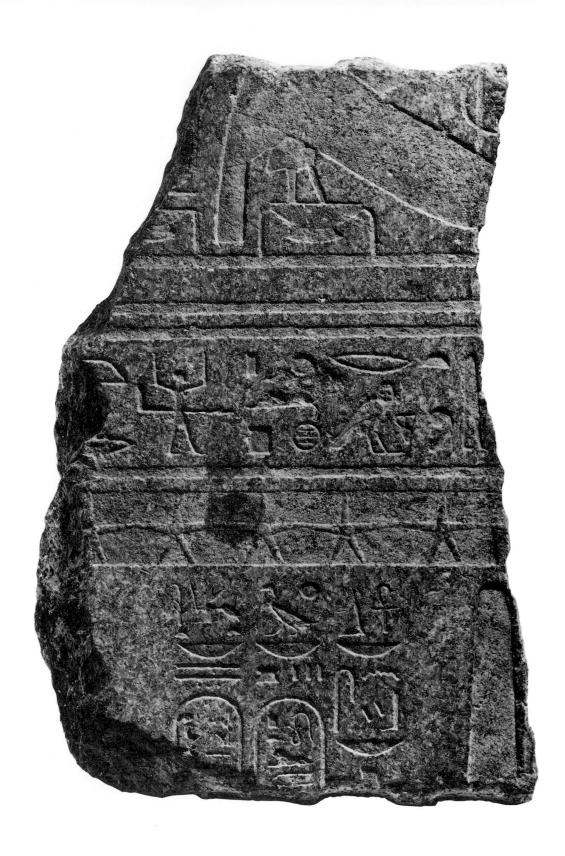

Egyptian, Ptolemaic Period, 285–246 B.C.

Corner Relief with Offering Scene (side)

Red granite, 29 x 18¼ in. (73.66 x 46.35 cm.)
The James G. Hanes Memorial Fund, 72.2.3b

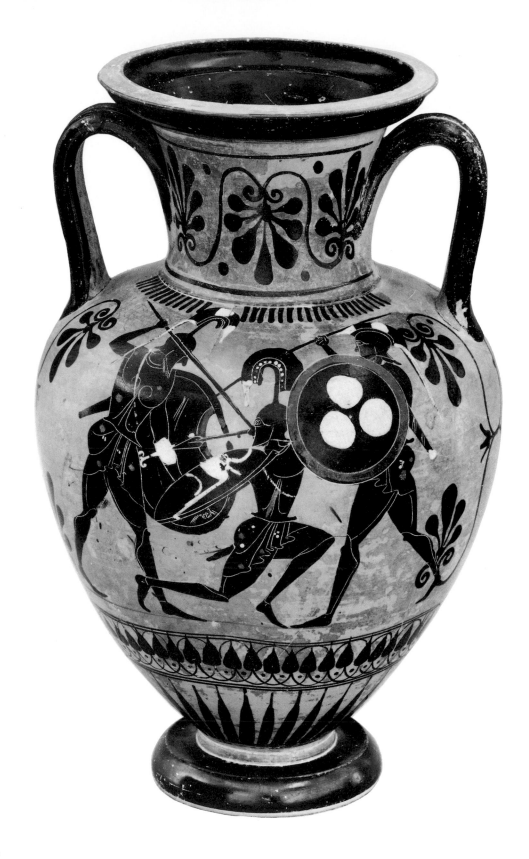

Greek, Attic
Leagros Group, c. 510–500 B.C.

Amphora

Black-figure ceramic with added red and white paint, h. 13½ in. (34.3 cm.)
74.1.6

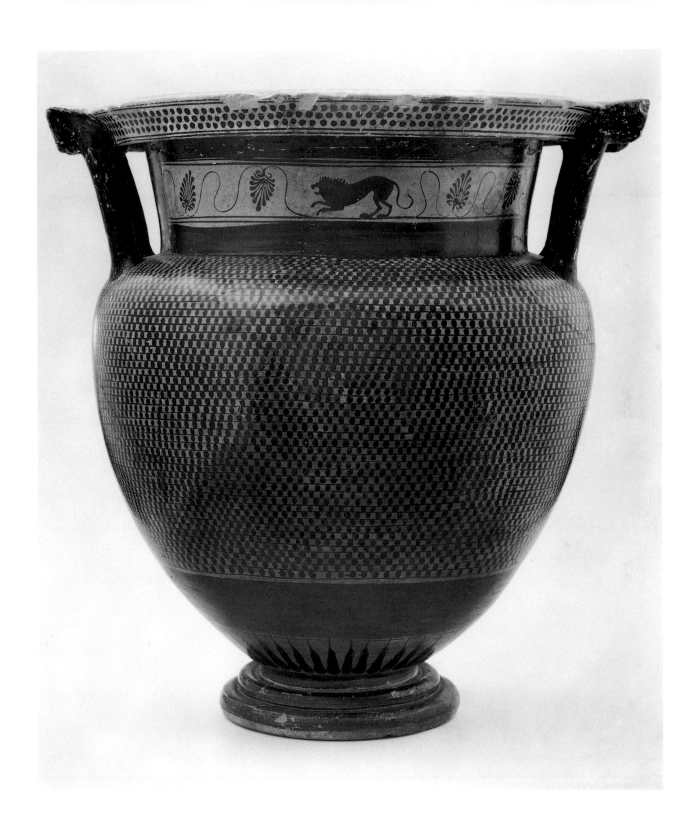

Greek, Attic, early 5th century B.C.

Column Krater

Ceramic with black glaze, h. 16¼ in. (41.27 cm.)
Gift of Mr. and Mrs. Gordon Hanes, 75.8.3

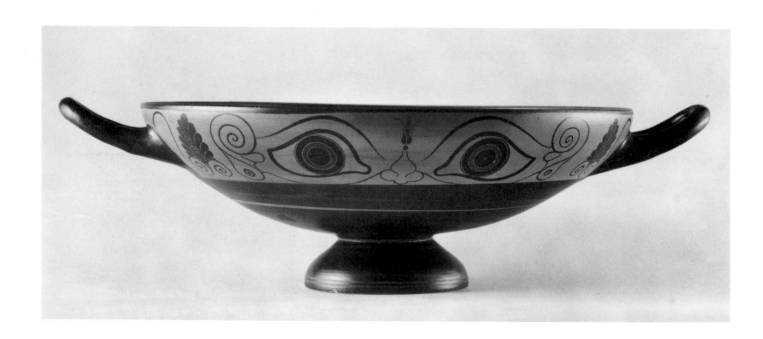

Greek, Chalcidian, c. 525–500 B.C.

Eye Cup

Ceramic with black glaze and applied red paint, h. 4¼ in. (10.8 cm.)
Museum Purchase Fund and North Carolina Museum of Art Foundation funds, 79.1.1

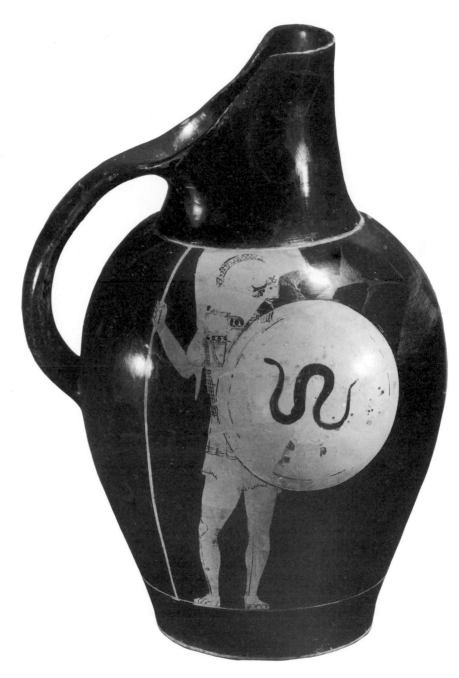

Greek, Attic, c. 470–460 B.C.
Painter of the Brussels Oinochoai

Oinochoe

Red-figure ceramic, h. 9⅝ in. (24.5 cm.)
Purchased with North Carolina Museum of Art Foundation funds, 79.11.5

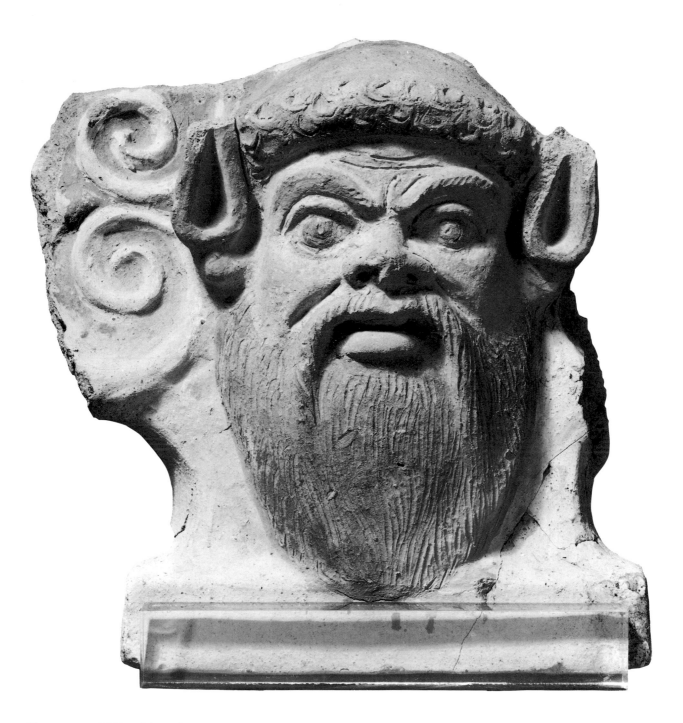

Etruscan, middle of the 5th century B.C.

Antefix in the Shape of a Satyr's Head

Terracotta with paint, h. 12⅜ in. (31.5 cm.)
Museum Purchase Fund and North Carolina Museum of Art Foundation funds, 77.20.1

South Italian, Daunian, attributed to a Canosan workshop, 4th–3rd century B.C.

Askos

Ceramic with black, pink, and red paint, h. 10¼ in. (26 cm.)
77.1.5

Greek, c. 300–100 B.C.

South Italian, Apulian, c. 320 B.C.
Workshop of the Patera Painter

Athena

Hydria

Bronze, h. 7¾ in. (19.7 cm.)
Purchased with funds from the North Carolina Art Society
Travel Committee, 79.10.1

Red-figure ceramic with added white paint,
h. 31 in. (78.7 cm.)
74.1.2

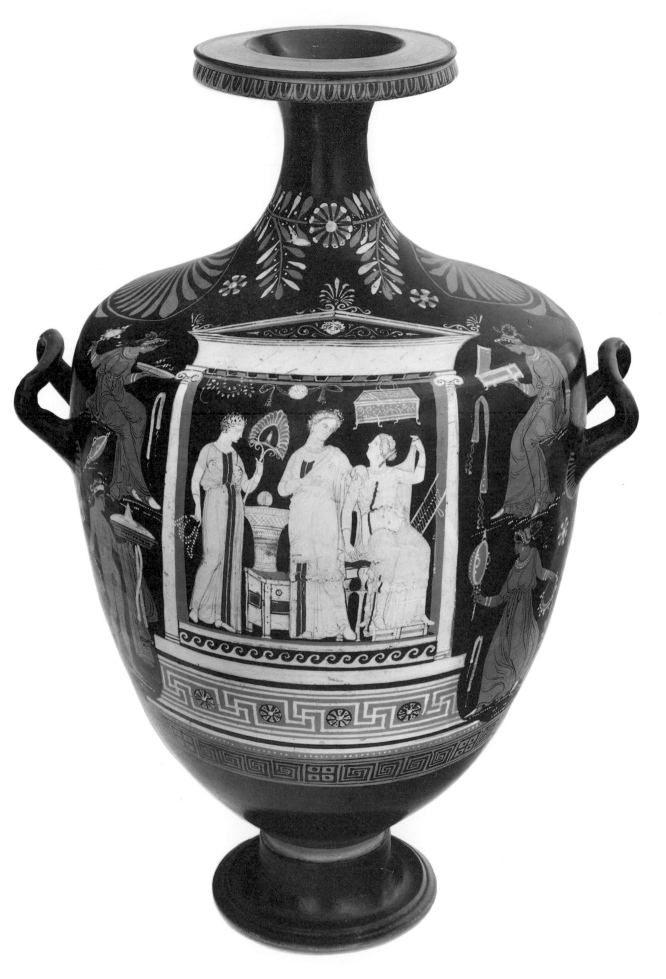

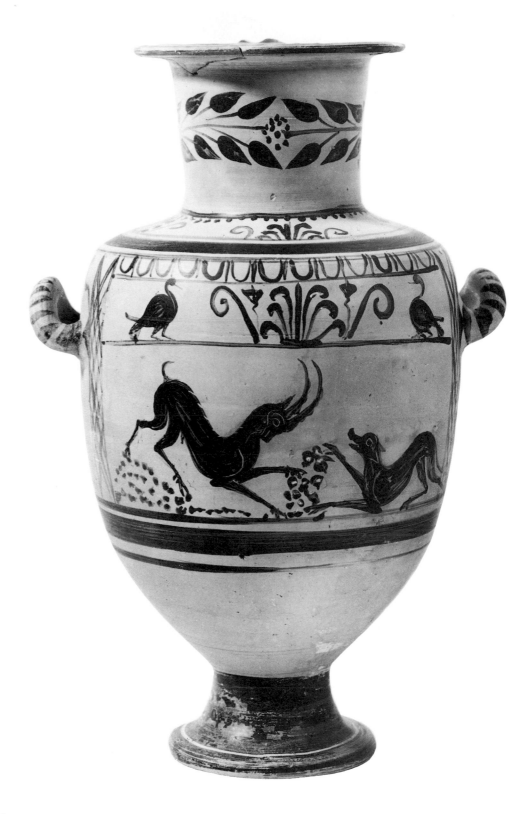

Greek, from Hadra, Egypt, 2nd–1st century B.C.

Hydria

Ceramic with buff slip and added paint, h. 13½ in. (34.1 cm.)
Gift of Mr. and Mrs. Gordon Hanes, 79.6.15

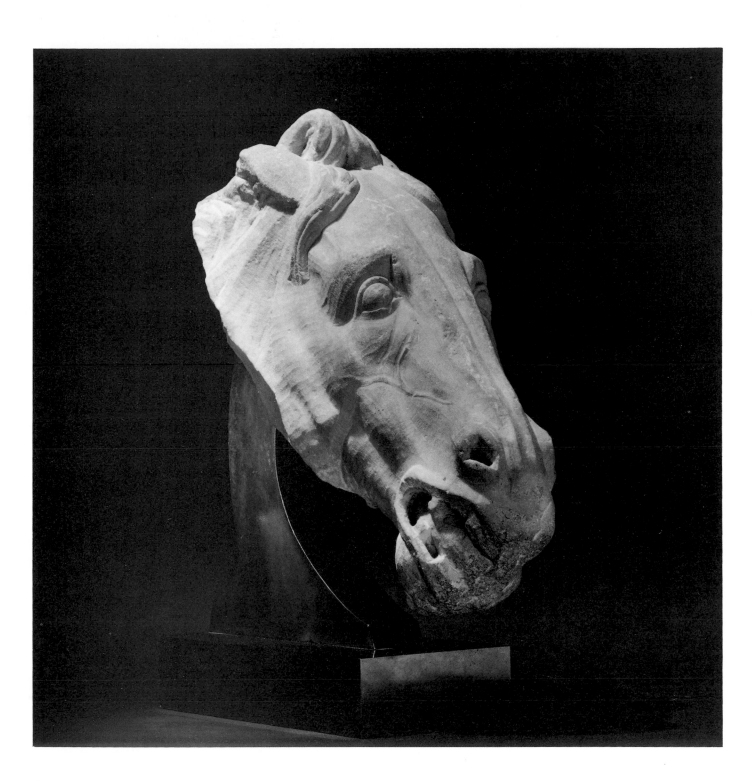

Roman, c. 200 B.C.

Head of a Horse

Marble, h. 12½ in. (31.8 cm.)
77.1.9

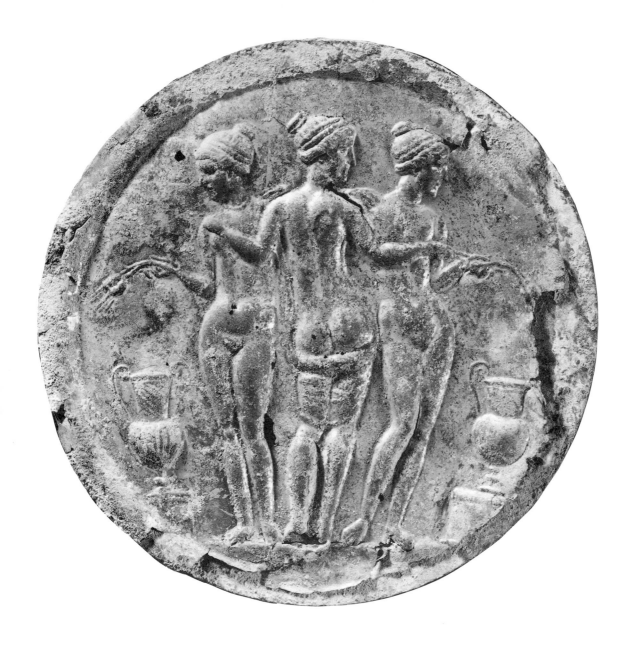

Roman, 150–31 B.C.

Greek, c. 60 B.C.

Mirror with Representation of the Three Graces

Torso of Aphrodite

Silver with gilt bronze relief, dia. 5⅛ in. (13 cm.)
77.1.8

Marble, h. 33 in. (83.82 cm.)
Purchased with funds from the North Carolina Art Society
(Robert F. Phifer Funds) in memory of
Katherine Pendleton Arrington, 69.34.1

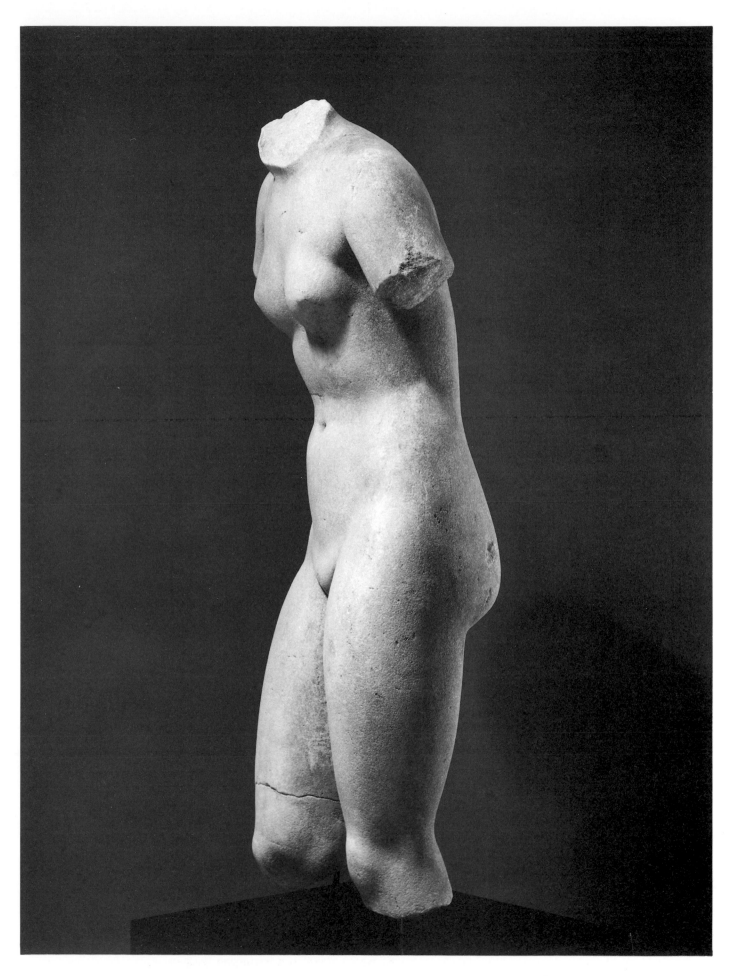

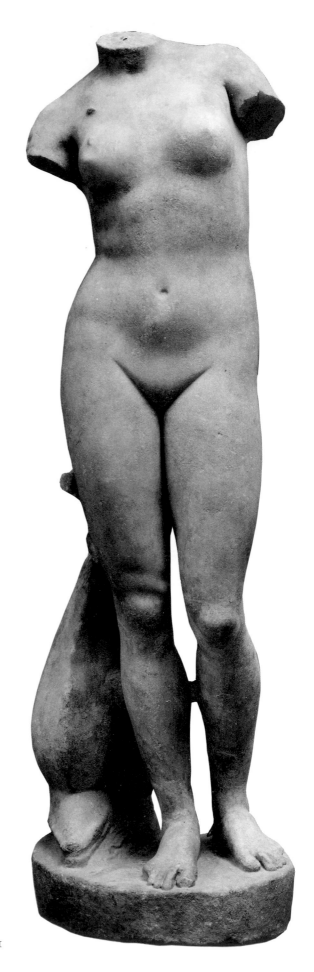

Roman, 1st century (after a Hellenistic original)

Aphrodite of Cyrene

Marble, h. 62¼ in. (158.1 cm.)
Purchased with funds from the North Carolina Art Society
(Robert F. Phifer Funds) and Museum Purchase Fund, 80.9.1

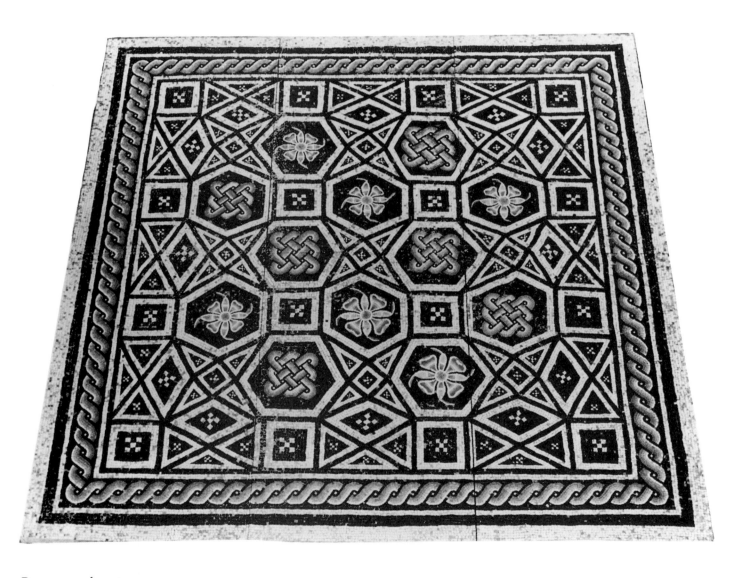

Roman, 2nd century

Mosaic

Marble and glass, 98½ x 98½ in. (250.3 x 250.3 cm.)
Gift of Mr. and Mrs. Gordon Hanes, 79.6.9

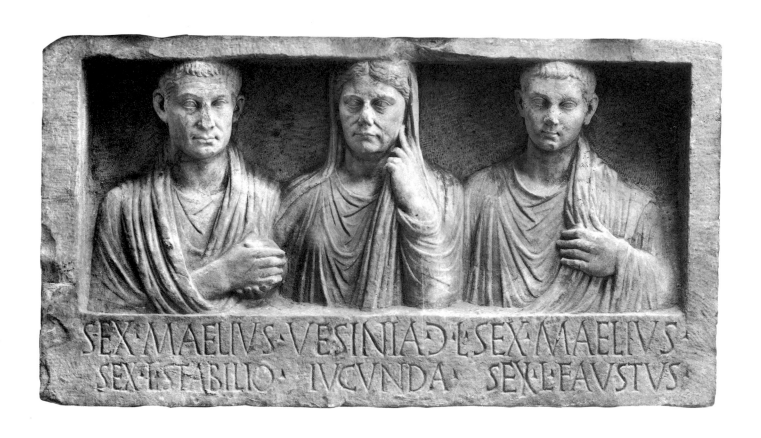

Roman, 1st century

Funerary Monument

Marble, 27½ x 67 x 15 in. (69.9 x 170.2 x 38.1 cm.)
79.1.2

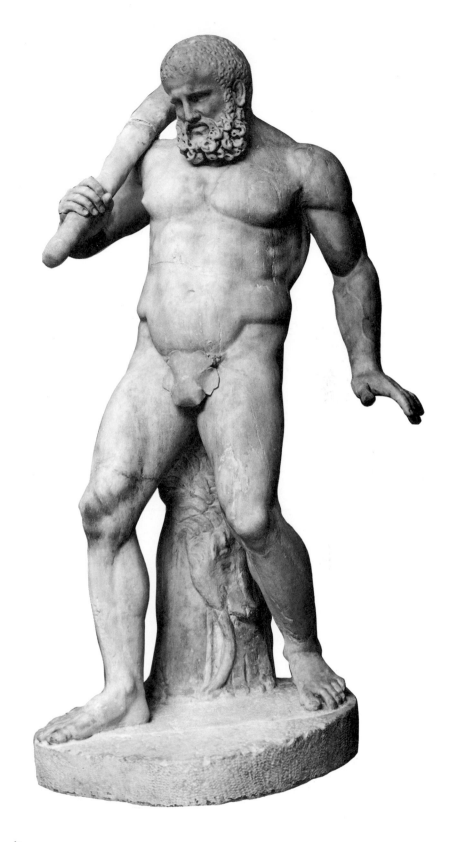

Roman, 2nd century (after a Hellenistic original)

Hercules

Marble, h. 65 in. (165.1 cm.)
Gift of Mr. and Mrs. Jack Linsky, 55.11.2

Roman, 2nd century

Sarcophagus Fragment

Marble, 39 x 22 in. (99.1 x 55.9 cm.)
Gift of Mr. and Mrs. Gordon Hanes, 79.11.8

African, Oceanic, and New World Cultures

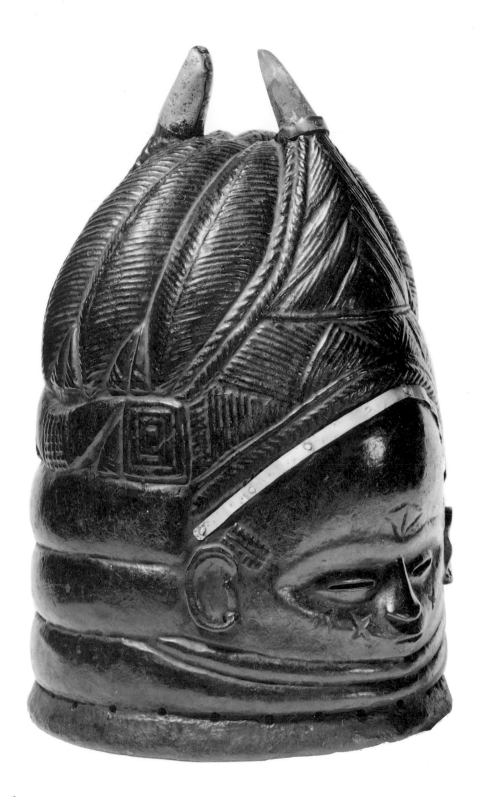

African, Sierra Leone, Mende

Helmet Mask

Wood, metal, h. 14¼ in. (36.2 cm.)
Gift of the James G. Hanes Memorial Fund, 73.8.25

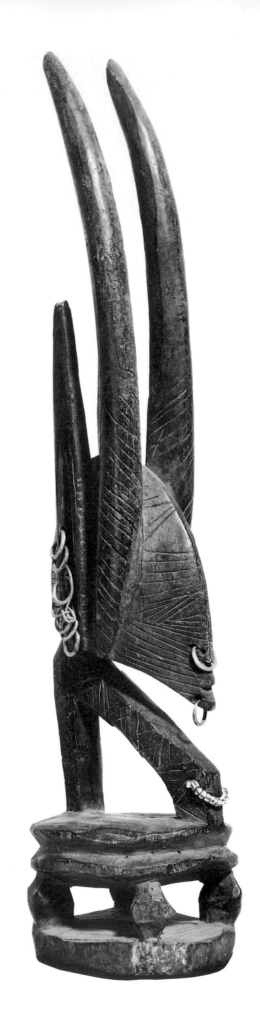

African, Mali, Bambara

Antelope Headpiece (Tji Wara)

Wood, metal, beads, h. 18⅛ in. (46 cm.)
Gift of the Hanes Corporation, 72.19.39

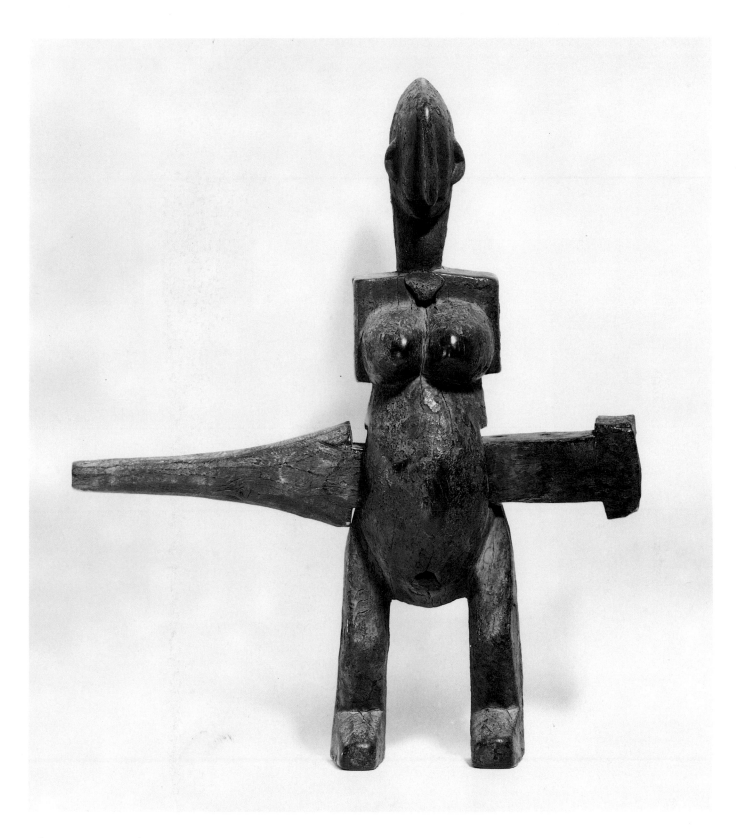

African, Mali, Bambara

Door Crossbolt with the Form of a Standing Female Figure

Wood, metal, h. 18¾ in. (47.6 cm.)
Gift of Lewis W. Pate, 73.15.18

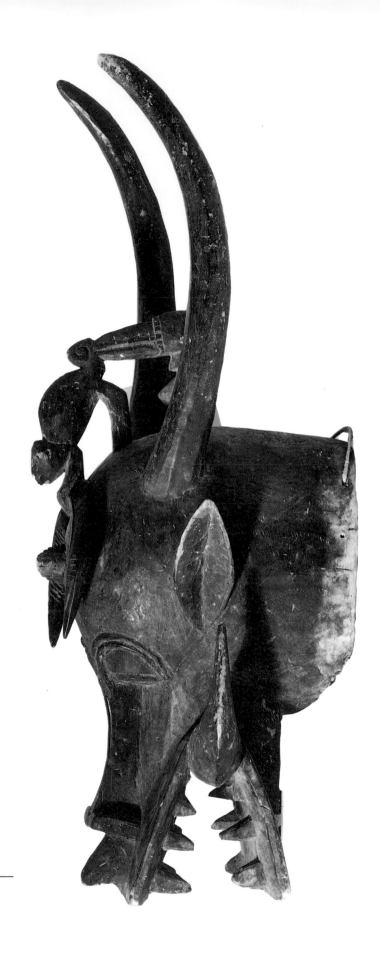

African, Ivory Coast, Senufo

Firespitter Helmet Mask

Wood, pigment, h. 33 in. (83.8 cm.)
Gift of the Hanes Corporation, 72.19.45

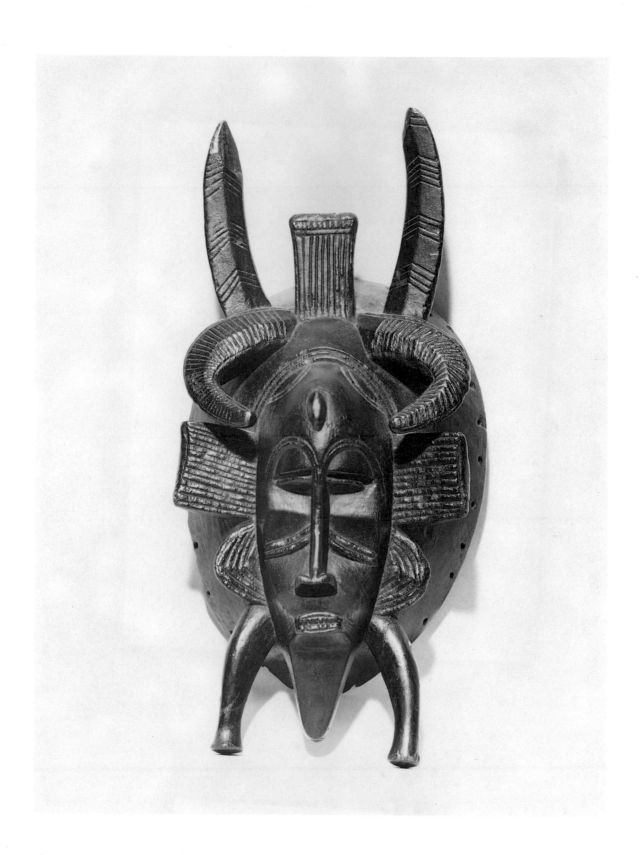

African, Ivory Coast, Senufo

Kplekple Mask

Wood, h. 12½ in. (31.7 cm.)
Gift of the Hanes Corporation, 72.19.12

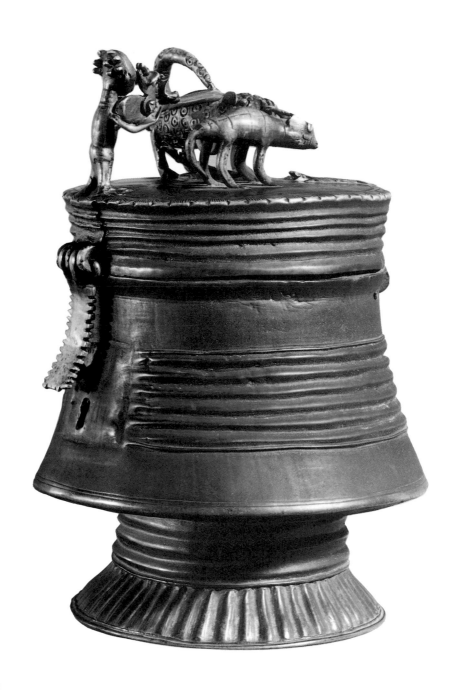

African, Ghana, Ashanti

Kuduo Box with Hinged Lid

Bronze, h. 9¹³/₁₆ in. (24.9 cm.)
The James G. Hanes Memorial Fund, 72.19.17

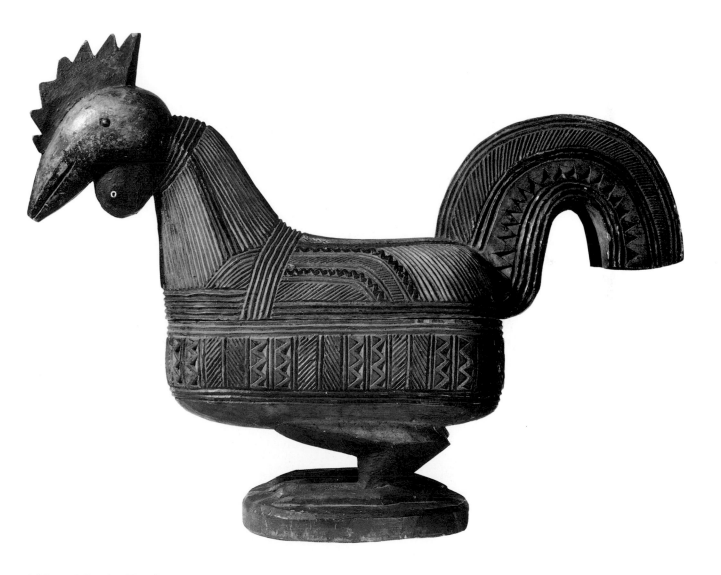

African, Nigeria, Yoruba

Ceremonial Dish in the Form of a Rooster

Wood, pigment, l. 21½ in. (54.6 cm.)
Gift of Edward H. Merrin, 71.45.6

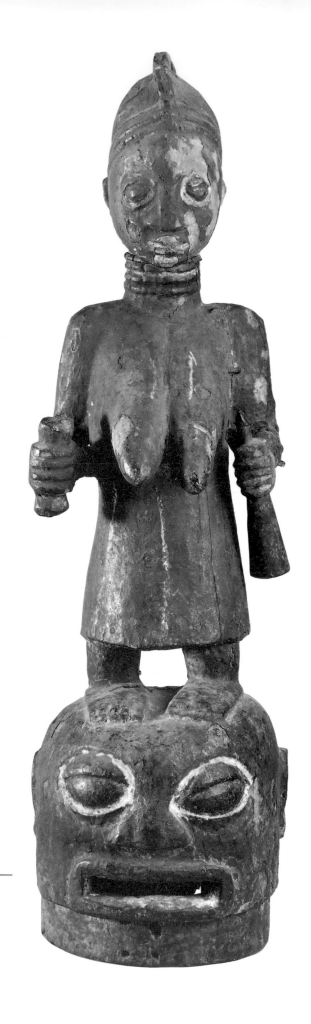

African, Nigeria, Yoruba

Epa Mask

Wood, pigment, h. 36½ in. (92.7 cm.)
Gift of Bob Bronson, 76.20.3

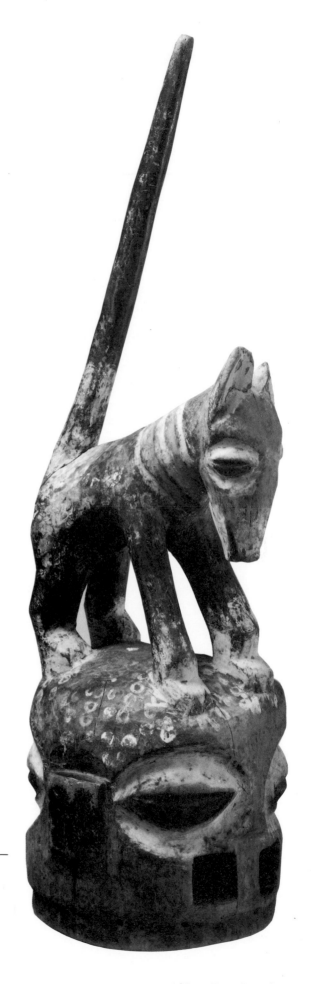

African, Nigeria, Yoruba

Epa Mask

Wood, pigment, h. 36¼ in. (92.1 cm.)
Gift of Mr. and Mrs. Mace Neufeld, 76.17.2

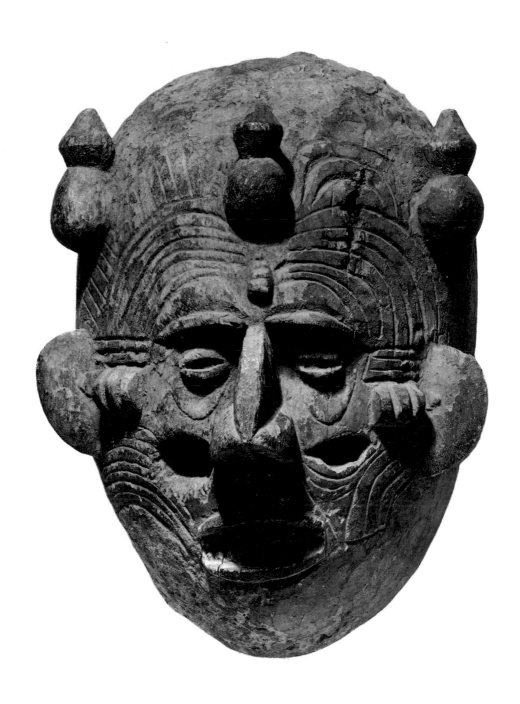

African, Nigeria, Ibo

Face Mask (Mmwa Cult)

Wood, h. 15 in. (38.1 cm.)
Gift of Fred Jamner, 75.38.3

72 African, Oceanic, and New World

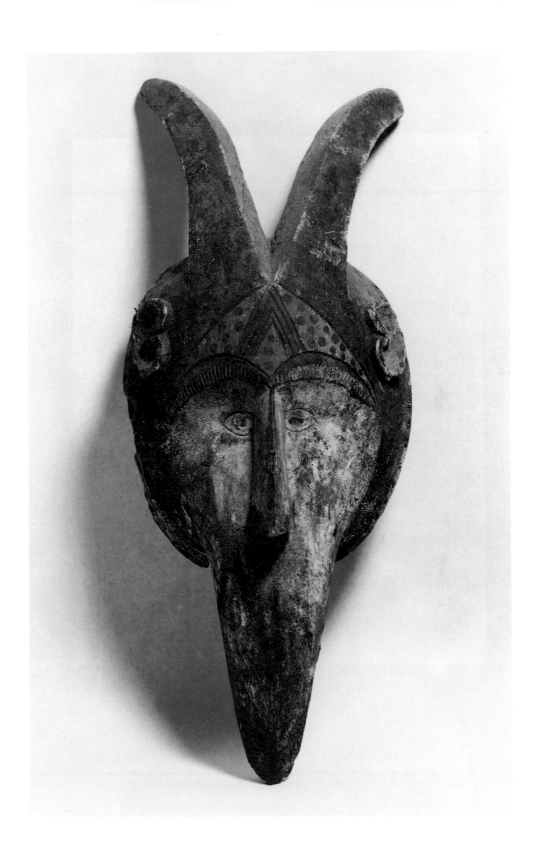

African, Nigeria, Ibo

Mask

Wood, pigment, h. 15 in. (38.1 cm.)
Gift of the Hanes Corporation, 72.19.31

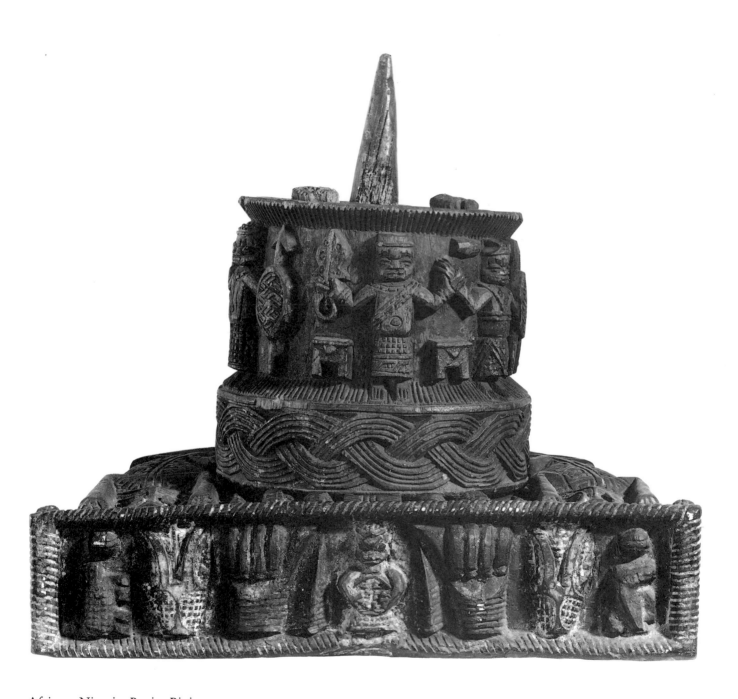

African, Nigeria, Benin, Bini

Shrine of the Hand (Ikegobo)

Wood, h. 19¾ in. (50.2 cm.)
The James G. Hanes Memorial Fund, 72.2.4

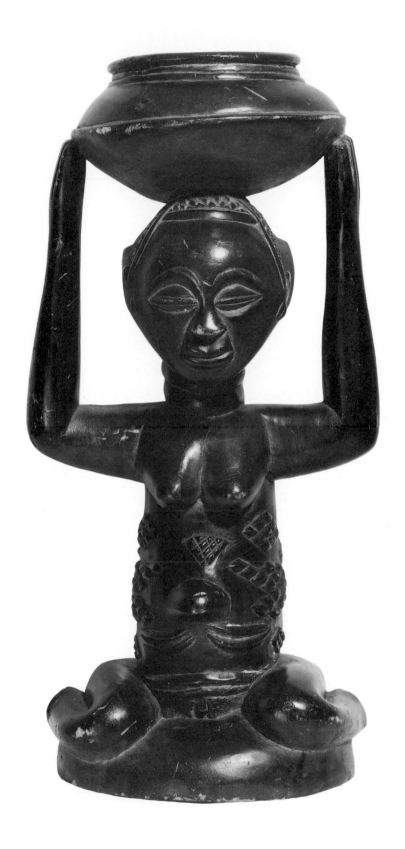

African, Zaire, Baluba

Seated Woman Holding a Bowl

Wood, h. 17¾ in. (45.1 cm.)
Gift of Mr. and Mrs. Gordon Hanes, 72.19.38

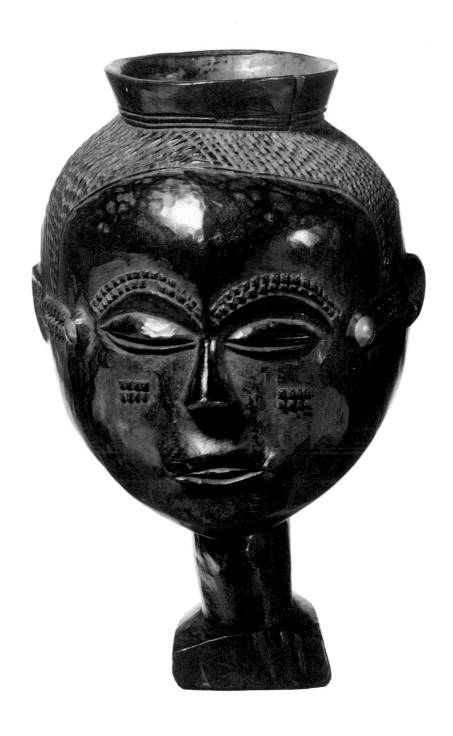

African, Zaire, Kuba

Cup

Wood, metal, h. 7⅜ in. (18.7 cm.)
Gift of Bob Bronson, 78.30.1

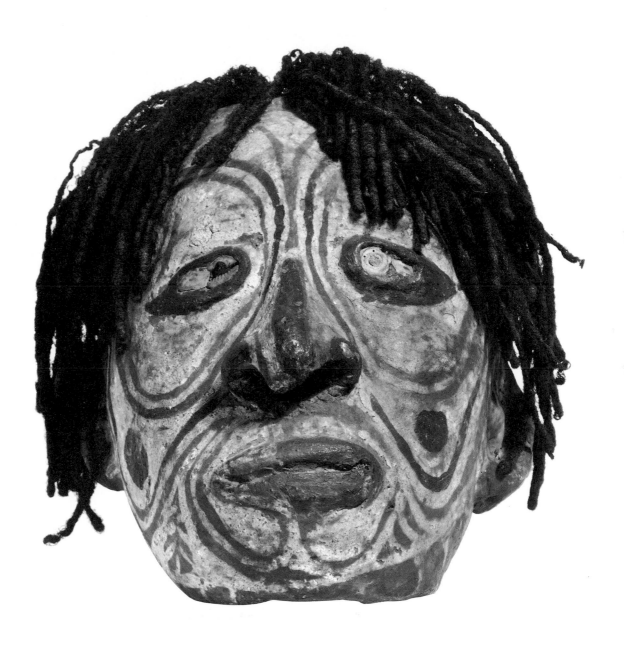

Oceanic, New Guinea, Middle Sepik River Region

Trophy Head

Bone, clay, hair, shell, pigment, h. 9 in. (22.9 cm.)
Gift of Mr. and Mrs. Gordon Hanes, 74.19.7

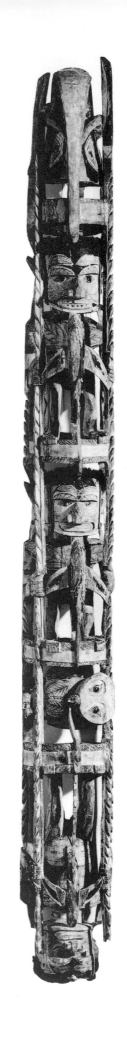

Oceanic, New Ireland, early 20th century

Malanggan Totem Pole

Wood, pigment, h. 92½ in. (229.8 cm.)
78.1.2

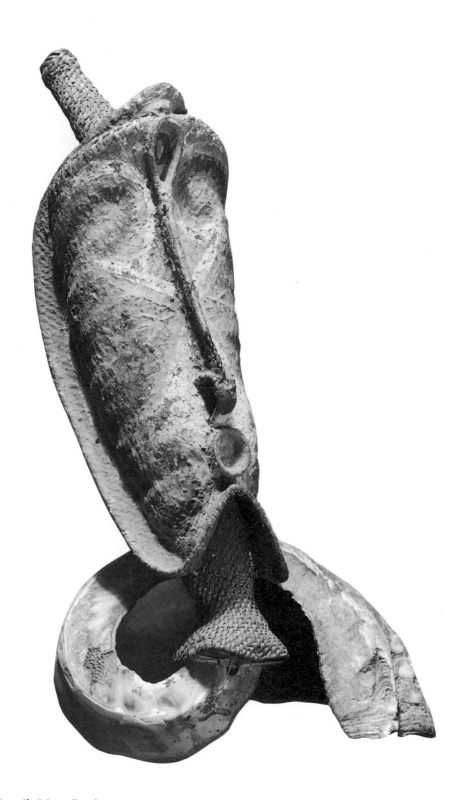

Oceanic, New Guinea, Maprik River Region

Bride Wealth Mask

Fiber, shell, pigment, h. 14⅞ in. (37.8 cm.)
Gift of Mr. and Mrs. Gordon Hanes, 77.2.6

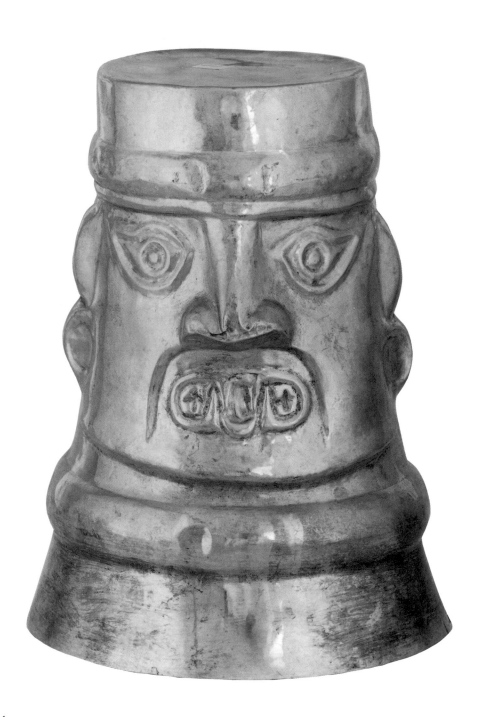

Pre-Columbian, Peru, Lambayeque, c. 1000

Beaker Depicting Face of a Deity

Gold alloy, h. 10 in. (25.4 cm.)
74.1.3

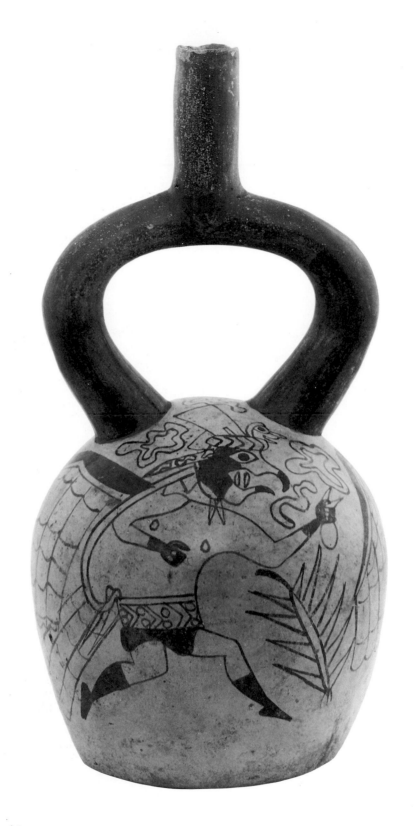

Pre-Columbian, Peru, Mochica IV, c. 200–500

Stirrup-spout Vessel with Figures of Two Warriors

Pottery with paint, h. 12 in. (30.5 cm.)
The James G. Hanes Memorial Fund, 74.2.11

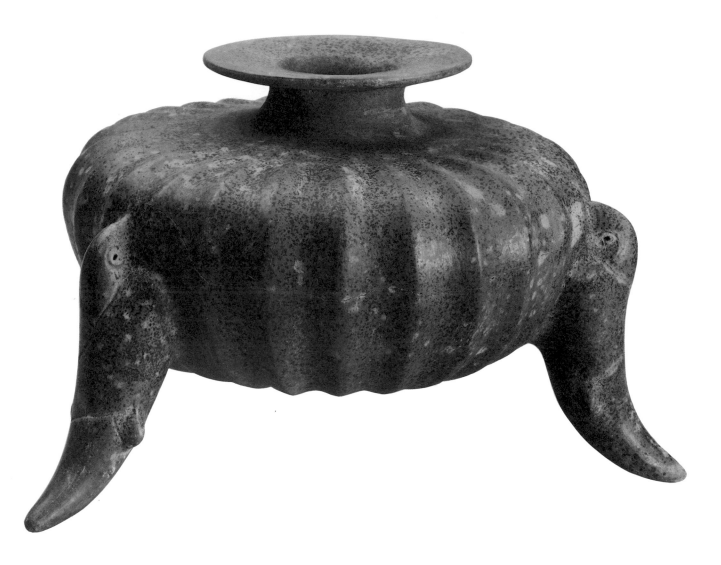

Pre-Columbian, Mexico, Colima, Protoclassic Period, c. 100 B.C.–250 A.D.

Tripod Pumpkin-shaped Vessel with Legs Representing Parrots

Pottery, dia. 14⅜ in. (36.5 cm.)
The James G. Hanes Memorial Fund, 74.2.13

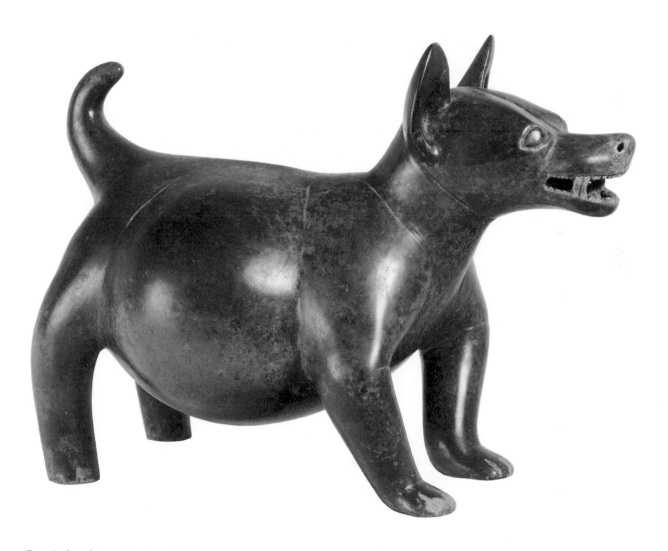

Pre-Columbian, Mexico, Colima

Dog

Pottery, h. 11 in. (27.9 cm.)
Gift of Mr. and Mrs. Mace Neufeld, 73.20.3

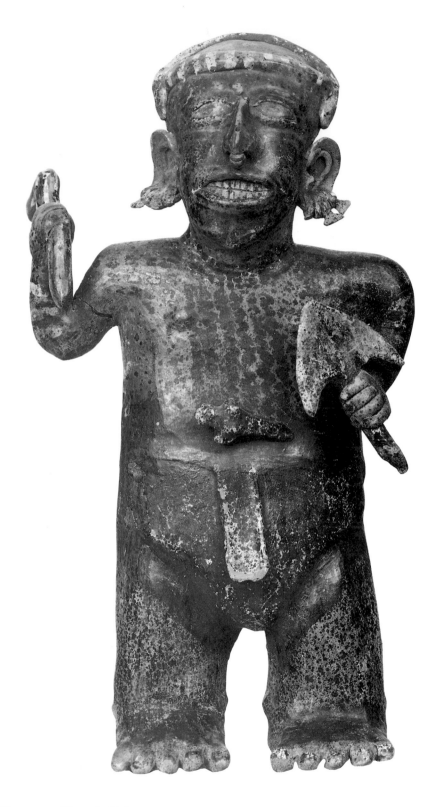

Pre-Columbian, Mexico, Tarascan, Nayarit Culture, c. 300

Standing Figure of a Warrior

Pottery with paint, h. 21 in. (53.3 cm.)
Gift of Mr. and Mrs. S. J. Levin, 58.8.1

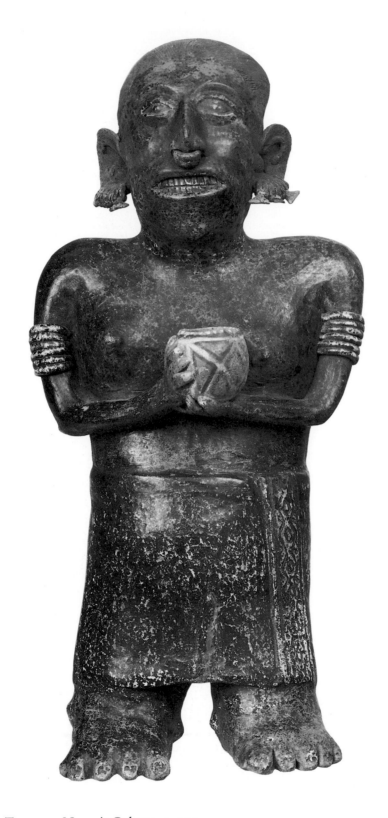

Pre-Columbian, Mexico, Tarascan, Nayarit Culture, c. 300

Standing Figure of a Warrior's Wife

Pottery with paint, h. 21 in. (53.3 cm.)
Gift of Mr. and Mrs. S. J. Levin, 58.8.2

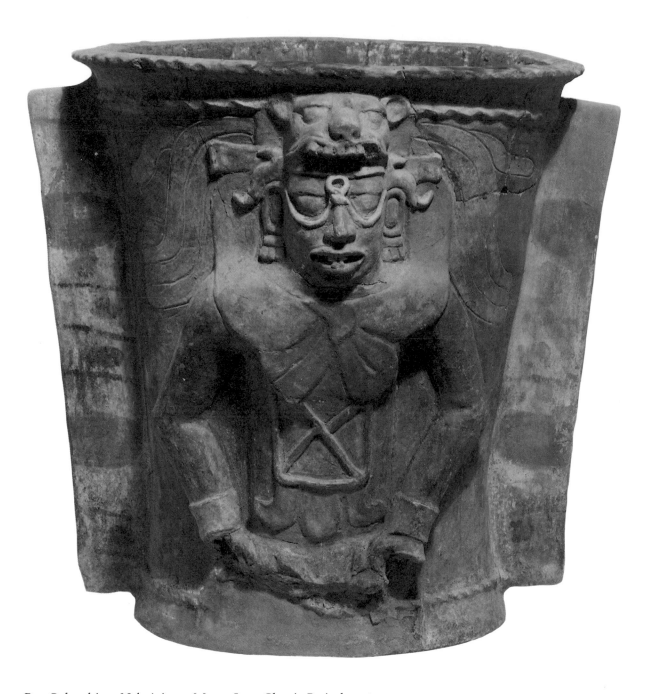

Pre-Columbian, Nebaj Area, Maya, Late Classic Period, c. 600–900

Incenario with Sun God Effigy

Pottery, h. 20 in. (50.8 cm.)
75.1.2

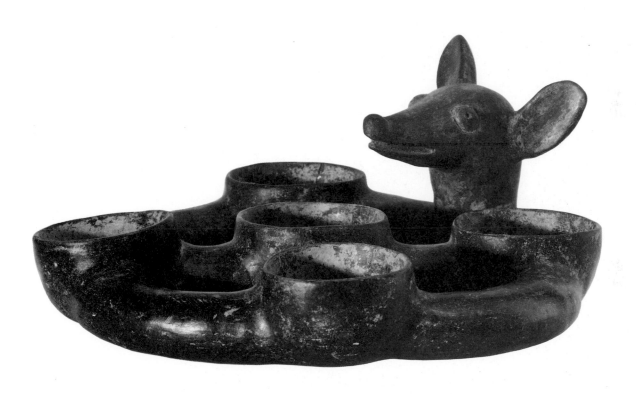

Pre-Columbian, Mexico, Maya, c. 200 B.C.

Ring-shaped Vessel with Five Interconnected Receptacles and a Deer Head

Pottery, dia. 9⅞ in. (25.1 cm.)
Gift of Mr. and Mrs. Joseph M. Goldenberg, 74.20.4

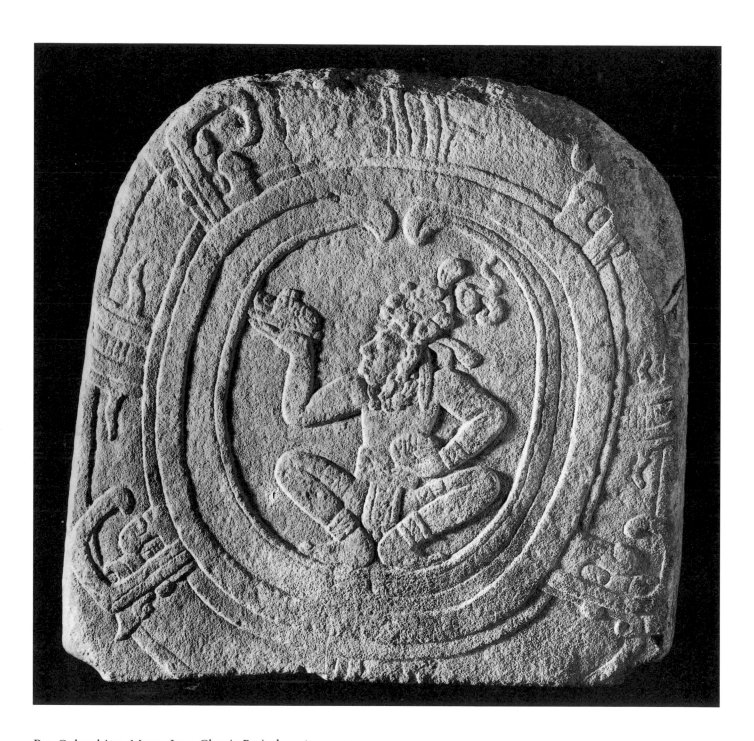

Pre-Columbian, Maya, Late Classic Period, c. 600–900

Ball Court Marker from Toniná

Stone, 23¼ x 23¼ in. (59 x 59 cm.)
Gift of Mr. and Mrs. Gordon Hanes, 82.14

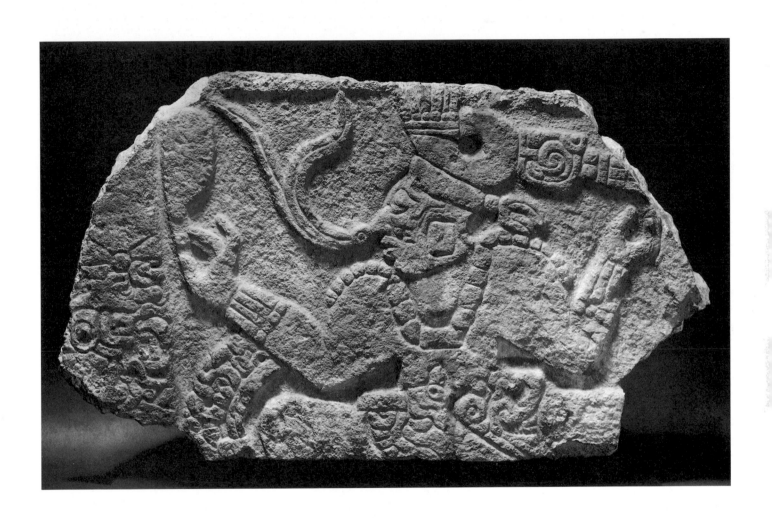

Pre-Columbian, Guatemala, Maya, Late Classic Period, c. 600–900

Relief with a Seated Priest

Limestone, 19¾ x 34½ in. (50.2 x 87.6 cm.)
Gift of Mr. and Mrs. Cedric Marks, 70.1.1

Pre-Columbian, Mexico, Vera Cruz, Maya, Late Classic Period, c. 600–900

Sacrifice Figure

Terracotta, h. 42½ in. (107.9 cm.)
Gift of Isidore M. Cohen, 71.44.1

European Art

Antonis Mor (Antonio Moro)
Dutch, 1517/20–1576/77

Portrait of a Gentleman, c. 1568

Oil on panel, 48 x 35¼ in. (122 x 89.5 cm.)
Gift of Mr. and Mrs. Ralph C. Price, 55.4.1

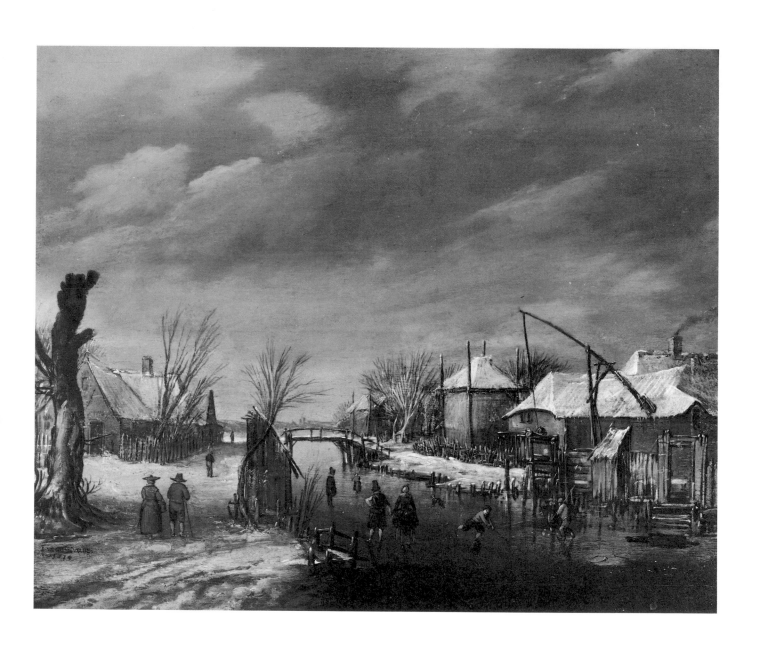

Esaias van de Velde
Dutch, active before 1614–1630

Winter Scene, 1614

Oil on panel, 10¼ x 12⅝ in. (26 x 32.1 cm.)
52.9.61

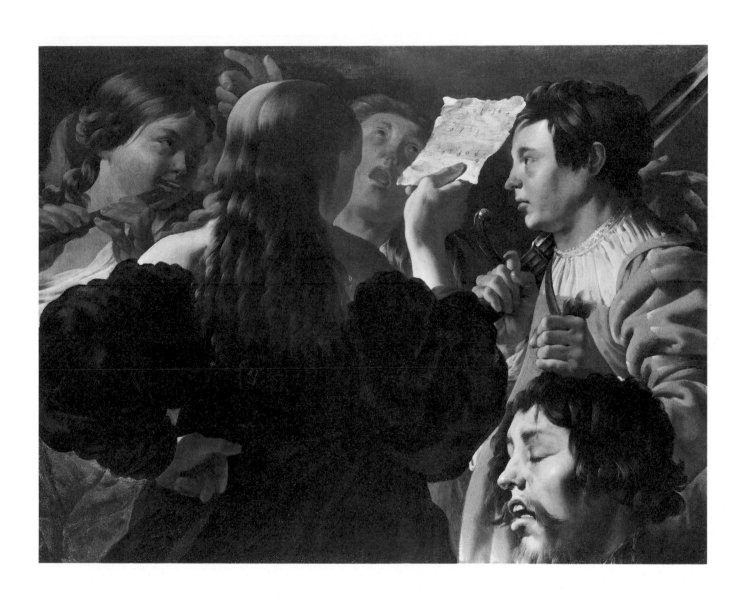

Hendrick ter Brugghen
Dutch, c. 1588–1629

David Praised by the Israelite Women, 1623

Oil on canvas, 32³/₁₆ x 41¹/₂ in. (81.8 x 105.3 cm.)
Gift of the Samuel H. Kress Foundation, 60.17.66

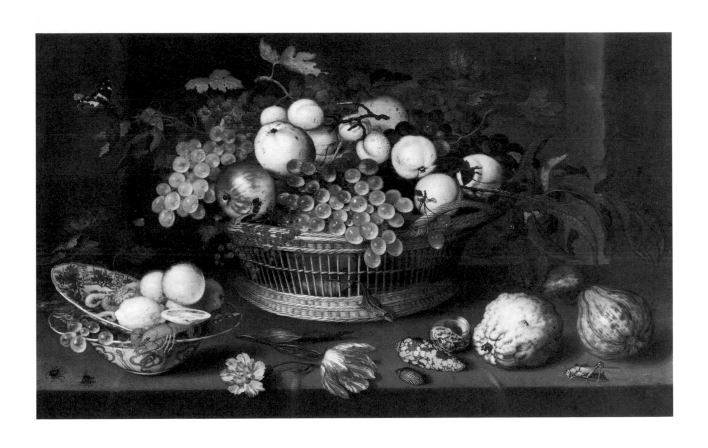

Balthasar van der Ast
Dutch, c. 1593–1656

Still Life with a Grasshopper, 1622

Oil on panel, 19½ x 32 in. (49.5 x 81.3 cm.)
52.9.197

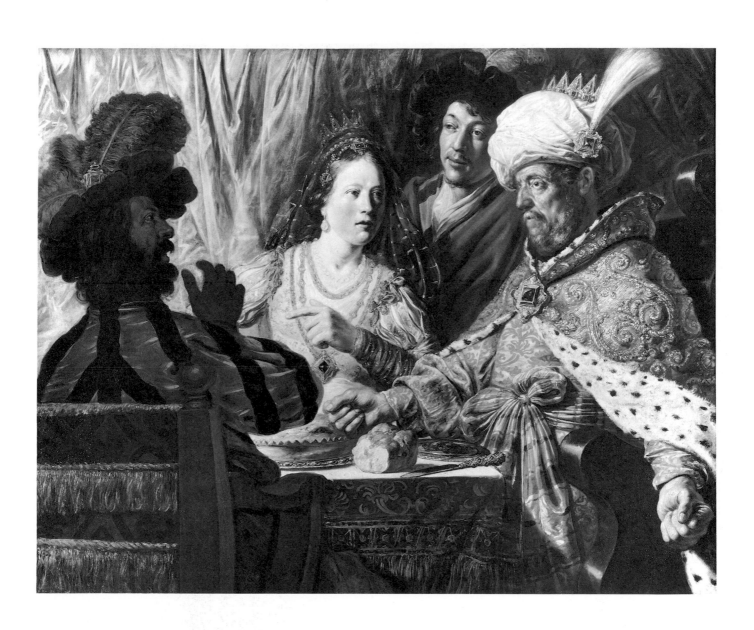

Jan Lievens
Dutch, 1607–1674

Esther Informing Ahasuerus of the Wickedness of Haman, c. 1625–26

Oil on canvas, 52¾ x 65½ in. (134 x 166.4 cm.)
52.9.55

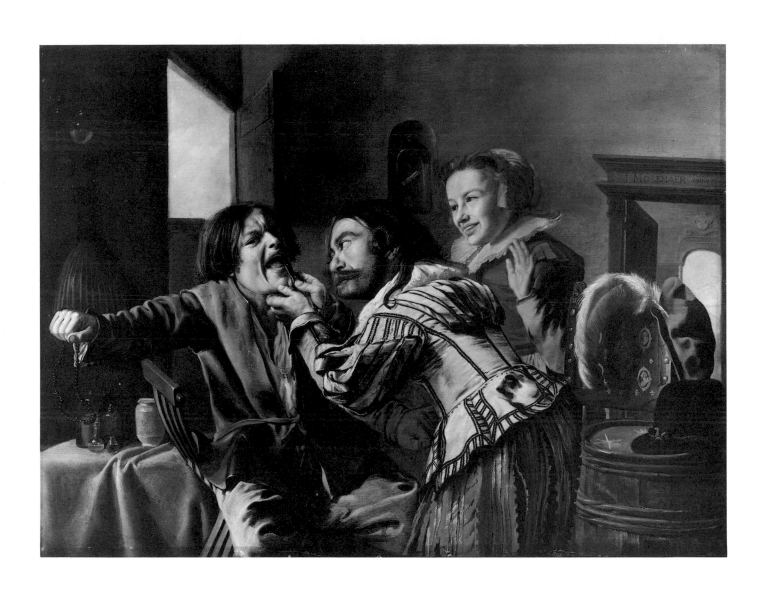

Jan Miensz. Molenaer
Dutch, 1609/10–1668

Young Man Having a Tooth Extracted, c. 1629

Oil on panel, 23 1/8 x 3 1 9/16 in. (58.8 x 80.1 cm.)
52.9.50

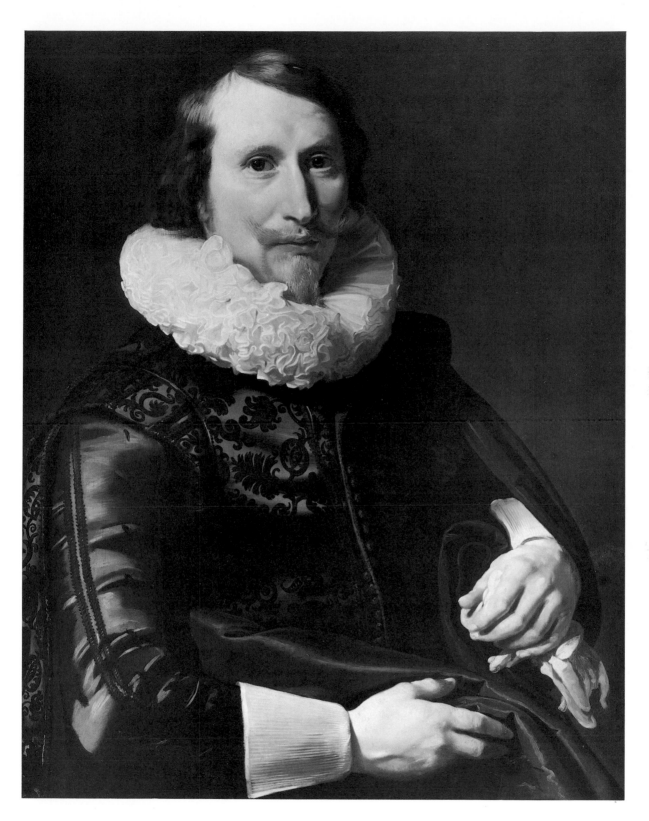

Thomas de Keyser
Dutch, 1596/7–1667

Portrait of a Gentleman, c. 1630

Oil on panel, 28¼ x 21⅞ in. (71.8 x 55.6 cm.)
Anonymous gift, 63.18.1

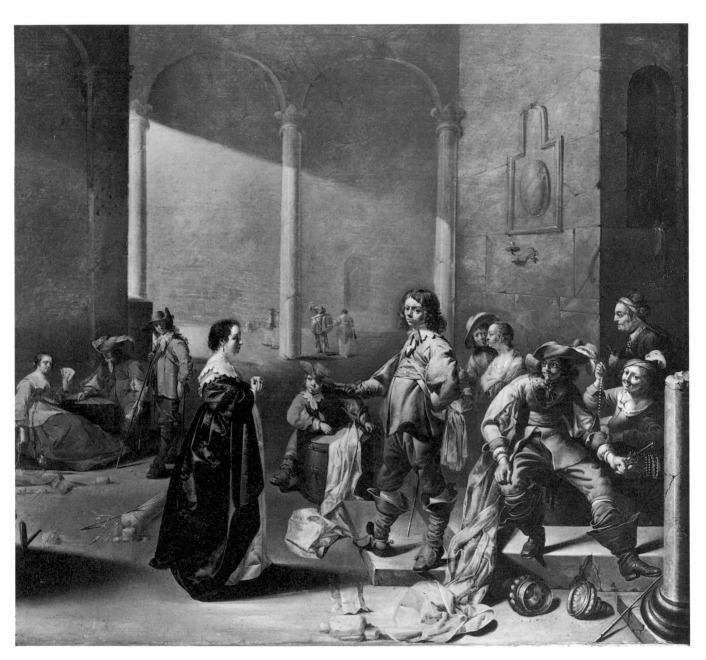

Jacob Duck
Dutch, c. 1600–after 1660

Soldiers' Quarters, c. 1635

Oil on panel, 17 3/16 x 19 1/16 in. (43.7 x 48.4 cm.)
52.9.38

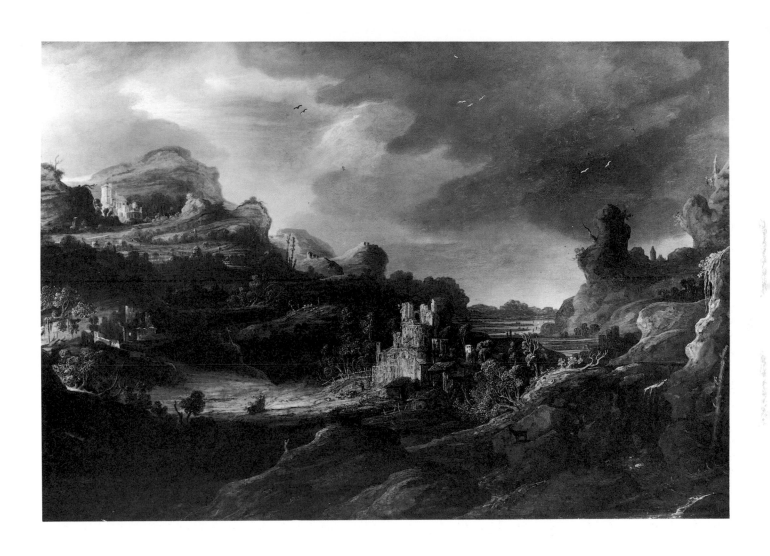

Follower of Rembrandt
Dutch, middle of the 17th century

Fantastic Landscape, c. 1640–50

Oil on panel, 34⅞ x 51½ in. (88.6 x 128.2 cm.)
Gift of Morton D. May, 59.3.1

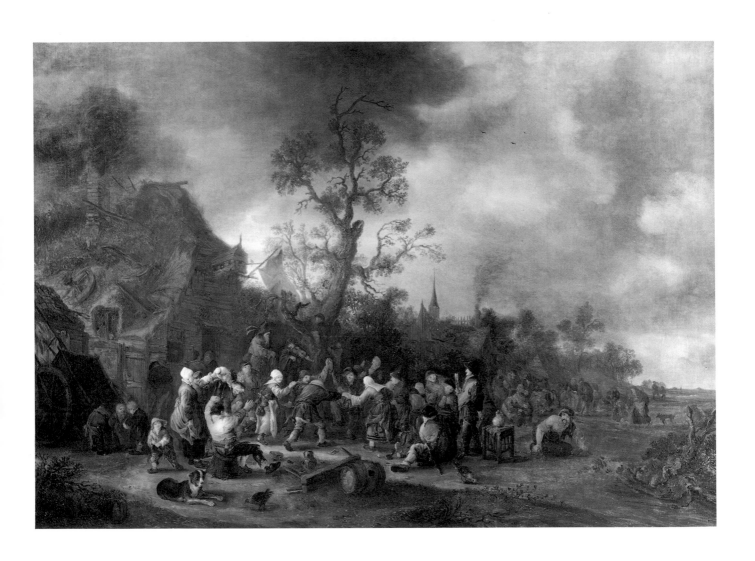

Isaack van Ostade
Dutch, 1621–1649

Peasants Gathered Outside an Inn, c. 1642

Oil on canvas, 42 5/16 x 58 5/8 in. (107.5 x 149 cm.)
52.9.53

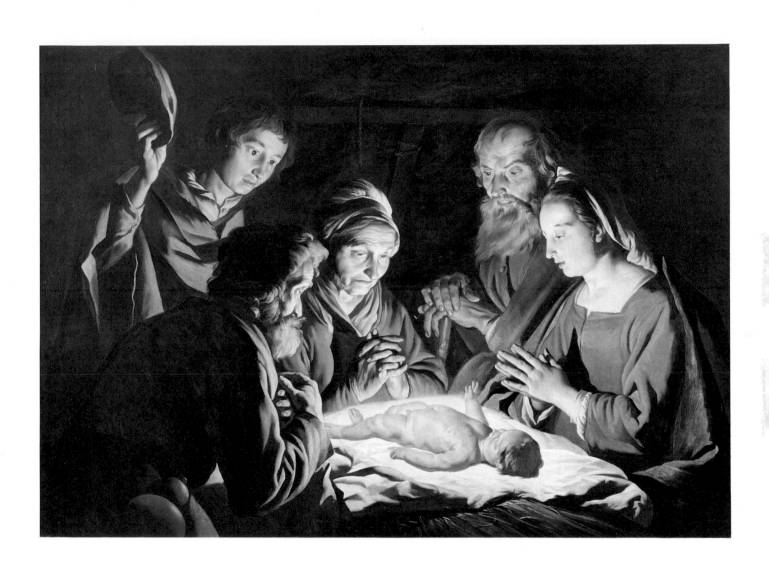

Matthias Stomer
Dutch, c. 1600–after 1650, active in Italy

The Nativity, c. 1640

Oil on canvas, 44⅝ x 63⅝ in. (113.5 x 161.5 cm.)
52.9.59

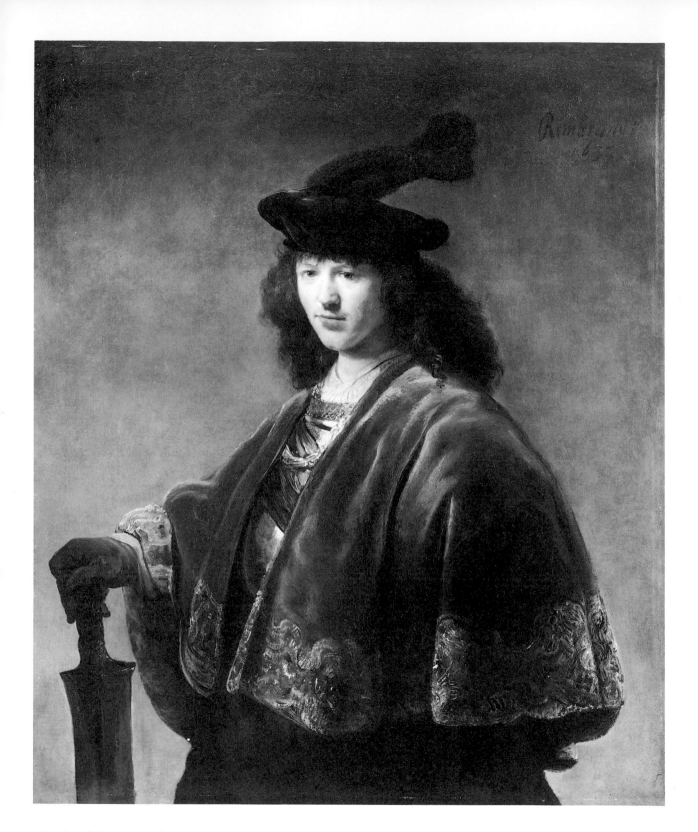

Circle of Rembrandt
Dutch, middle of the 17th century

Portrait of a Man, thought to be Ferdinand Bol (1616–1680), c. 1630–40

Oil on canvas, 46⁹/₁₆ x 38¹/₁₆ in. (118.4 x 96.7 cm.)
Gift of the Samuel H. Kress Foundation, 60.17.68

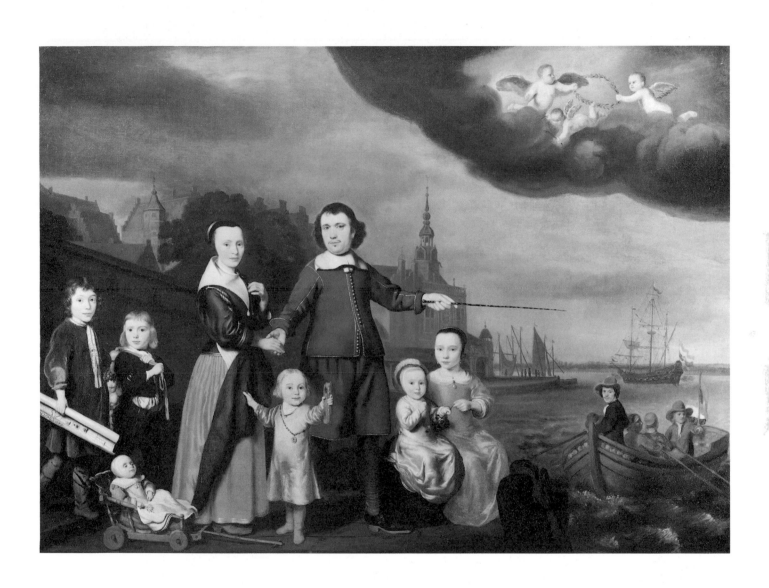

Nicolaes Maes
Dutch, 1634–1693

Captain Job. Jansz. Cuyter and Family, 1659

Oil on canvas, 43½ x 60 in. (110.5 x 152.4 cm.)
52.9.47

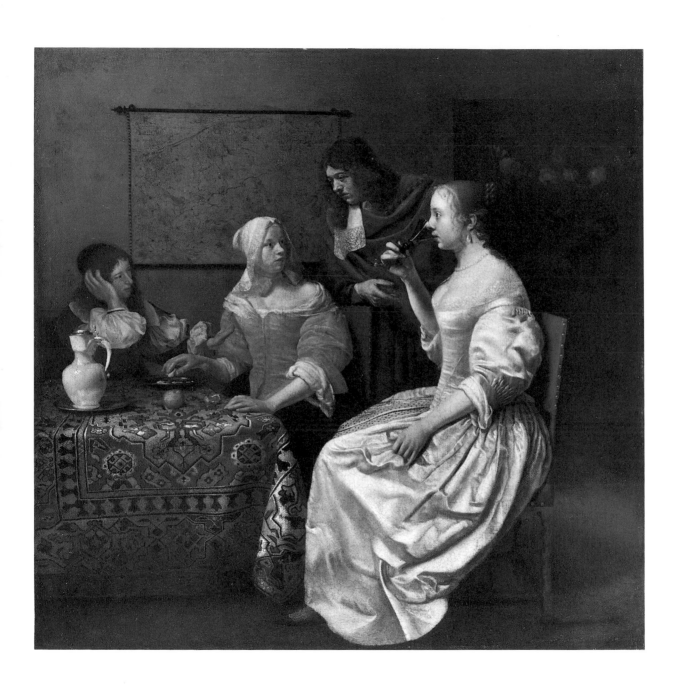

Jacob Ochtervelt
Dutch, 1634–1682

Men and Women at a Table, c. 1665

Oil on canvas, 18¾ x 18¾ in. (47.8 x 47.8 cm.)
52.9.52

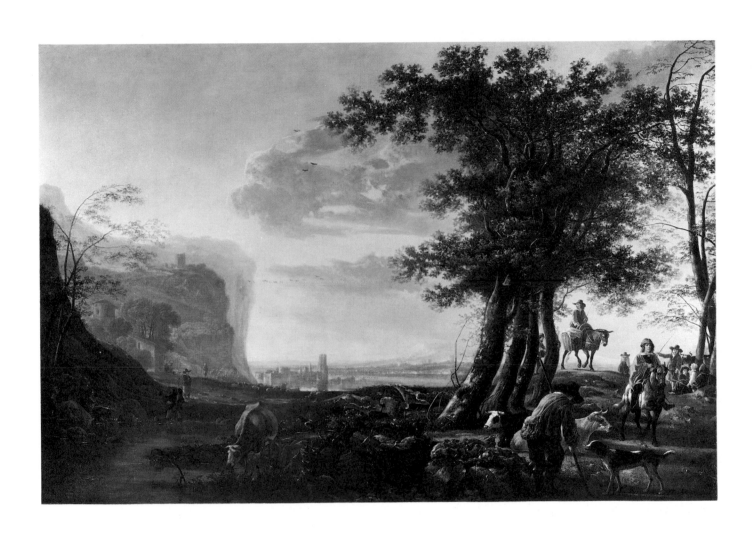

Aelbert Cuyp
Dutch, 1620–1691

Landscape with Figures and Cattle, c. 1660–70

Oil on canvas, 53 x 77⅞ in. (134.6 x 197.8 cm.)
52.9.36

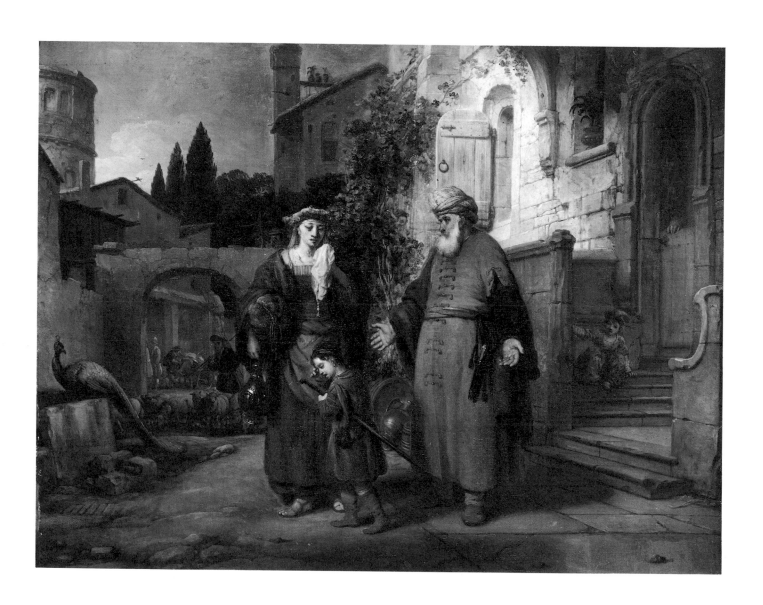

Gerbrandt van den Eeckhout
Dutch, 1621–1674

The Expulsion of Hagar, 1666

Oil on canvas, 21¾ x 27 in. (55.2 x 68.6 cm.)
52.9.39

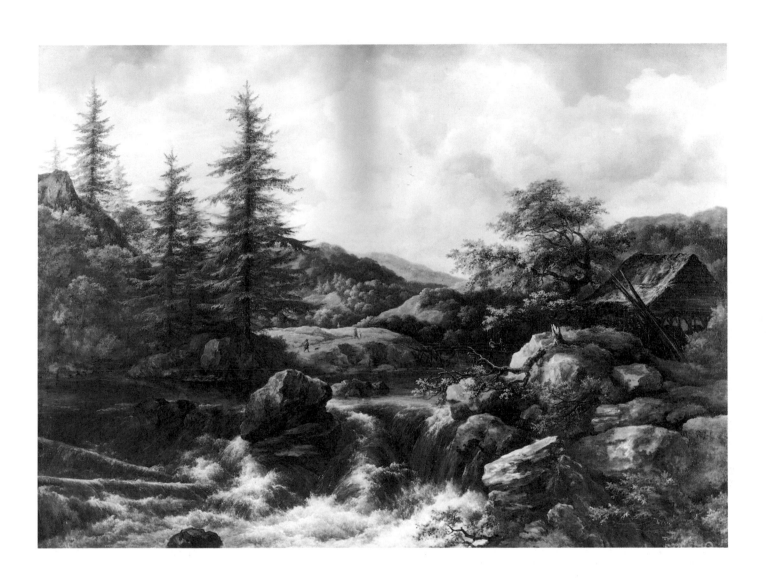

Jacob van Ruisdael
Dutch, 1628/29–1682

Wooded Landscape with Waterfall, c. 1665–70

Oil on canvas, 41 x 56½ in. (104.1 x 143.5 cm.)
52.9.56

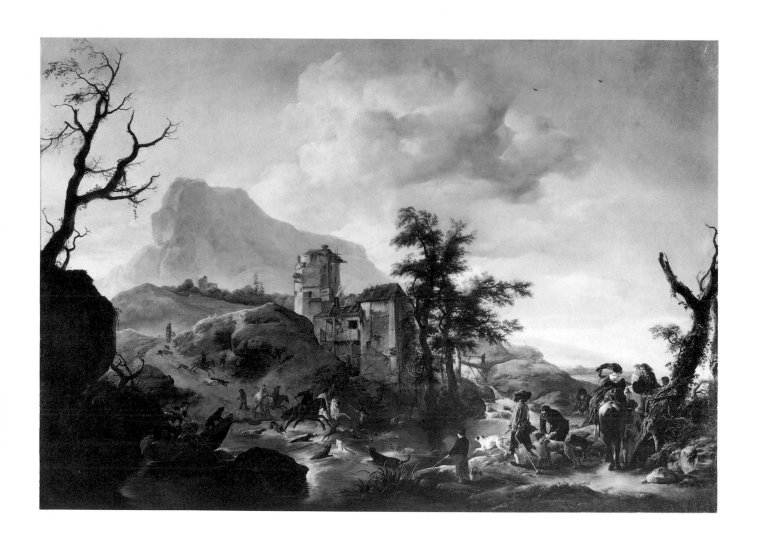

Philips Wouwerman
Dutch, 1619–1668

Jan Steen
Dutch, 1625/26–1679

The Deer Hunt, c. 1665

Oil on canvas, 53 3/16 x 76 15/16 in. (135.1 x 195.3 cm.)
52.9.64

The Worship of the Golden Calf, c. 1671–72

Oil on canvas, 70¼ x 61¼ in. (178.4 x 155.6 cm.)
52.9.58

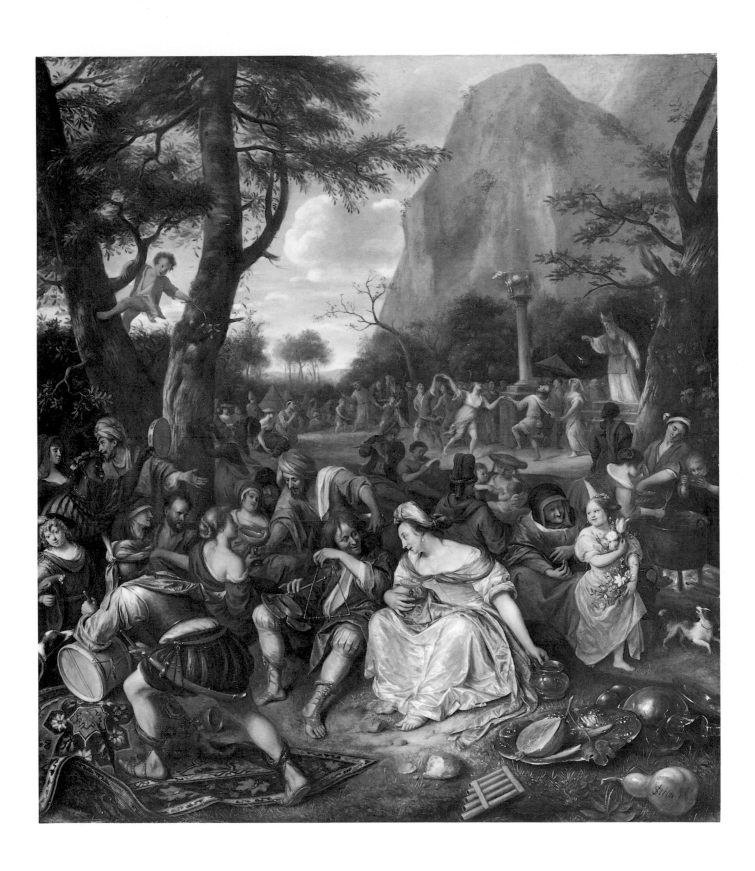

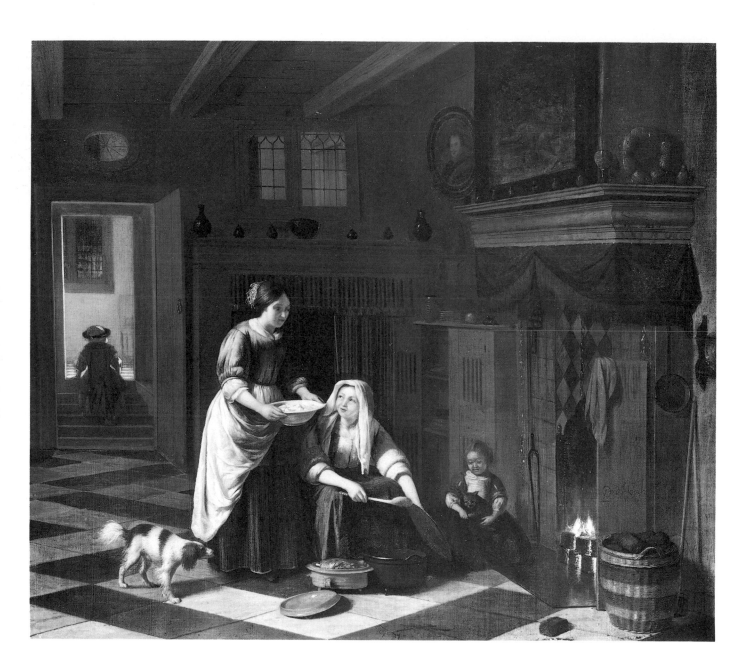

Pieter de Hooch
Dutch, 1629–1684

Two Women and a Child by a Fireplace, c. 1670–75

Oil on canvas, 25¼ x 30¼ in. (64 x 77 cm.)
52.9.45

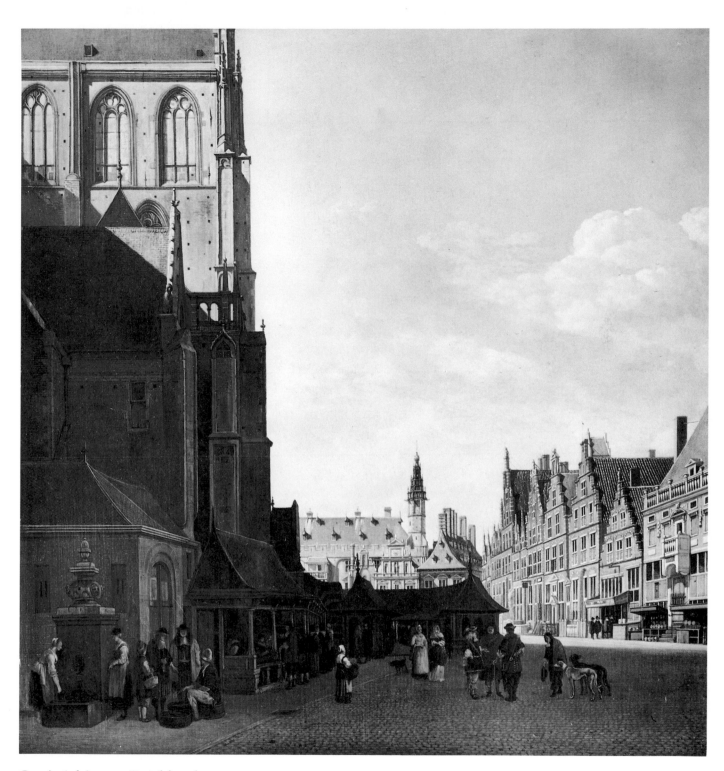

Gerrit Adriaensz. Berckheyde
Dutch, 1638–1698

Groote Markt, Haarlem, early 1670s

Oil on panel, 17¾ x 16¾ in. (45.2 x 42.6 cm.)
Gift of the Samuel H. Kress Foundation, 60.17.69

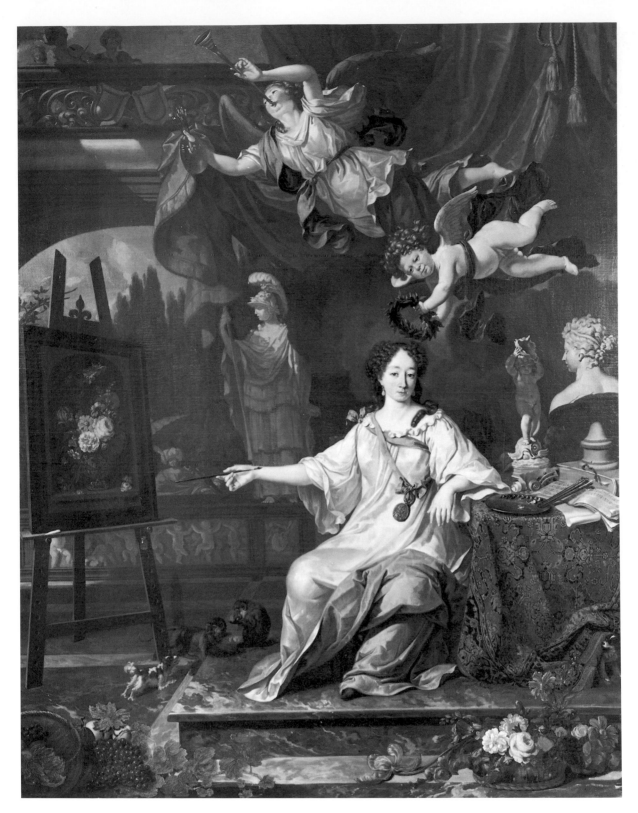

Constantijn Netscher
Dutch, 1668–1723

Rachel Ruysch (1664–1750) in Her Studio, c. 1710

Oil on canvas, 44 ¹⁵/₁₆ x 35 ⁷/₈ in. (114.1 x 91 cm.)
Gift of Armand and Victor Hammer, 57.10.1

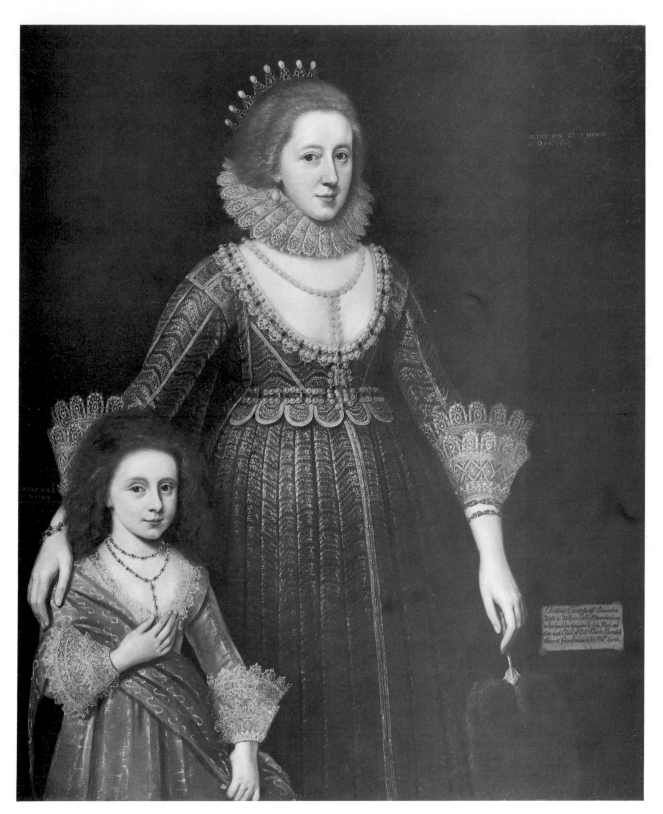

Paul van Somer
Flemish, c. 1577/8–1621/2, active in London

The Countess of Devonshire (c. 1598–1675) and Her Daughter, 1619

Oil on canvas, 51½ x 41½ in. (130.8 x 105.4 cm.)
Gift of The Honorable and Mrs. Luther H. Hodges, 58.3.1

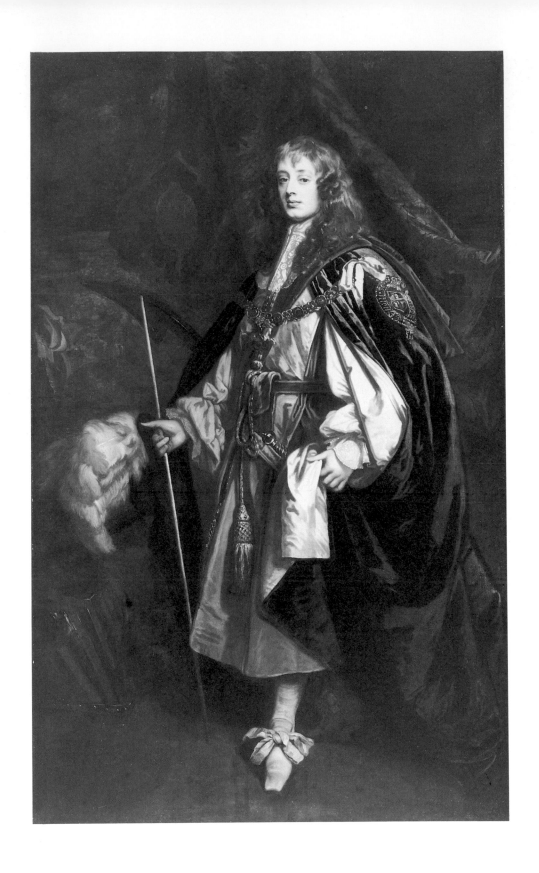

Sir Peter Lely
English, 1618–1680

Charles Stuart, 3rd Duke of Richmond and 6th Duke of Lennox (1639/40–1671), c. 1661–63

Oil on canvas, 86 9/16 x 52 1/2 in. (219.9 x 133.3 cm.)
Gift of Mrs. Edward Shearson, 55.6.1

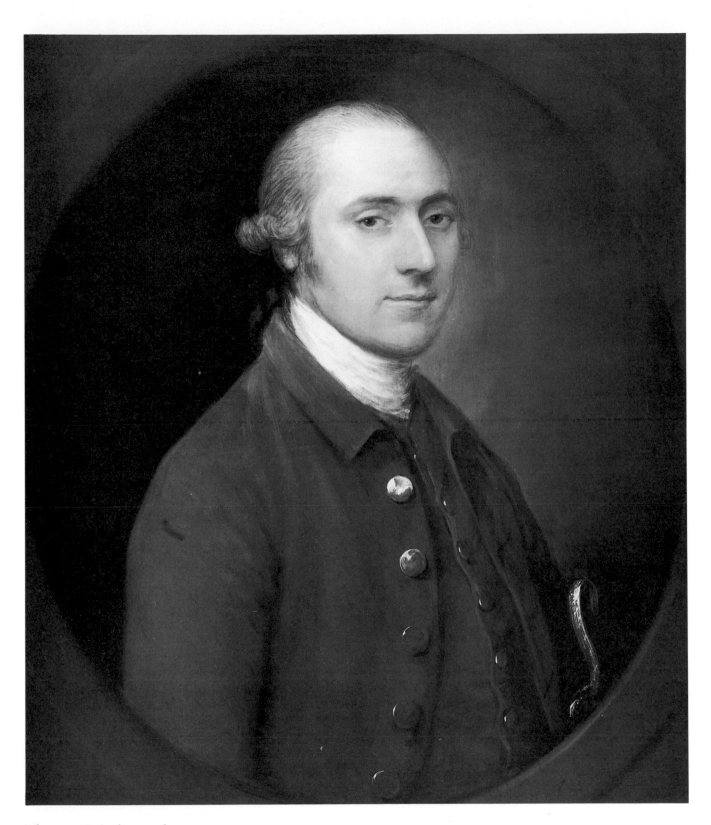

Thomas Gainsborough
English, 1727–1788

Clement Tudway (d. 1815), c. 1772

Oil on canvas, 30³/₁₆ x 25¹/₄ in. (76.8 x 63.8 cm.)
Gift of Mrs. Lillian Boscowitz in memory of her mother Mrs. Franklin Terry, 60.11.1

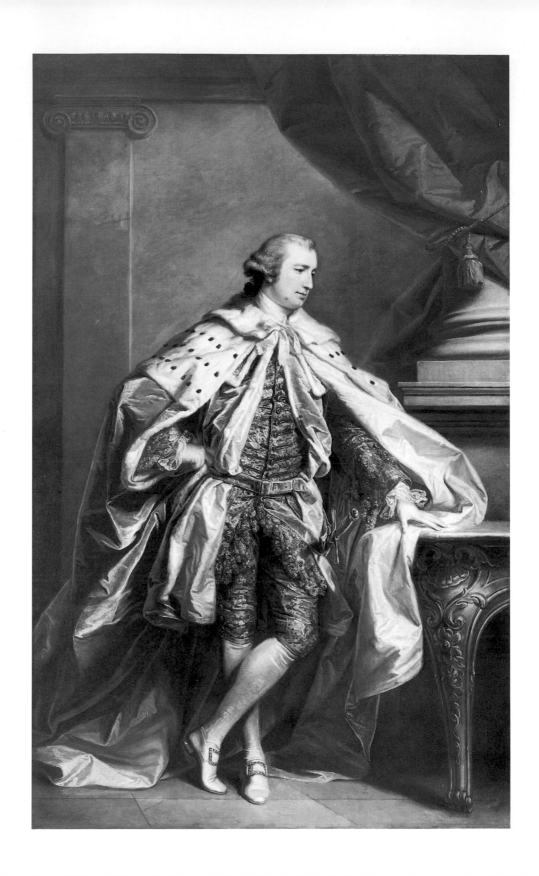

Francis Cotes
English, 1726–1770

James Duff, 2nd Earl of Fife (1729–1809), 1765

Oil on canvas, 94¼ x 58¼ in. (339.5 x 147.9 cm.)
52.9.67

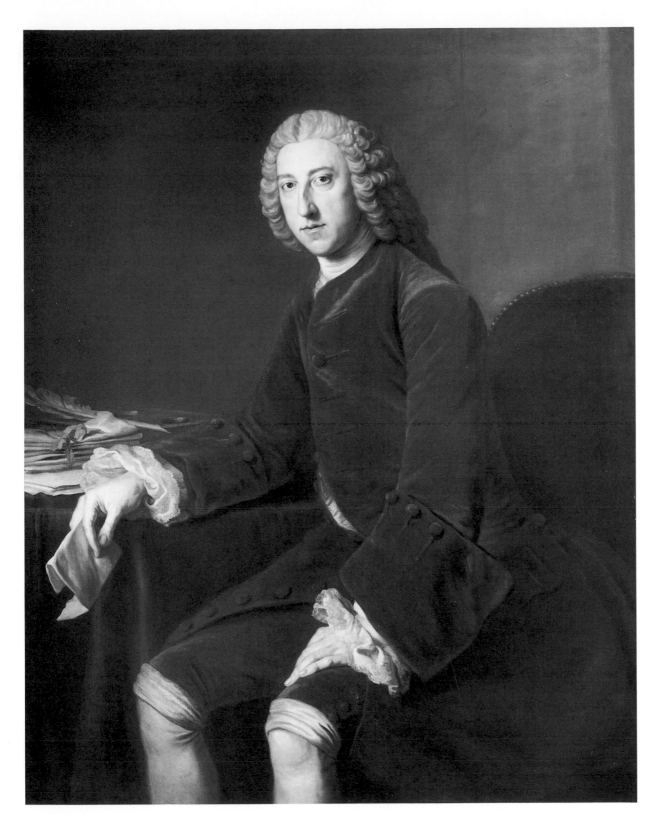

William Hoare
English, 1707–1792

William Pitt, later 1st Earl of Chatham (1708–1788), c. 1754

Oil on canvas, 50¹/₁₆ x 40¹/₁₆ in. (127.3 x 101.8 cm.)
Gift of Mr. and Mrs. Aubrey Lee Brooks, 55.2.1

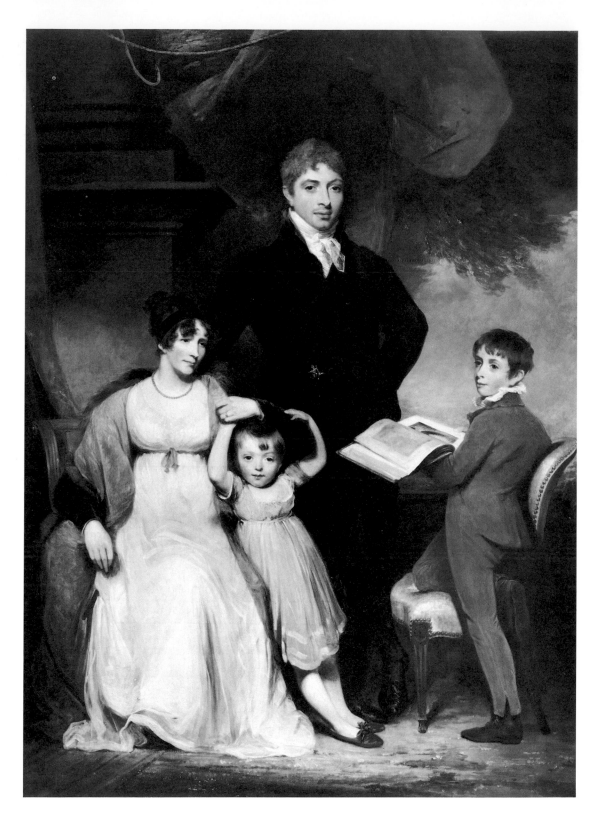

John Hoppner
English, 1758–1810

Portrait of a Family, c. 1800

Oil on canvas, 93⅞ x 67 in. (238.4 x 170.2 cm.)
Original State Appropriation and funds from the North Carolina Art Society
(Robert F. Phifer Funds), 52.9.75

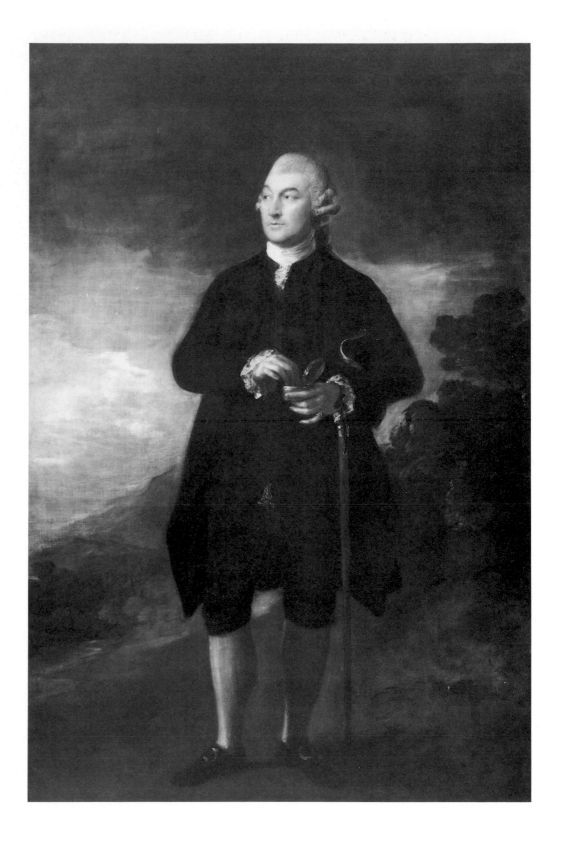

Thomas Gainsborough
English, 1727–1788

Portrait of a Gentleman, said to be John Scrimgeour, c. 1778

Oil on canvas, 92¼ x 61⅛ in. (234.4 x 155.3 cm.)
Original State Appropriation and funds from the North Carolina Art Society
(Robert F. Phifer Funds), 52.9.70

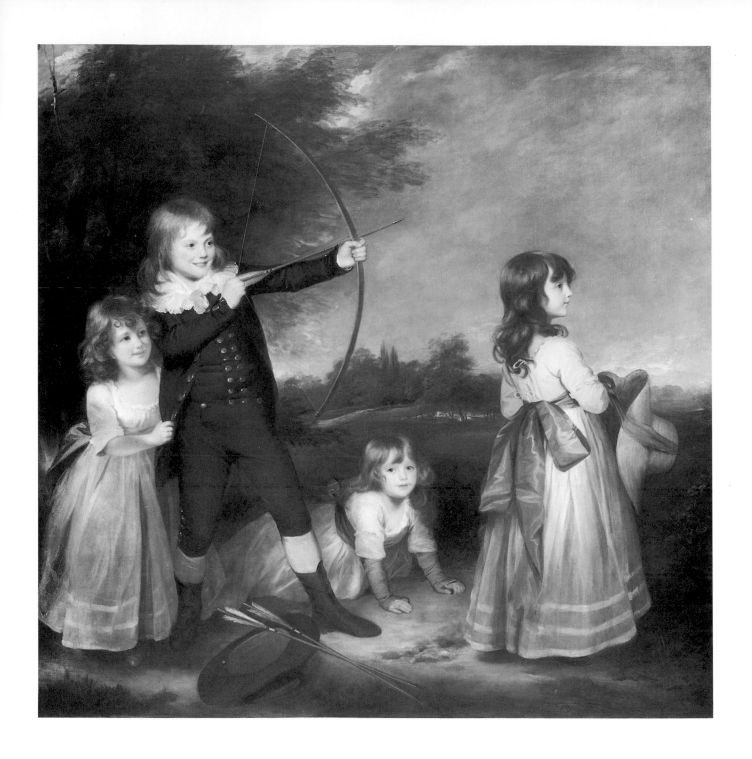

Sir William Beechey
English, 1753–1839

Sir Thomas Lawrence
English, 1769–1830

The Oddie Children, 1789

Oil on canvas, 72 x 71⅞ in. (183 x 182.5 cm.)
52.9.65

Lady Louisa Harvey (1758–1841)
and Her Children, Edward and Louisa, begun 1793

Oil on canvas, 94 x 59 in. (238.8 x 149.9 cm.)
Purchased with funds from the North Carolina Art
Society (Robert F. Phifer Funds), 52.9.79

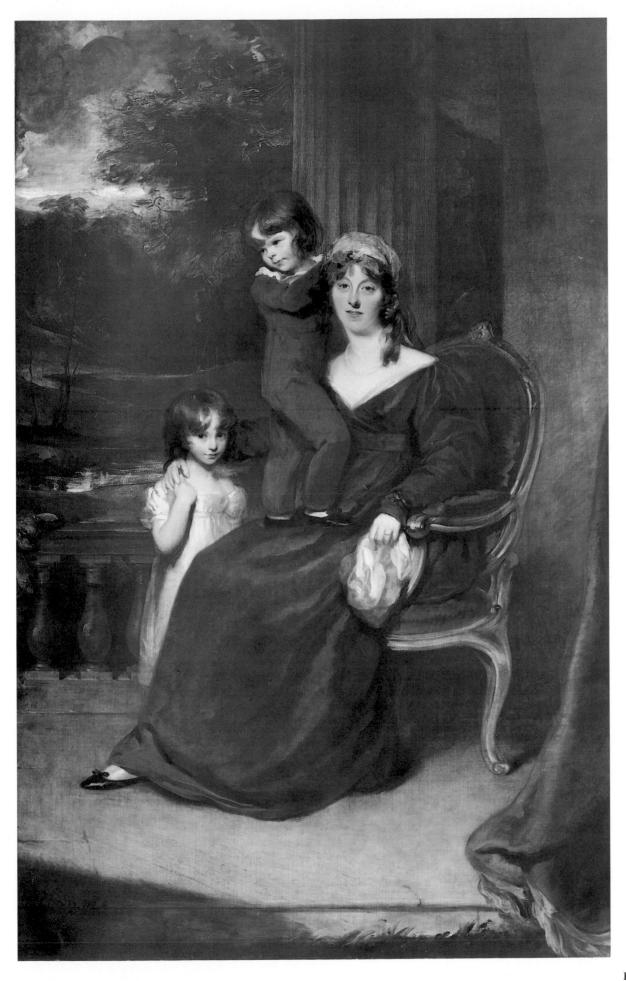

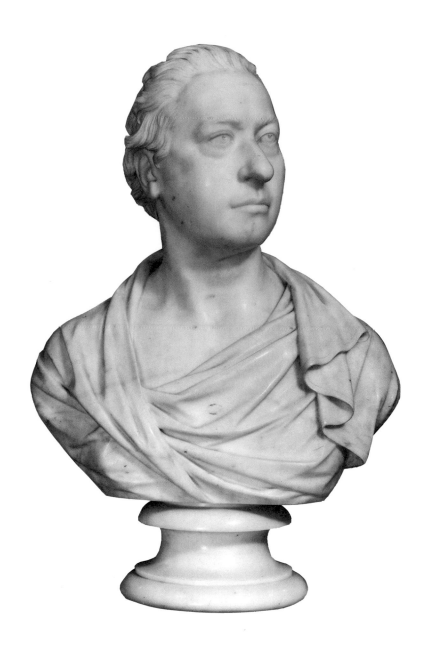

Joseph Nollekens
English, 1737–1823

William, 5th Duke of Devonshire (1749–1811), c. 1812

Marble, h. 27¼ in. (69.2 cm.)
Gift of Mr. and Mrs. Ralph W. Gardner, 58.11.1

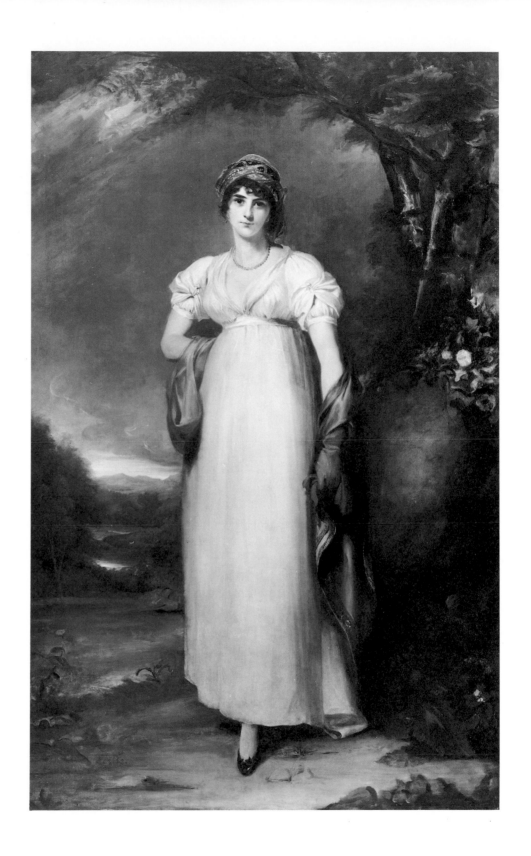

Sir Thomas Lawrence
English, 1769–1830

Mrs. John Halkett (d. 1805), c. 1802

Oil on canvas, 93 x 57 in. (236.2 x 144.8 cm.)
52.9.77

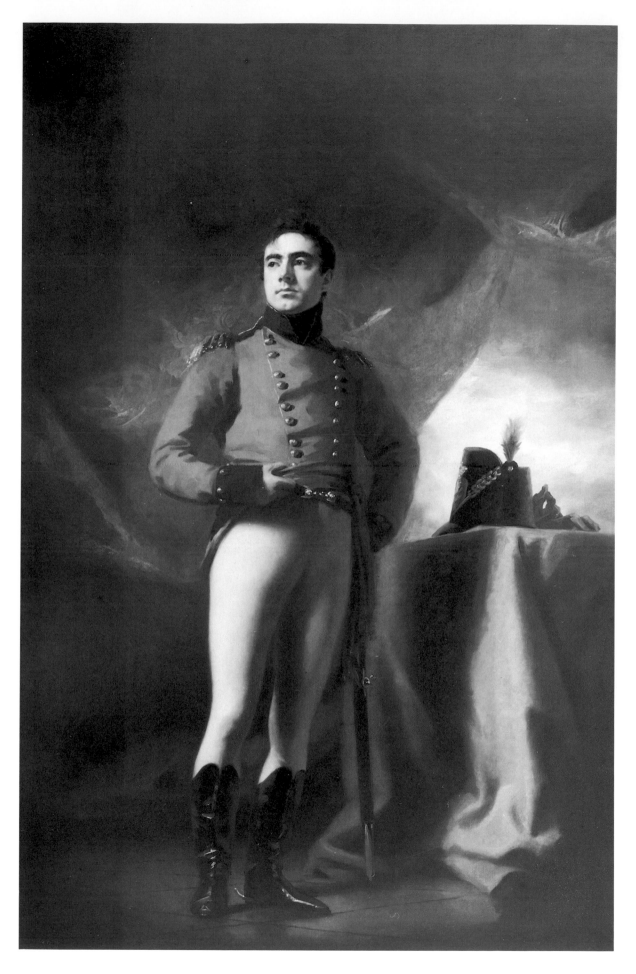

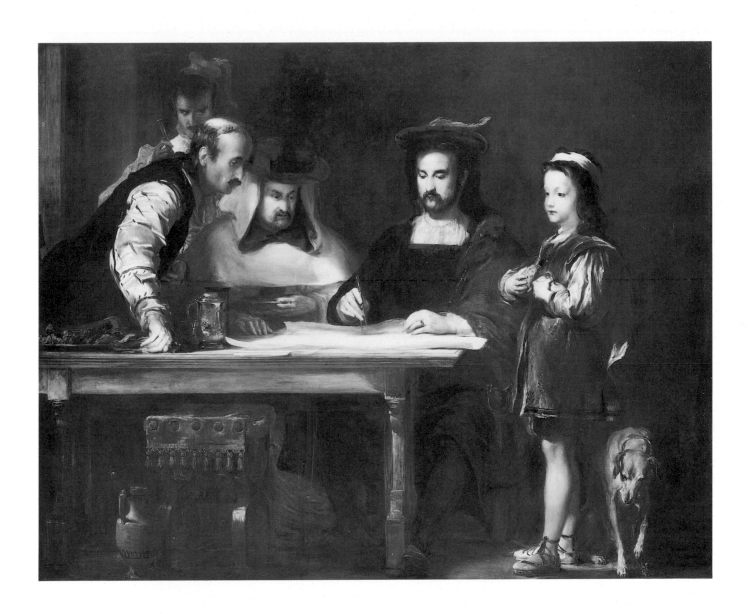

Sir Henry Raeburn
Scottish, 1756–1823

Thomas Robert Hay, 11th Earl of Kinnoull (1785–1866),
1815

Oil on canvas, 93½ x 59 in. (237.4 x 149.9 cm.)
64.19.1

Sir David Wilkie
Scottish, 1785–1841

Christopher Columbus Explaining the Project of His
Intended Voyage for the Discovery of the New World
in the Convent of La Rábida, 1834

Oil on canvas, 58½ x 74¼ in. (148.6 x 188.6 cm.)
Gift of Hirschl & Adler Galleries, 57.17.1

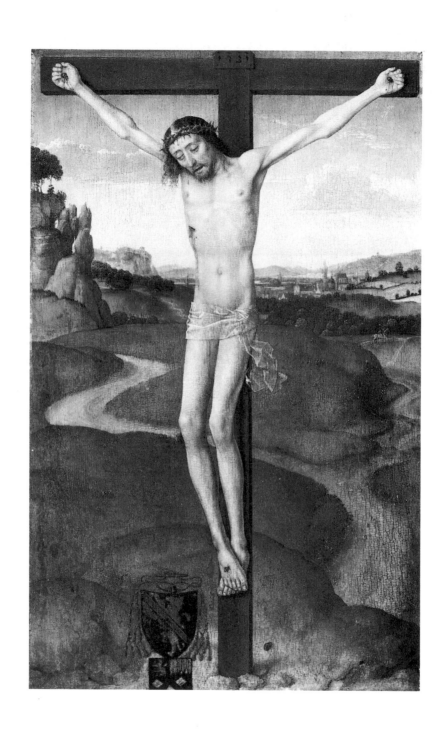

Hans Memling
Flemish, c. 1433–1494

Christ on the Cross, c. 1480

Oil on panel, 17¾ x 11 in. (45 x 28 cm.)
52.9.102

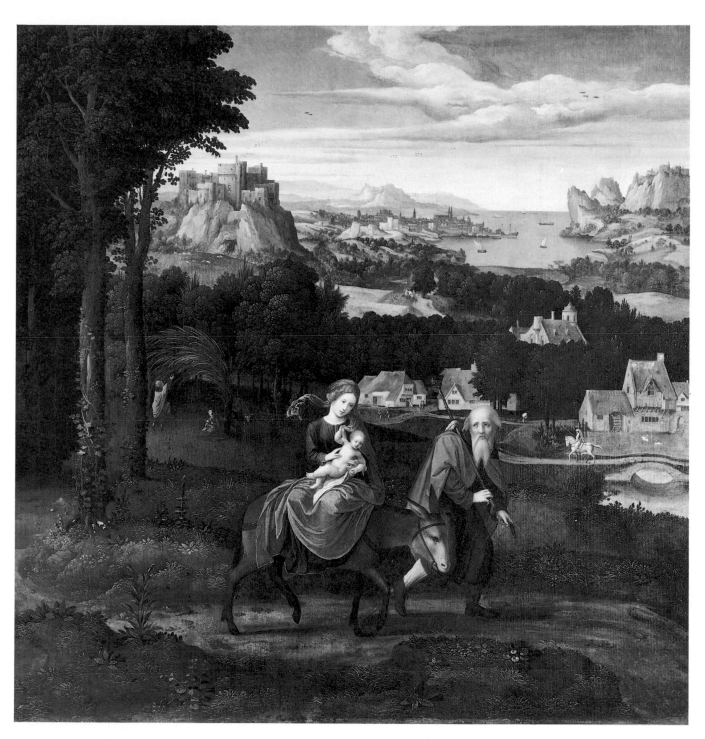

Master of the Half-Lengths
Flemish, c. 1525–1550

The Flight into Egypt

Oil on panel, 25¾ x 24⅞ in. (65.4 x 63.2 cm.)
Purchased with funds from the North Carolina Art Society (Robert F. Phifer Funds), 52.9.105

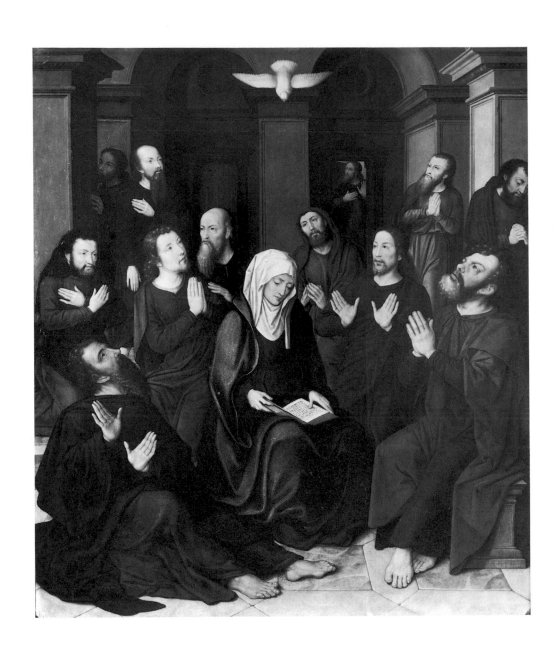

Ambrosius Benson
Flemish, active before 1519–1550

The Pentecost

Oil on panel, 36¹/₈ x 31⁵/₁₆ in. (91.8 x 79.5 cm.)
Gift of Mr. and Mrs. Jack Linsky, 52.11.1

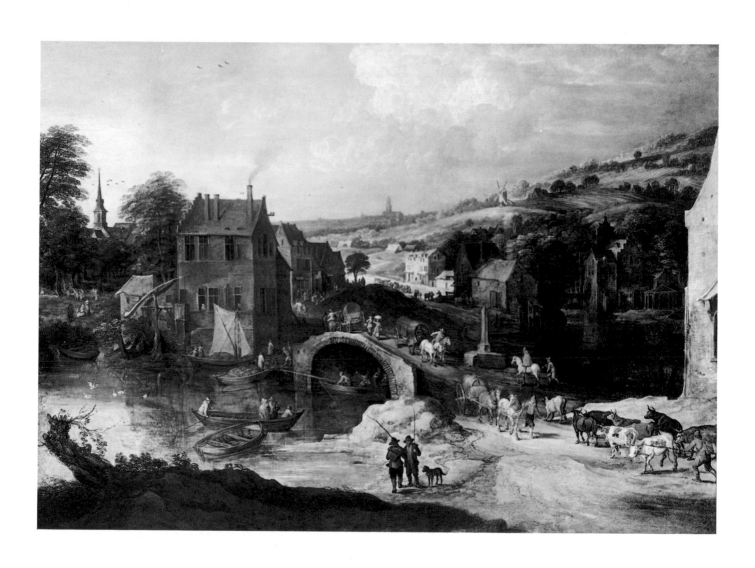

Joos de Momper
Flemish, 1564–1635

Landscape with a Bridge

Oil on canvas, 52½ x 74 in. (133.3 x 188 cm.)
52.9.103

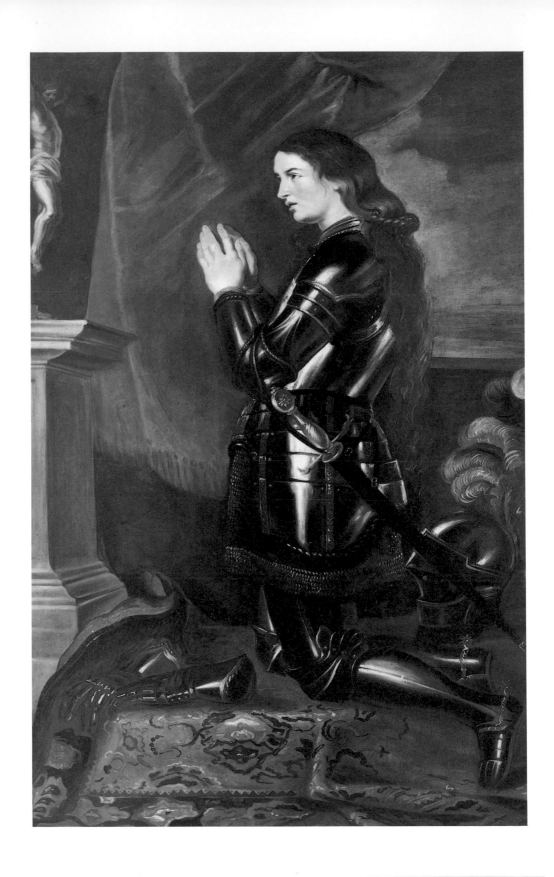

Peter Paul Rubens
Flemish, 1577–1640

Joan of Arc (1412/13–1431), c. 1618–20

Oil on canvas, 71⅝ x 45¹³⁄₁₆ in. (181.9 x 116.4 cm.)
Original State Appropriation and funds from the North Carolina Art Society
(Robert F. Phifer Funds), 52.9.111

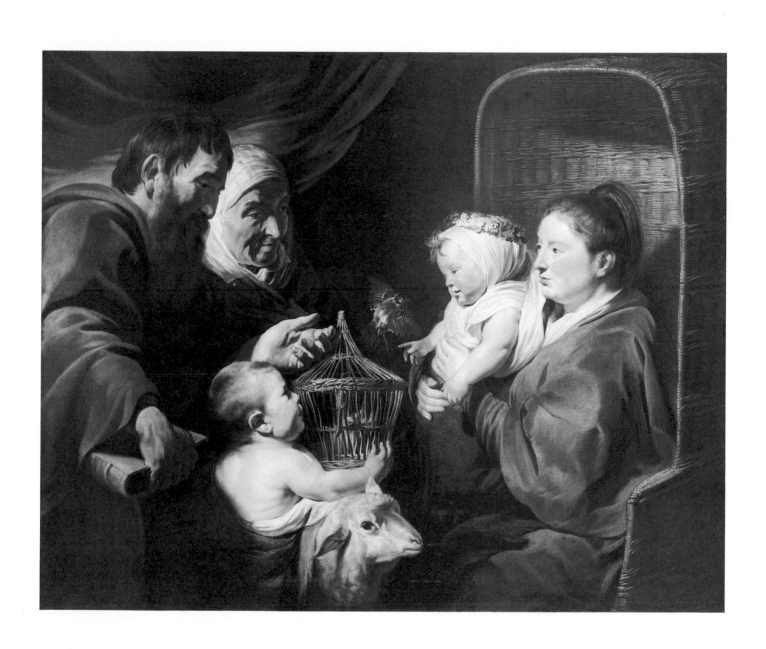

Jacob Jordaens
Flemish, 1593–1678

The Holy Family, c. 1615

Oil on canvas, 46 x 56⅞ in. (116.8 x 144.5 cm.)
52.9.101

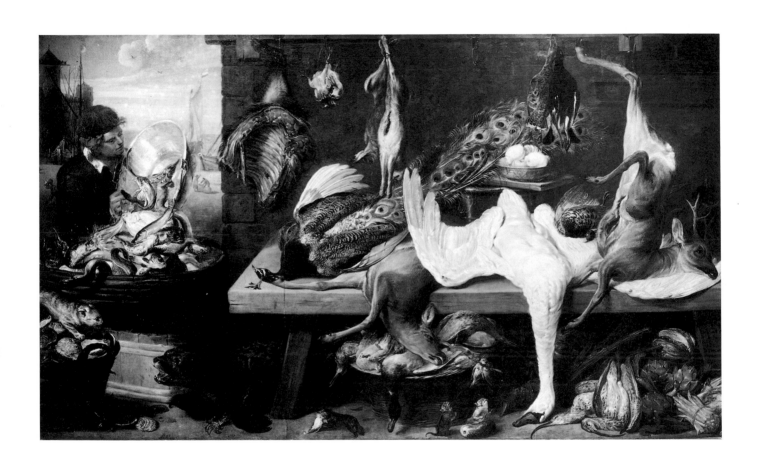

Frans Snyders
Flemish, 1579–1657

Still Life with Dead Swan on a Quay, c. 1616–21

Oil on canvas, 79⅜ x 136 in. (201.6 x 345.4 cm.)
52.9.113

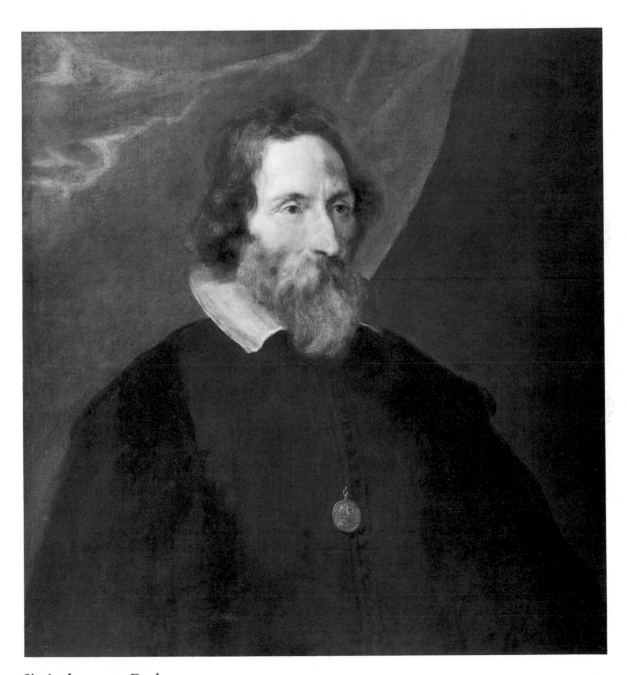

Sir Anthony van Dyck
Flemish, 1599–1641

Erycius Puteanus (1574–1646), c. 1629

Oil on canvas, 29⅝ x 26¹¹/₁₆ in. (75.2 x 67.8 cm.)
52.9.95

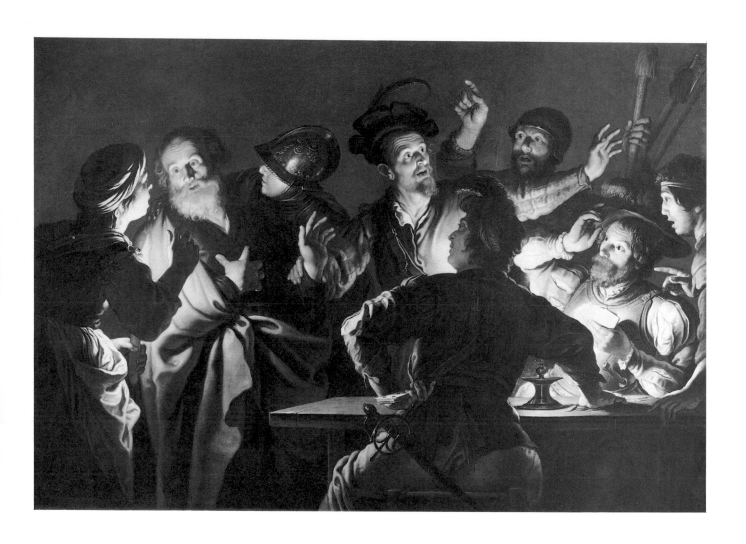

Gerard Seghers
Flemish, 1591–1651

The Denial of St. Peter, c. 1620–25

Oil on canvas, 62 x 89⅝ in. (157.5 x 227.7 cm.)
52.9.112

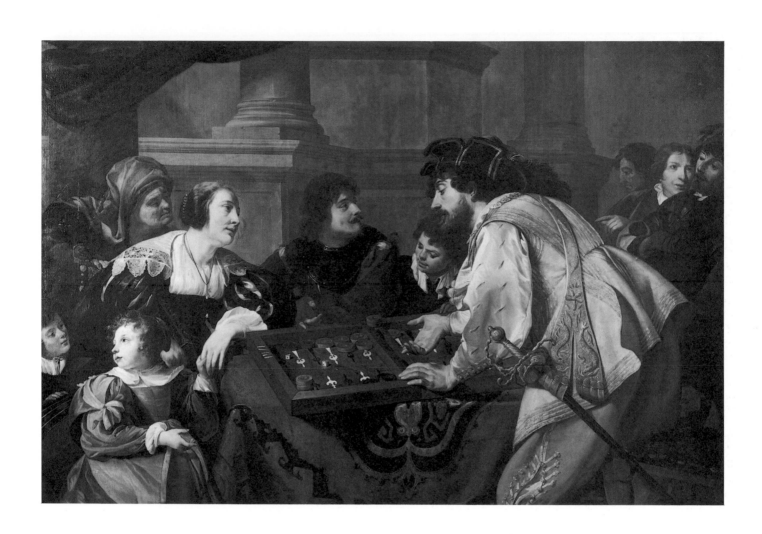

Theodor Rombouts
Flemish, 1597–1637

The Backgammon Players, 1634

Oil on canvas, 63¹/₄ x 92⁷/₁₆ in. (160.5 x 234.8 cm.)
Gift of E. Graham Flanagan, Charles R. Flanagan, and Mrs. Rosemond Flanagan Wagner
in memory of their father E. G. Flanagan, 57.2.1

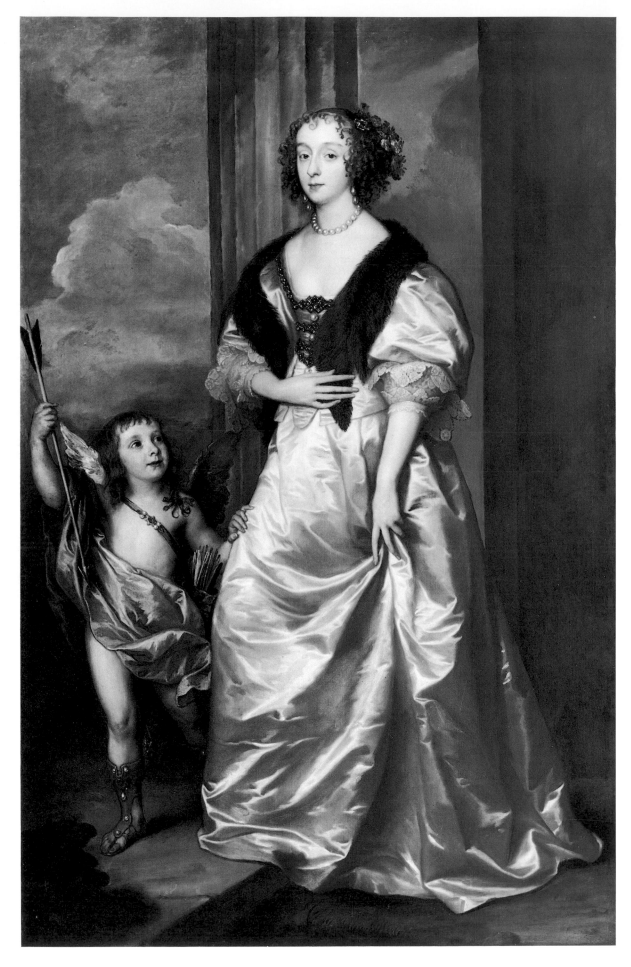

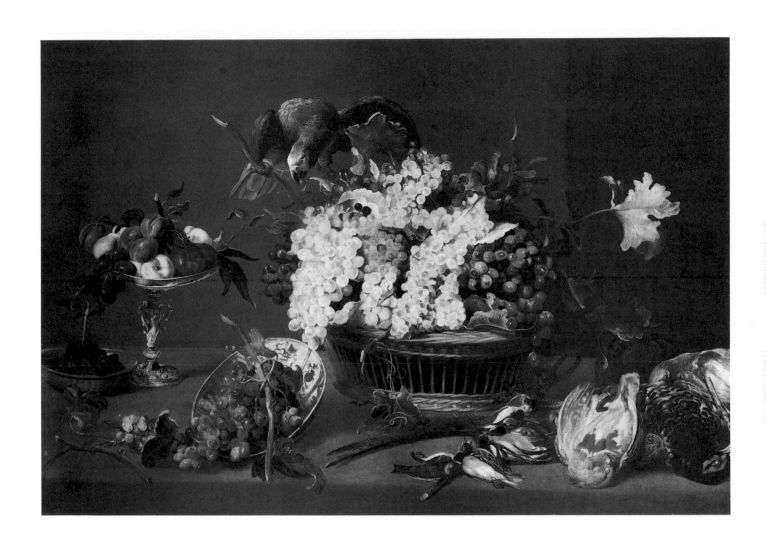

Sir Anthony van Dyck
Flemish, 1599–1641

Lady Mary Villiers, later Duchess of Richmond and Lennox (1622–1685) with Charles Hamilton, Earl of Arran (d. 1640), c. 1635
Oil on canvas, 83³/₈ x 52⁹/₁₆ in. (211.7 x 133.5 cm.)
Gift of Mrs. Theodore Webb, 52.17.1

Frans Snyders
Flemish, 1579–1657

Still Life with a Parrot, c. 1635–37

Oil on canvas, 36⁵/₈ x 53¹/₁₆ in. (93 x 134.7 cm.)
52.9.201

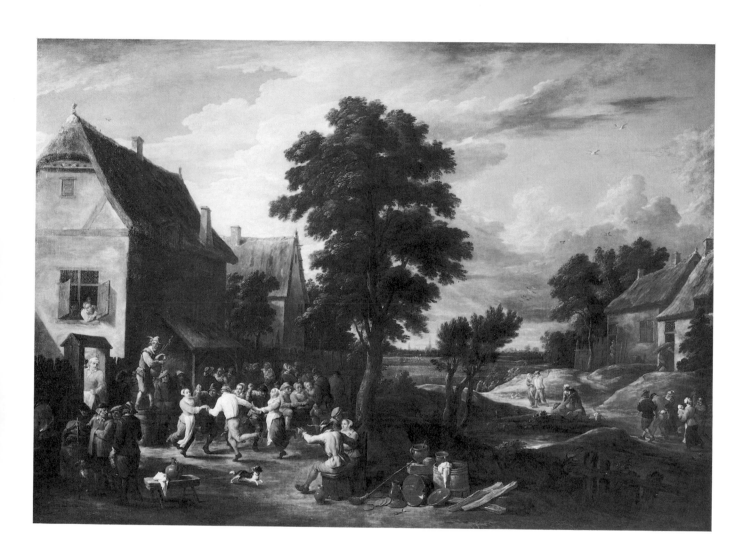

David Teniers II
Flemish, 1610–1690

Jacob Jordaens
Flemish, 1593–1678

Dancers at a Village Inn, c. 1670

Oil on canvas, 65¾ x 94⅞ in. (167 x 241 cm.)
52.9.115

The Adoration of the Shepherds, 1657

Oil on canvas, 106¼ x 81 in. (270 x 205.7 cm.)
Gift of John Motley Morehead, 55.7.1

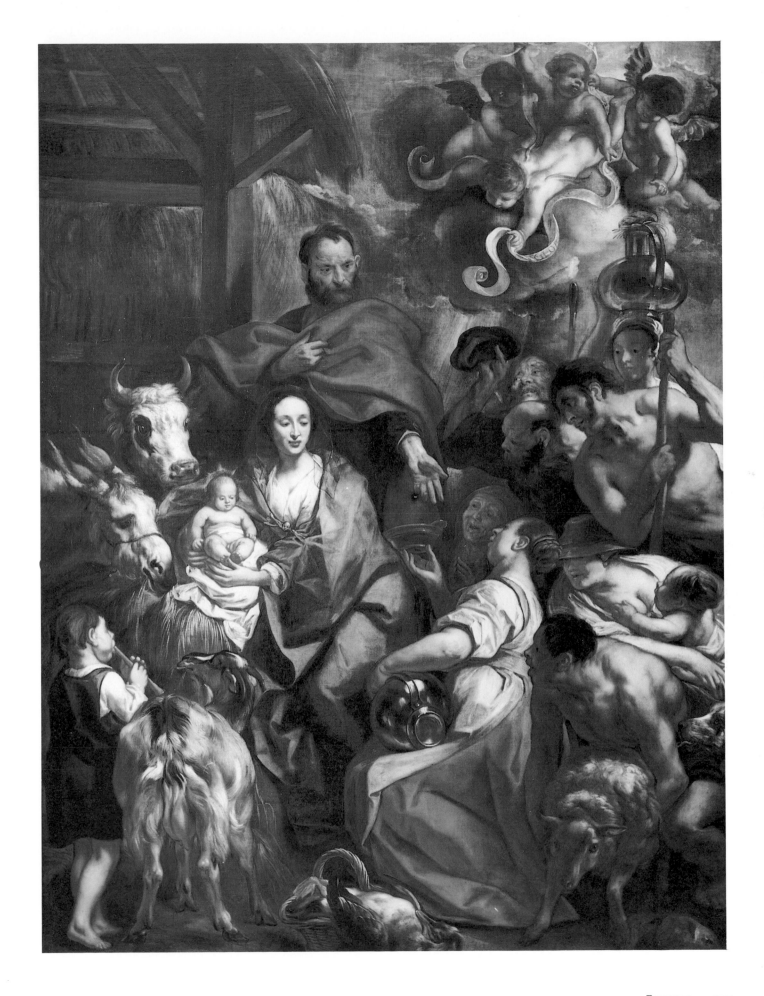

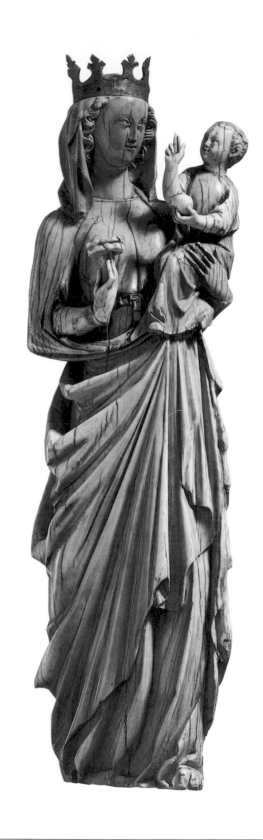

French (Parisian), late 13th century

Madonna and Child, c. 1260–90

Ivory, metal, h. 11¾ in. (29.8 cm.)
Gift of Mrs. Edsel Ford in memory of W. R. Valentiner, 59.6.1

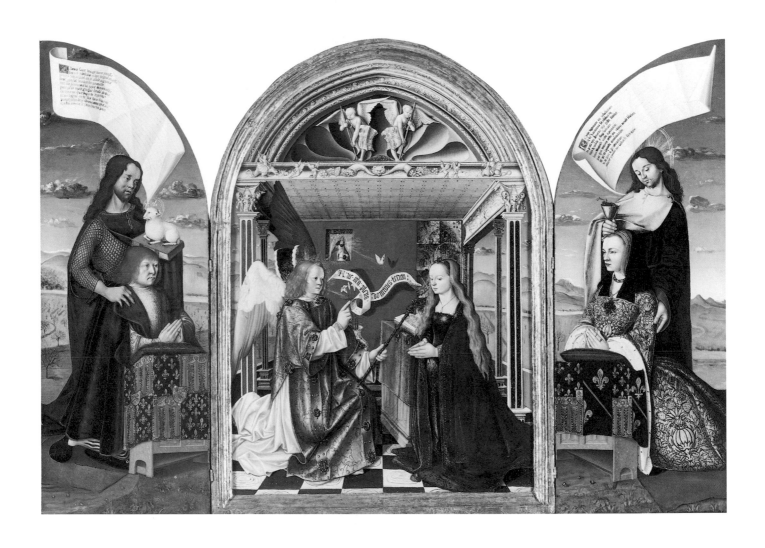

Master of the Latour d'Auvergne Triptych
French, active c. 1490–1500

The Annunciation with Saints and Donors, called the Latour d'Auvergne Triptych, c. 1497

Oil on panel, center 28¾ x 19⁷⁄₁₆ in. (73 x 49.4 cm.), wings (each) 26½ x 9³⁄₈ in. (67.3 x 23.6 cm.)
Gift of the Samuel H. Kress Foundation, 60.17.61

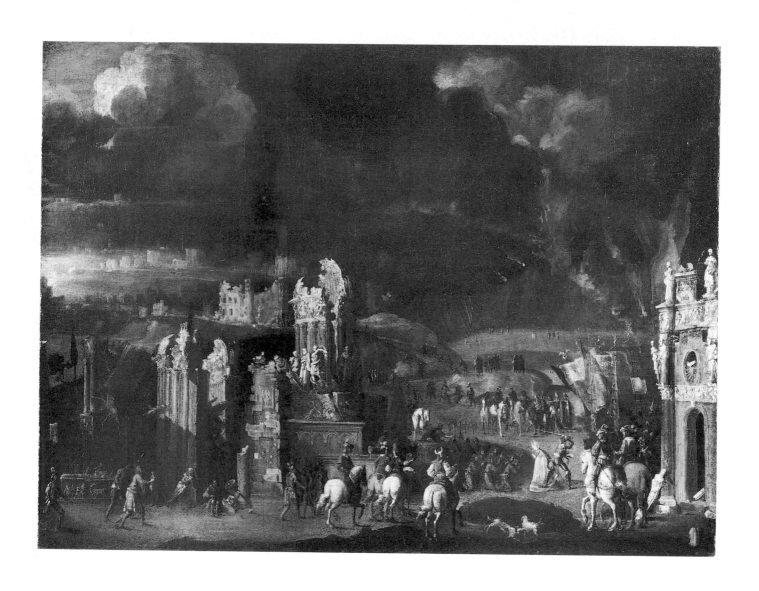

François de Nomé, called Monsù Desiderio
French, c. 1593–after 1644, active in Italy

The Martyrdom of St. Januarius, 1622

Oil on canvas, 29¾ x 40⅛ in. (75.5 x 101.9 cm.)
52.9.213

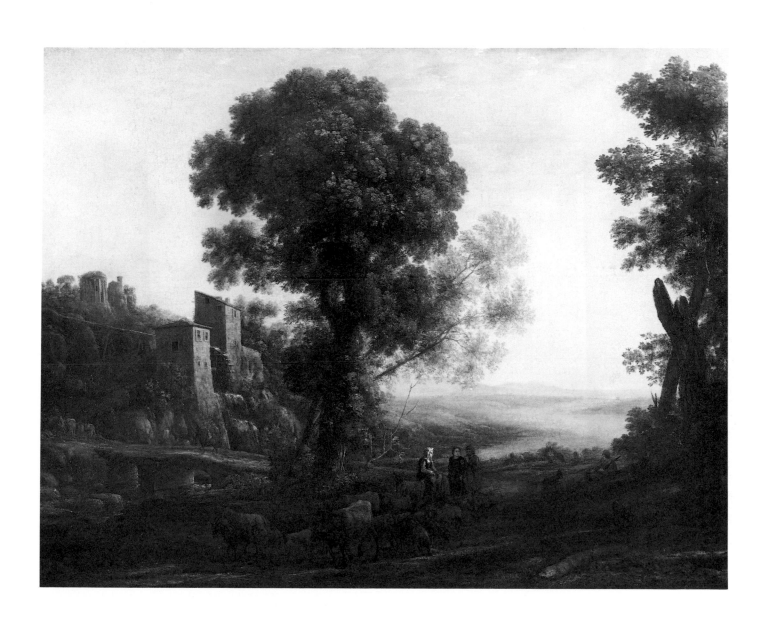

Claude Gellée, called Claude Lorrain
French, 1600–1682

Landscape with Three Peasants Returning with Their Herds, c. 1637

Oil on canvas, 30 x 40 in. (76.2 x 101.7 cm.)
52.9.125

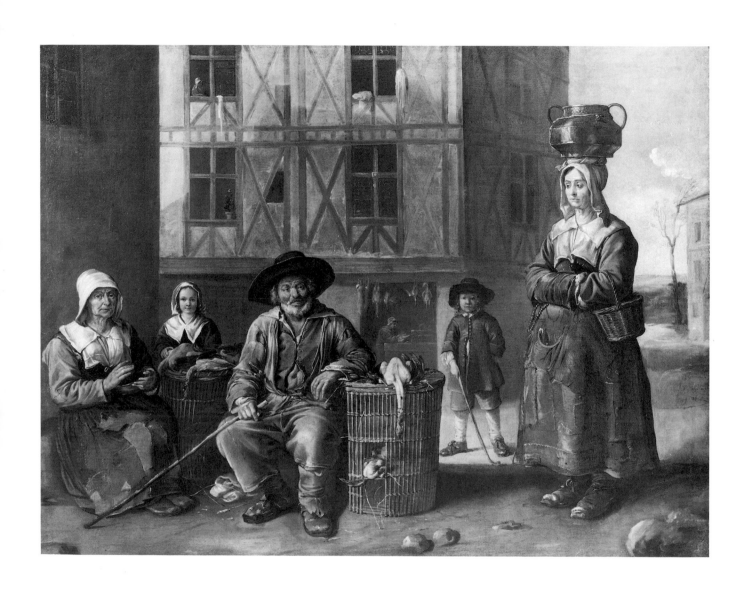

Jean Michelin
French, 17th century

A Poultry Merchant and an Old Woman Warming Her Hands, 165[2?]

Oil on canvas, 39½ x 51¾ in. (100.3 x 131.5 cm.)
52.9.126

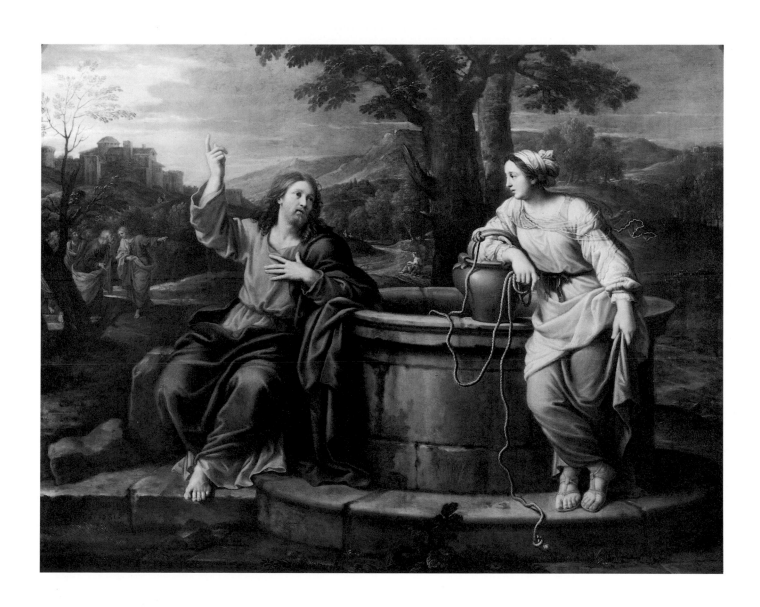

Pierre Mignard
French, 1612–1695

Christ and the Woman of Samaria, 1681

Oil on canvas, 48 x 63 in. (121.9 x 160 cm.)
52.9.127

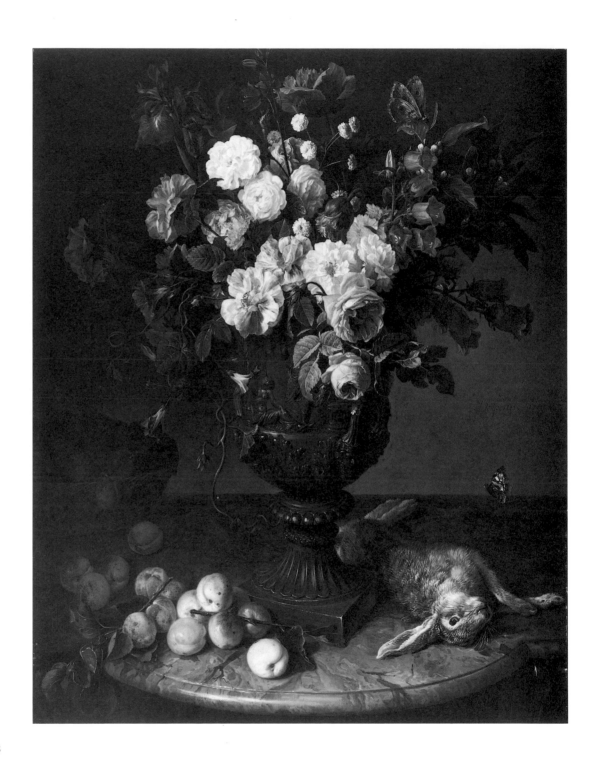

François Desportes
French, 1661–1743

Urn of Flowers with a Dead Rabbit, 1715

Oil on canvas, 40¹/₁₆ x 31³/₄ in. (101.7 x 80.4 cm.)
52.9.123

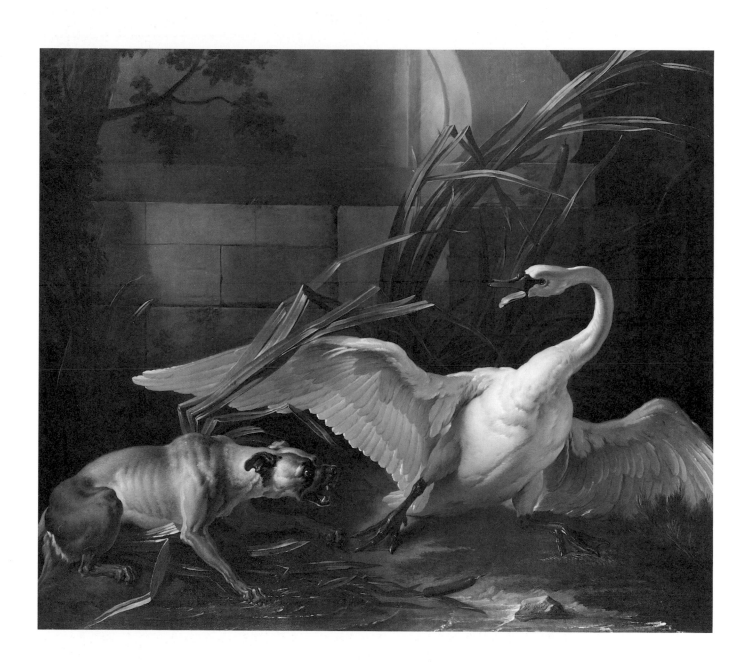

Jean-Baptiste Oudry
French, 1686–1755

Swan Frightened by a Dog, 1745

Oil on canvas, 70⅜ x 82⅛ in. (179.7 x 208.6 cm.)
Original State Appropriation and funds from the North Carolina Art Society
(Robert F. Phifer Funds), 52.9.131

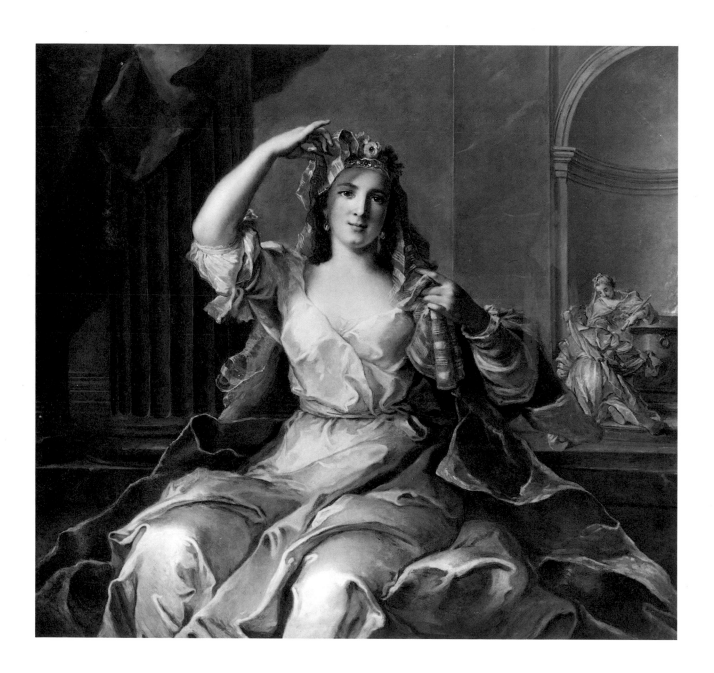

Jean-Marc Nattier
French, 1685–1766

Portrait of a Lady as a Vestal Virgin, 1759

Oil on canvas, 49⅞ x 54½ in. (126.9 x 138.4 cm.)
52.9.130

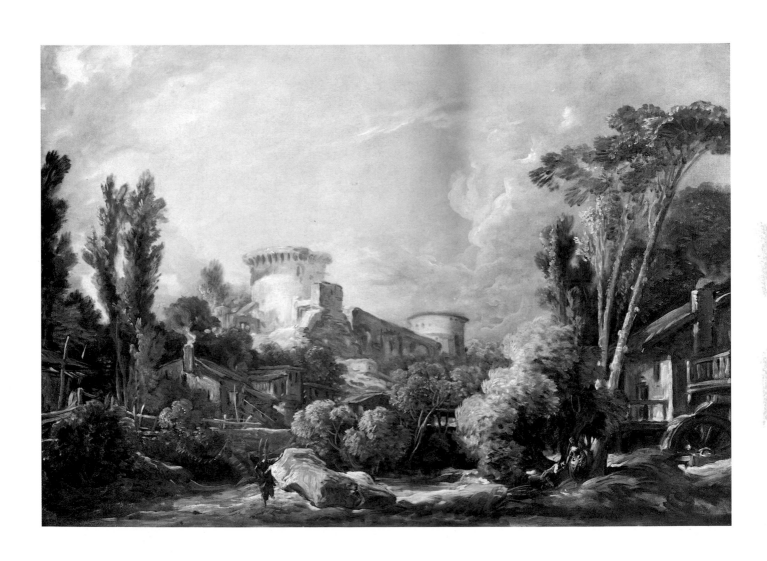

François Boucher
French, 1703–1770

Landscape with a Castle and a Mill, c. 1765

Oil on canvas, 20⁷/₈ x 30³/₁₆ in. (53 x 76.7 cm.)
52.9.120

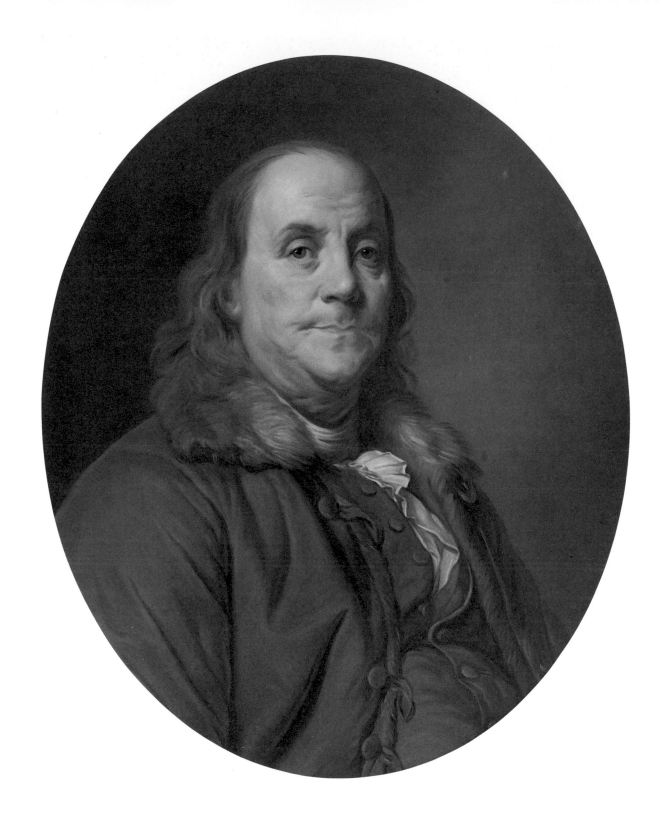

Joseph-Siffred Duplessis
French, 1725–1802

Benjamin Franklin (1706–90), c. 1779

Oil on canvas, 28⅝ x 23 in. (72.7 x 58.4 cm.)
Gift of the North Carolina Citizens Association, 75.26.1

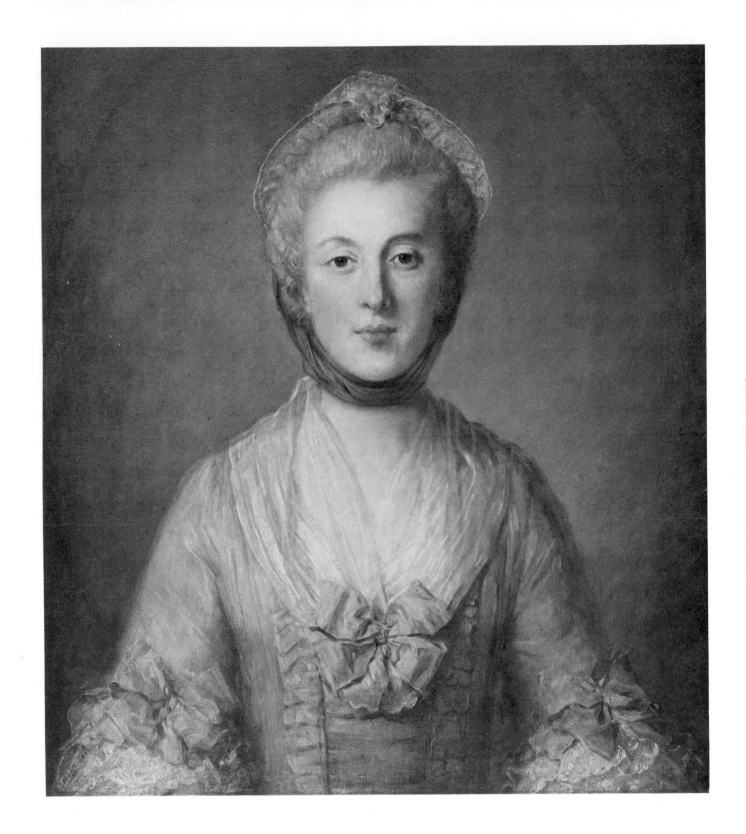

Jean-Baptiste Perronneau
French, 1715–1783

Portrait of a Lady, 1768

Oil on canvas, 29 x 23⁹/₁₆ in. (73.7 x 59.9 cm.)
Gift of John L. Loeb, 56.1.1

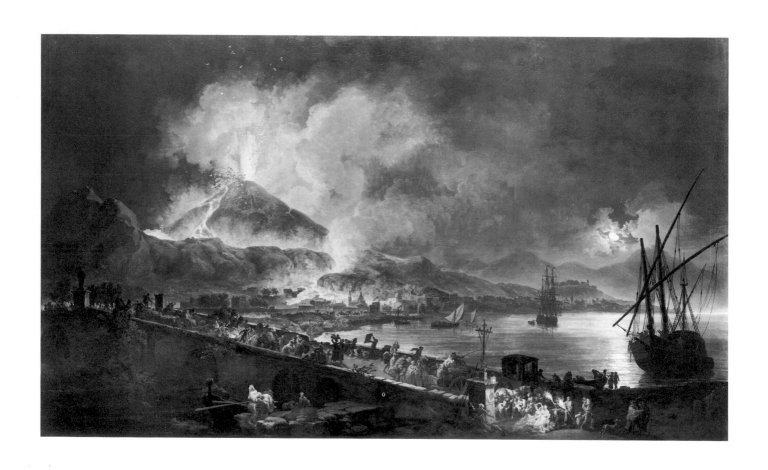

Pierre-Jacques Volaire
French, 1727–before 1802

The Eruption of Mt. Vesuvius, 1777

Oil on canvas, 53¼ x 89 in. (135.2 x 226.2 cm.)
Alcy C. Kendrick Funds and Museum Purchase Fund, by exchange, 82.1

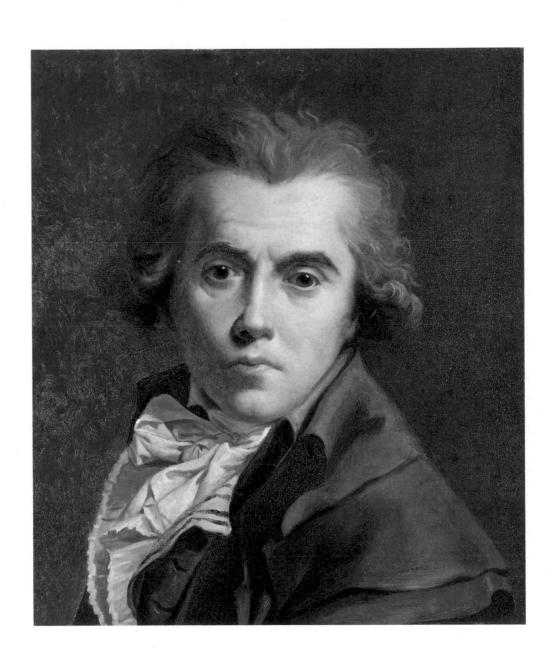

Jacques-Louis David
French, 1748–1825

Self-Portrait, c. 1790–95

Oil on canvas, 18¹/₄ x 15⁷/₁₆ in. (46.3 x 39.3 cm.)
52.9.122

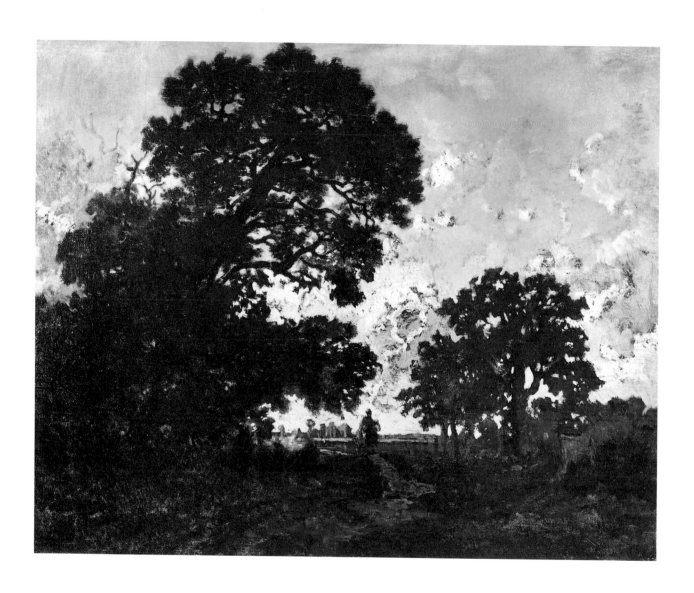

Pierre Étienne Théodore Rousseau
French, 1812–1867

The Beech in the Forest of L'Isle Adam

Oil on canvas, 31½ x 39¼ in. (79.9 x 99.7 cm.)
Purchased with funds from the North Carolina Art Society (Robert F. Phifer Funds)
and Museum Purchase Fund, 68.2.1

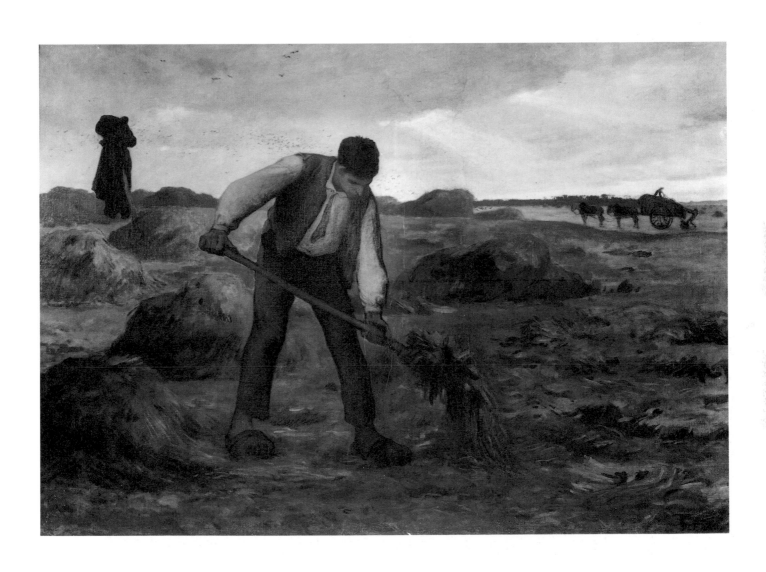

Jean-François Millet
French, 1814–1875

Peasant Spreading Manure, 1854–55

Oil on canvas, 32 x 43¾ in. (81.3 x 111.1 cm.)
Purchased with funds from the North Carolina Art Society (Robert F. Phifer Funds), 52.9.128

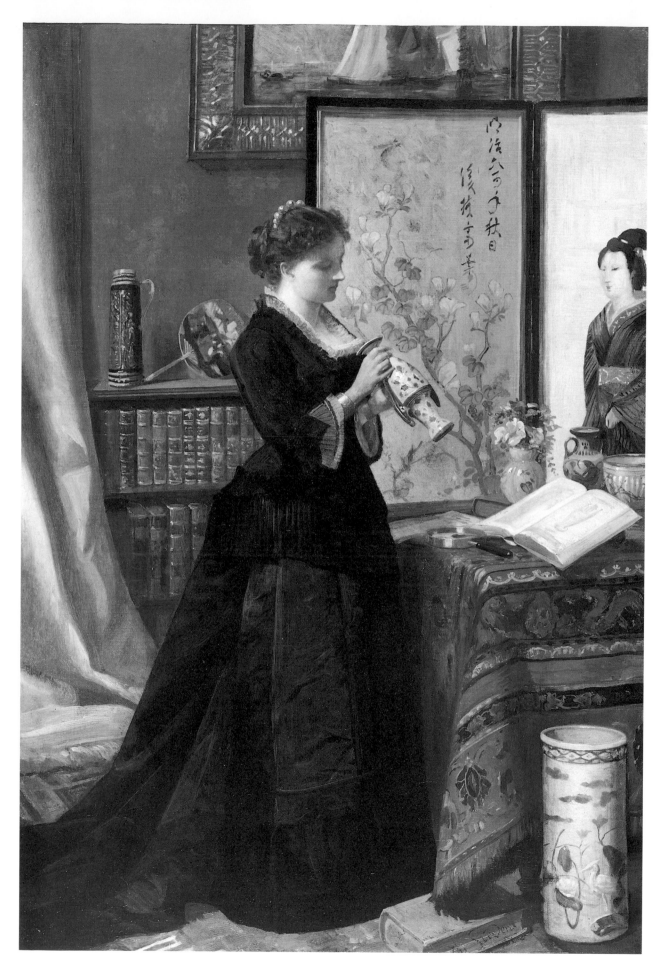

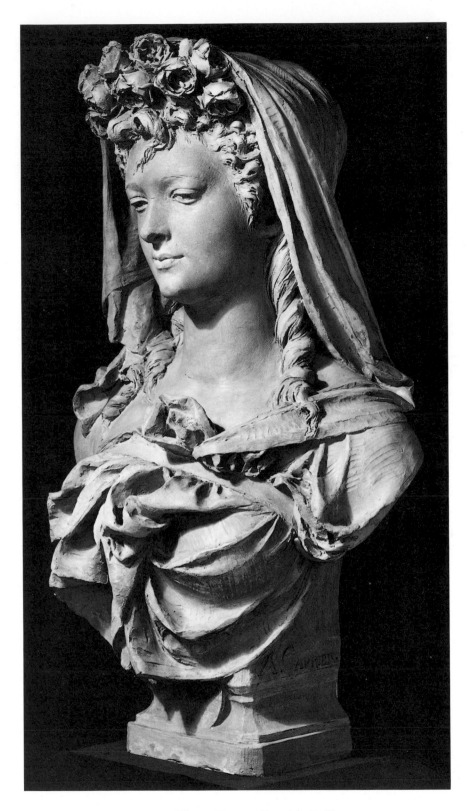

Alfred Stevens
Belgian, 1823–1906, active in Paris

Albert-Ernest Carrier-Belleuse
French, 1824–1887

The Porcelain Collector, 1868

Bust of a Woman

Oil on canvas, 27 x 18¼ in. (68.6 x 46.4 cm.)
Gift of Dr. and Mrs. Henry C. Landon III, 81.11.1

Terracotta, h. 24½ in. (62.2 cm.)
Purchased with funds from the Lady Marcia Cunliffe-Owen
Bequest and Museum Purchase Fund, 81.1.1

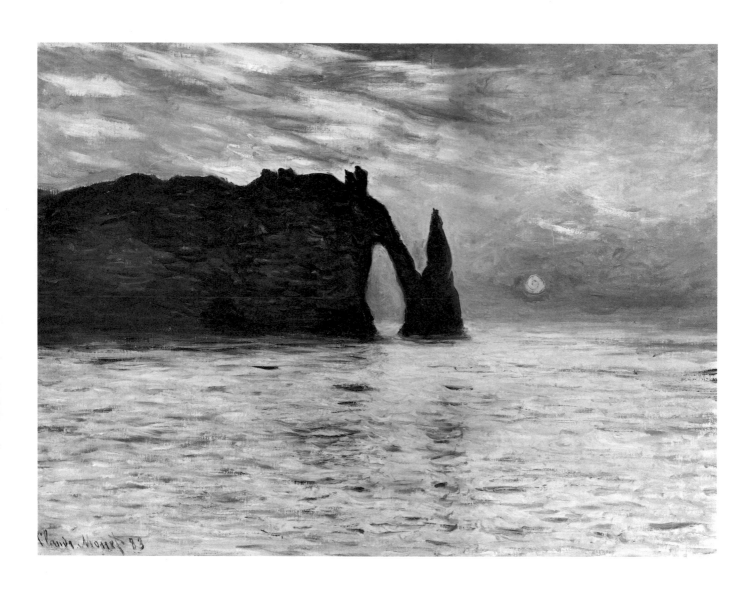

Claude Monet
French, 1840–1926

The Cliff, Étretat, Sunset, 1883

Oil on canvas, 25 13/16 x 32 3/16 in. (65.5 x 81.8 cm.)
67.24.1

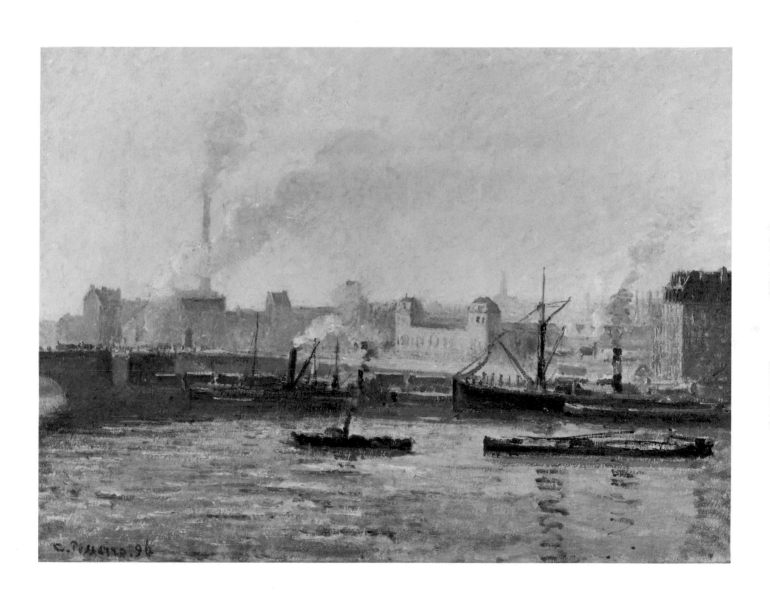

Camille Pissarro
French, 1831–1903

The St. Sever Bridge from Rouen, Fog, 1896

Oil on canvas, 23⅜ x 32¼ in. (60 x 81.3 cm.)
Gift of Wachovia Bank and Trust Company, 67.26.1

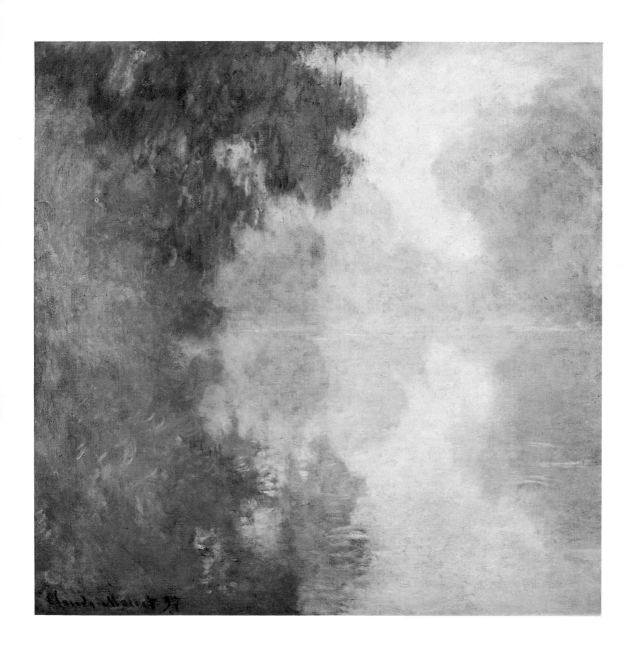

Claude Monet
French, 1840–1926

The Seine at Giverny, Morning Mists, 1897

Oil on canvas, 35 x 36 in. (89 x 91.5 cm.)
Purchased with funds from the North Carolina Art Society
(Robert F. Phifer Funds) and the Sarah Graham Kenan
Foundation, 75.24.1

Stefan Lochner
German, active c. 1400–1451

St. Jerome in His Study, c. 1440

Tempera on panel, 15 9/16 x 11 7/8 in. (39.5 x 30.2 cm.)
Purchased with funds from the North Carolina Art Society
(Robert F. Phifer Funds), 52.9.139

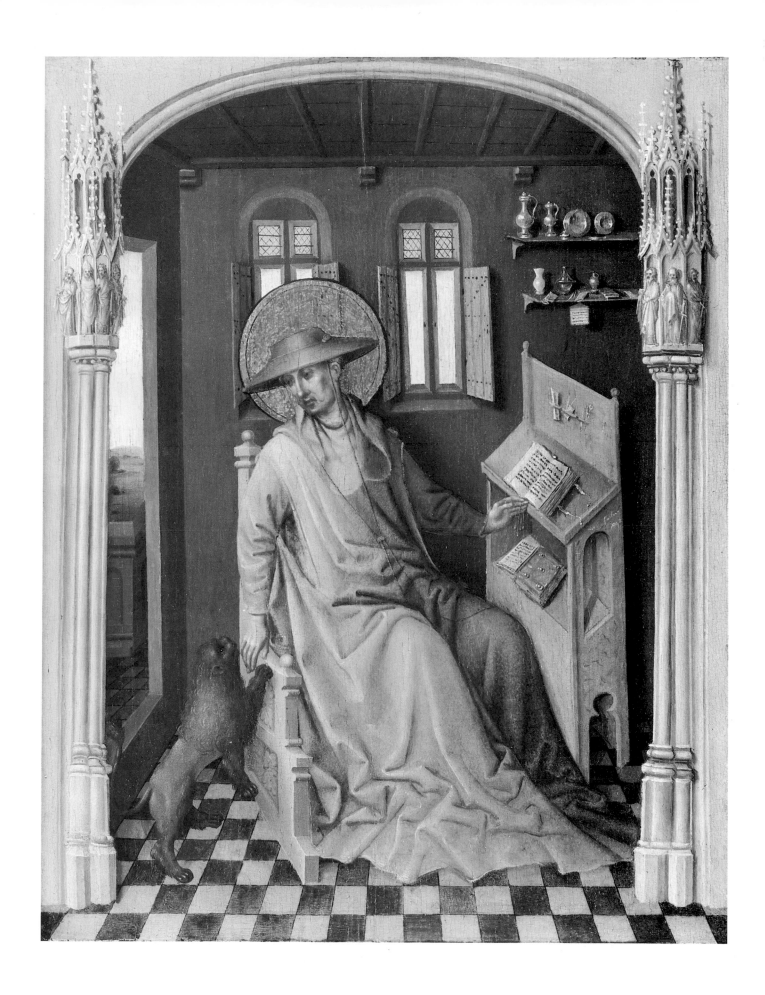

South German, middle of the 15th century

St. Barbara and St. Valentine with Caspar von Laubenberg and His Sons, c. 1450

Tempera, oil, and gold leaf on panel, 45⅝ x 20⅛ in. (115.8 x 51.2 cm.)
52.9.142

South German, middle of the 15th century

St. Catherine and St. Vitus with Anna von Freiberg and Her Daughters, c. 1450

Tempera, oil, and gold leaf on panel, 45³/₈ x 20³/₁₆ in. (115.2 x 51.2 cm.)
52.9.143

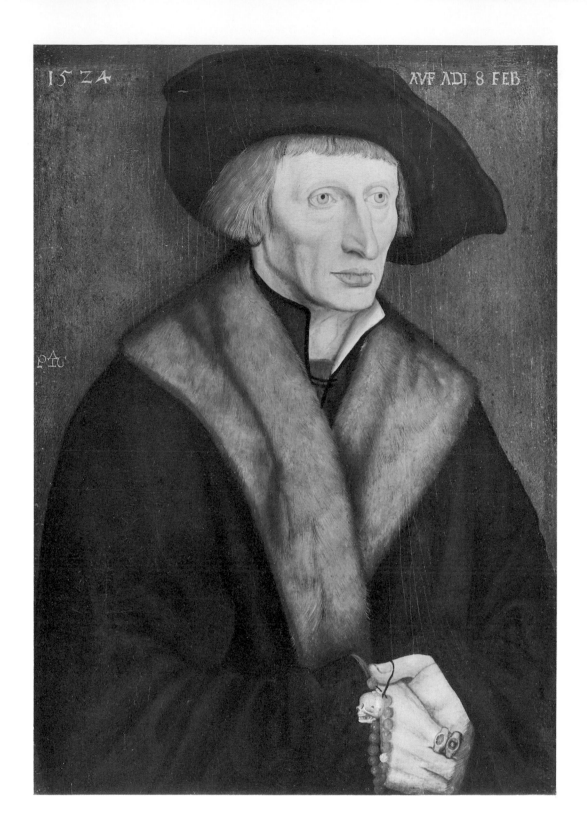

Peter Gaertner
German, active 1524–1537

Portrait of a Man, 1524
Oil on panel, 19¾ x 13½ in. (49.2 x 34.3 cm.)
52.9.138

Hans Suess von Kulmbach
German, 1480–1522

Portrait of a Man, c. 1510–20

Oil on panel, 18⅝ x 12⅛ in. (47.3 x 31.1 cm.)
Gift of Mrs. Arthur Lehman, 57.25.1

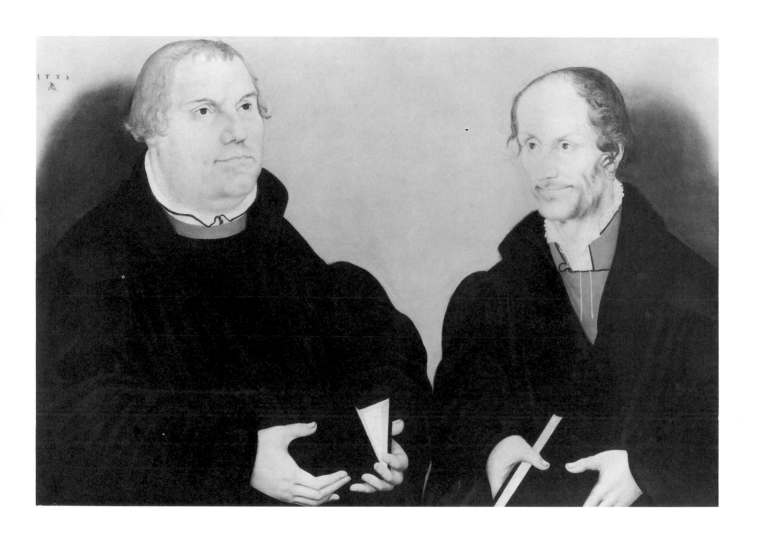

Lucas Cranach the Younger
German, 1515–1586

Martin Luther (1483–1546) and Philipp Melanchthon (1497–1560), 1558

Oil on panel, 24⅛ x 34⅞ in. (61.2 x 88.5 cm.)
Gift of the Samuel H. Kress Foundation, 60.17.65

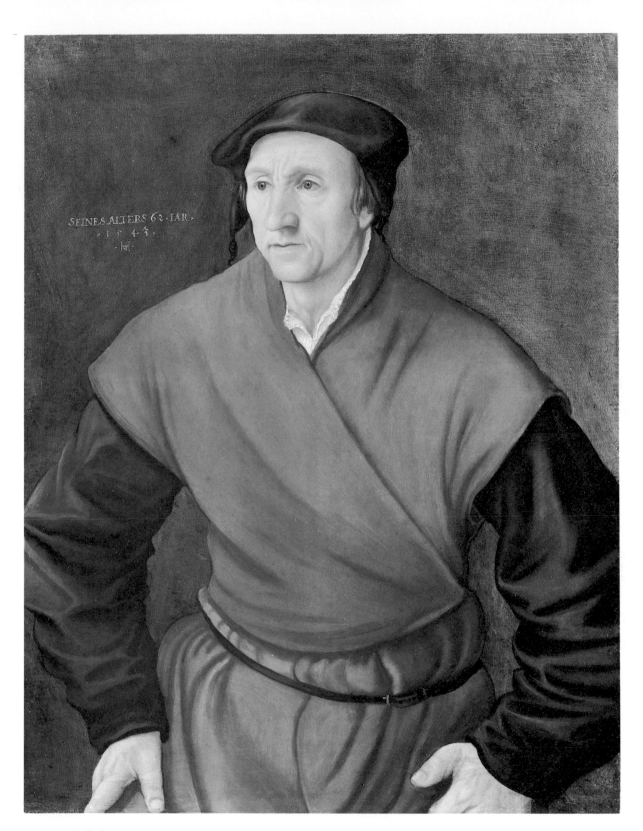

Hans Mielich
German, 1516–1573

Portrait of a Man, 1543

Oil on panel, 25⁷/₁₆ x 19¹/₄ in. (64.6 x 49 cm.)
52.9.140

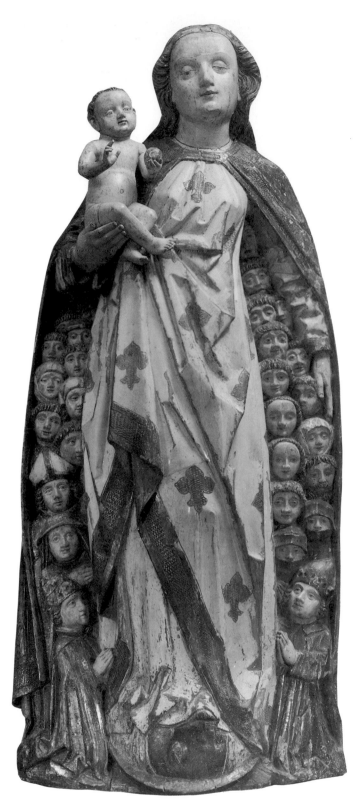

Peter Koellin attributed to
German, active third quarter of the 15th century

Madonna and Child Sheltering Supplicants under Her Cloak, c. 1470

Lindenwood with gesso and polychrome, h. 57 in. (144.8 cm.)
Gift of R. J. Reynolds Industries, Inc., 61.13.1

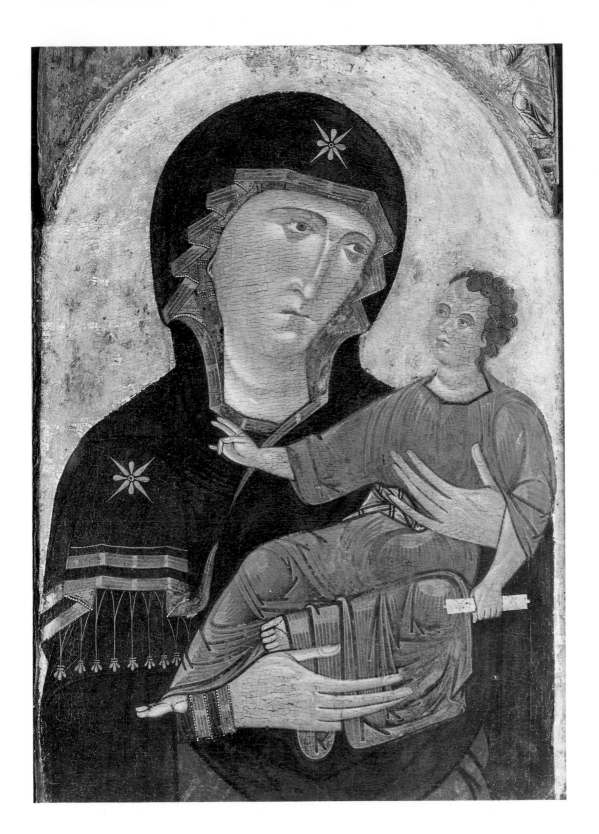

Berlinghiero
Italian, active c. 1215–1240

Madonna and Child, c. 1220

Tempera and gold leaf on panel, 28¾ x 19¼ in. (73 x 48.9 cm.)
Gift of Wachovia Bank and Trust Company, 57.16.1

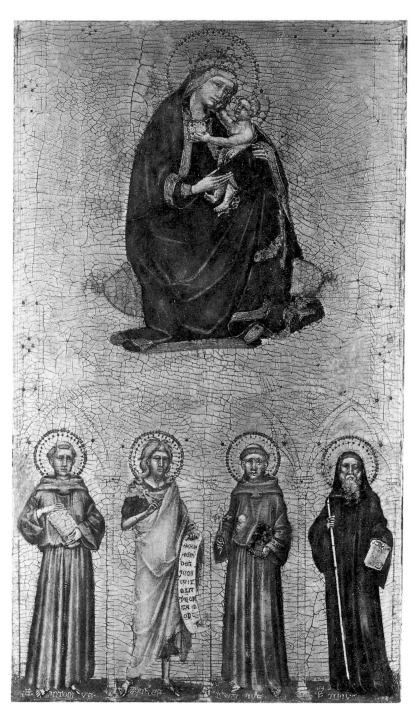

Guariento d'Arpo
Italian, active 1338–1368/70

Madonna and Child with Saints, c. 1360

Tempera and gold leaf on panel, 16⅛ x 9⅛ in. (40.9 x 23.2 cm.)
Gift of the Samuel H. Kress Foundation, 60.17.17

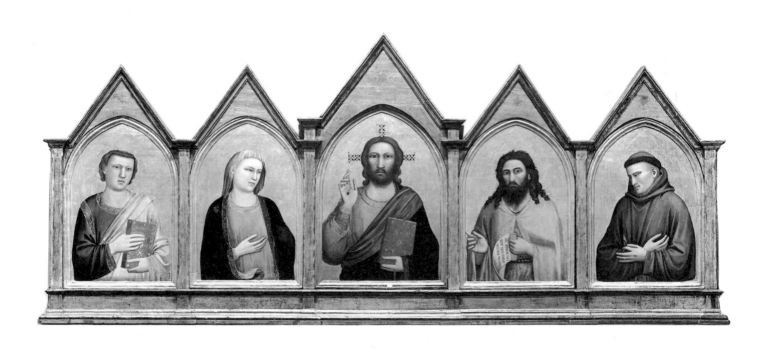

Giotto di Bondone and assistants
Italian, c. 1266–1336

The Peruzzi Altarpiece, c. 1322

Tempera and gold leaf on panel, entire ensemble 41½ x 98¼ in. (105.4 x 249 cm.)
Gift of the Samuel H. Kress Foundation, 60.17.7

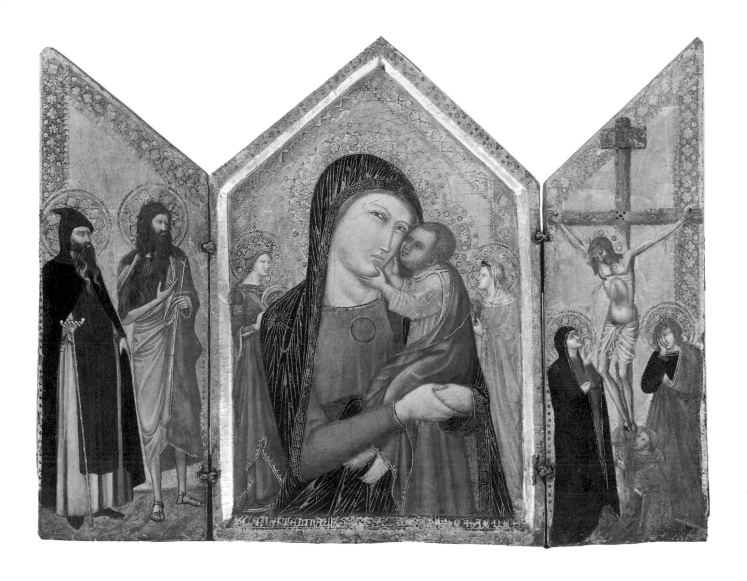

Italian, 14th century

Madonna and Child, the Crucifixion, and Saints, c. 1340

Tempera and gold leaf on wood, left 15 x 5¼ in. (38.1 x 13.4 cm.), center 15¼ x 10⅛ in.
(38.8 x 25.7 cm.), right 15 x 4⅞ in. (38.1 x 12.4 cm.)
Gift of the Samuel H. Kress Foundation, 60.17.6

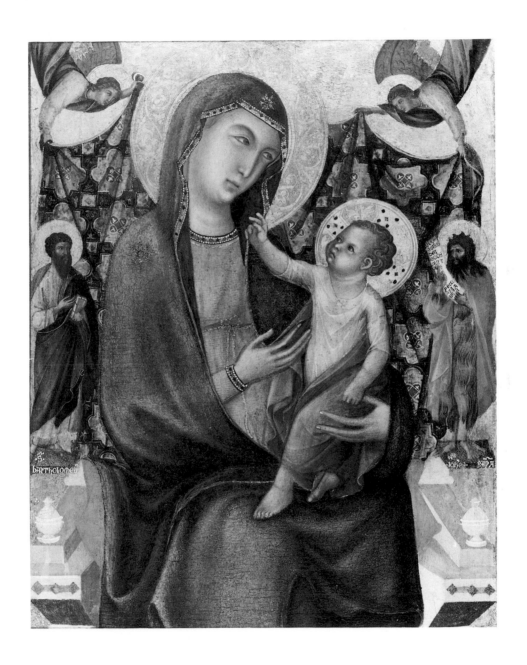

Master of San Torpè attributed to
Italian, active early 14th century

Madonna and Child with St. Bartholomew and St. John the Baptist, c. 1320

Tempera and gold leaf on panel, transferred to canvas, 19¹¹/₁₆ x 15½ in. (49.9 x 39.3 cm.)
Gift of the Samuel H. Kress Foundation, 60.17.3

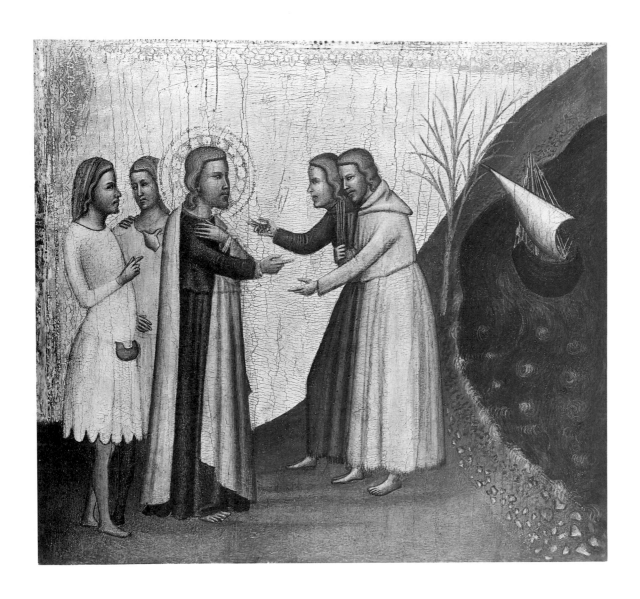

Francescuccio Ghissi attributed to
Italian, active c. 1359–c. 1395

Acteus and Eugenius Imploring St. John the Evangelist to Restore Their Wealth, c. 1375

Tempera and gold leaf on panel, 13¾ x 15 in. (34.9 x 38.1 cm.)
Gift of the Samuel H. Kress Foundation, 60.17.19

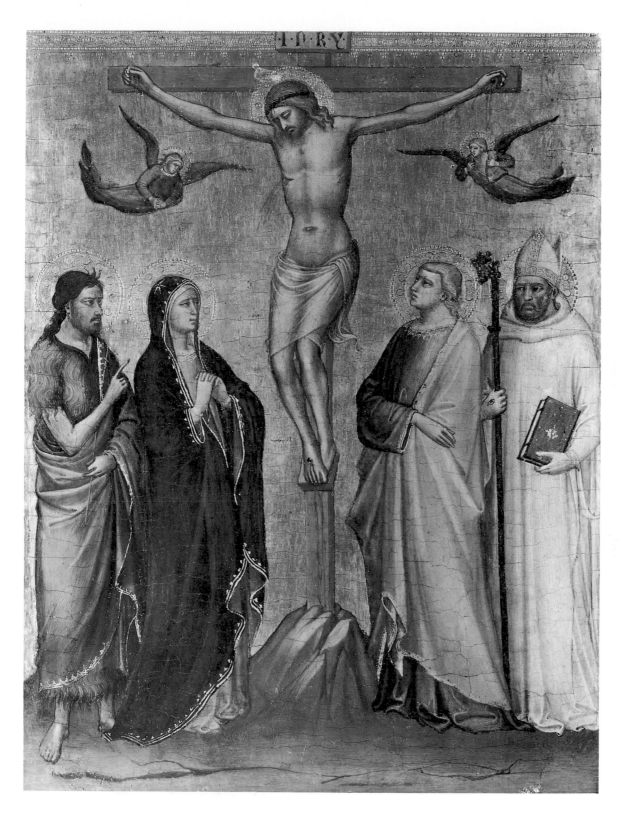

Mariotto di Nardo attributed to
Italian, active c. 1380–1424

Crucifixion with St. John the Baptist, the Virgin, St. John the Evangelist, and St. Nicholas, c. 1380–85

Tempera and gold leaf on panel, 13 x 9⅞ in. (33 x 25.1 cm.)
Gift of the Samuel H. Kress Foundation, 60.17.10

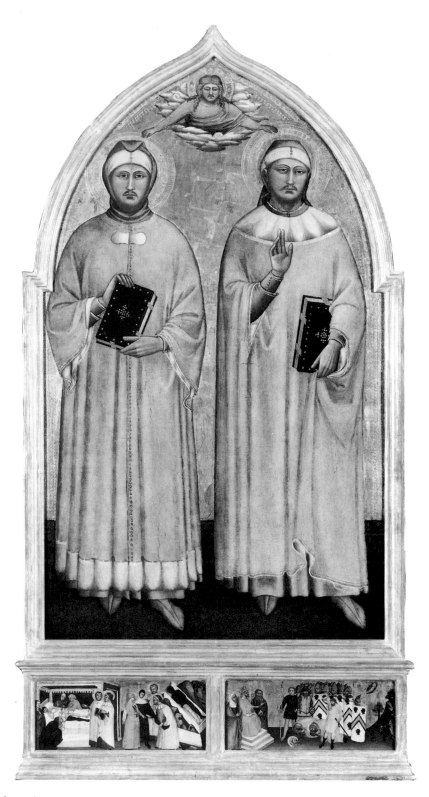

Master of the Rinuccini Chapel (Matteo di Pacino?)
Italian, active third quarter of the 14th century

St. Cosmas and St. Damian, c. 1370–75

Tempera and gold leaf on panel, 52¾ x 30⅝ in. (134 x 77.8 cm.)
Gift of the Samuel H. Kress Foundation, 60.17.9

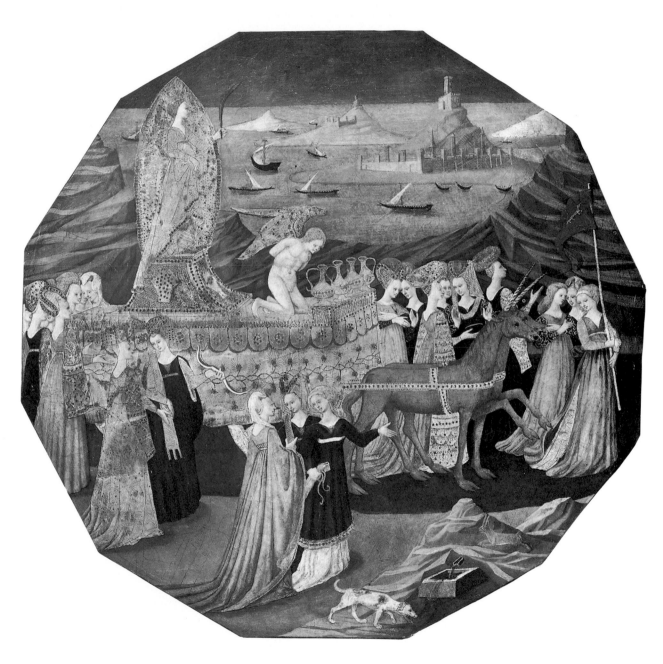

Apollonio di Giovanni, workshop of
Italian, 1415/17–1465

The Triumph of Chastity, c. 1450–60

Tempera and gold leaf on panel, 23 x 23¼ in. (58.4 x 59.1 cm.)
Gift of the Samuel H. Kress Foundation, 60.17.23

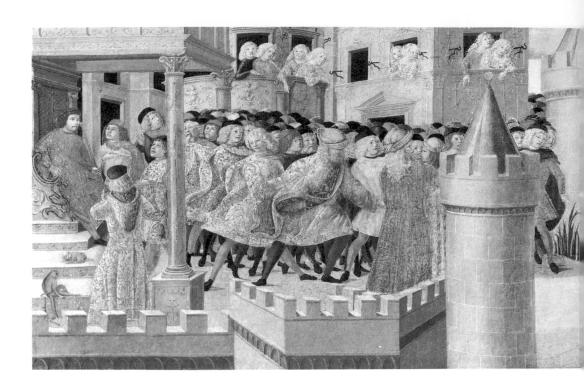

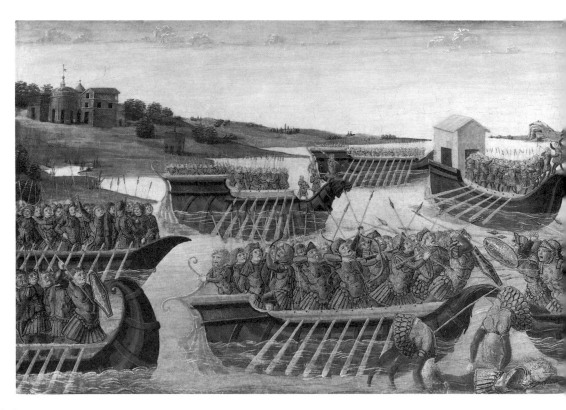

Neroccio de' Landi and workshop
Italian, 1447–1500

The Battle of Actium, c. 1480–95 (lower illustration)

Tempera and gold leaf on panel, 14⅜ x 44⅛ in. (36.5 x 112.1 cm.)
Gift of the Samuel H. Kress Foundation, 60.17.30

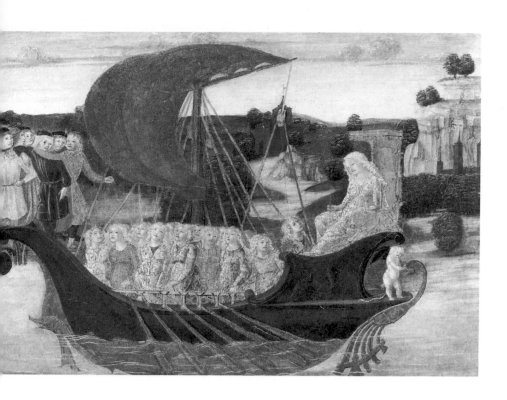

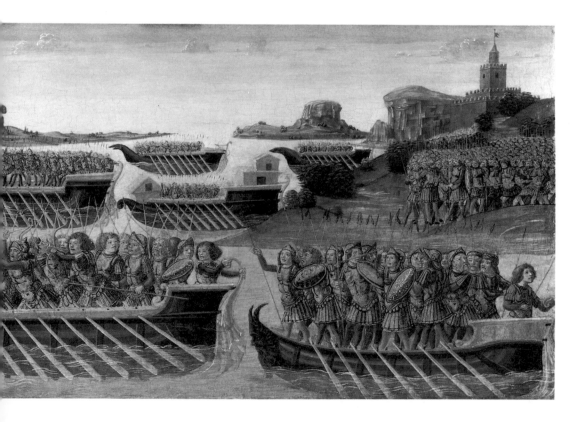

The Visit of Cleopatra to Antony, c. 1480–95 (upper illustration)

Tempera, gold and silver leaf on panel, 14¼ x 44½ in. (36.2 x 113 cm.)
Gift of the Samuel H. Kress Foundation, 60.17.29

Francesco di Simone Ferrucci
Italian, 1437–1493

Madonna and Child, c. 1478
Marble, dia. 24½ in. (62.2 cm.)
Gift of the Samuel H. Kress Foundation, 60.17.25

Francesco Laurana
Italian, 1420/25–1502

Federigo da Montefeltro, Duke of Urbino (1414–1482), c. 1475–76

Marble, dia. 19¾ in. (50.2 cm.)
58.4.6

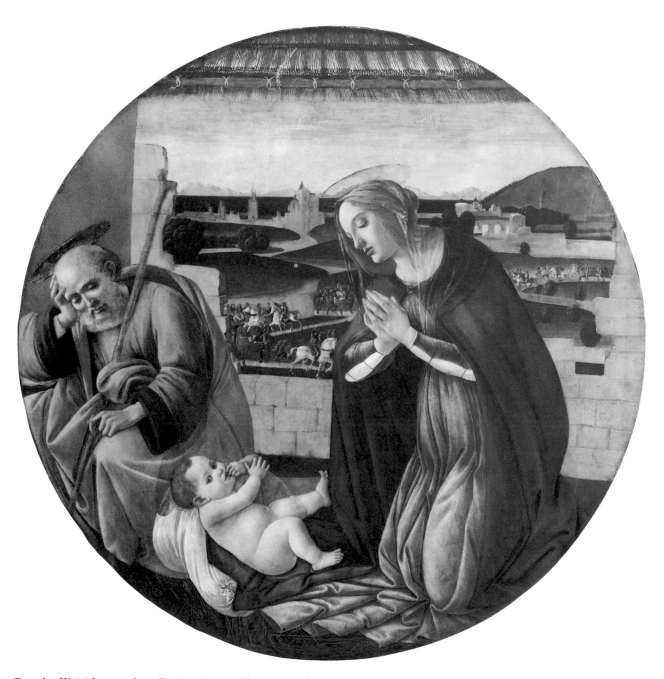

Botticelli (Alessandro di Mariano Filipepi) and assistants
Italian, 1444/45–1510

Francesco Francia (Francesco Raibolini)
Italian, c. 1450–1517/18

The Adoration of the Child, c. 1490

Tempera on panel, dia. 49½ in. (125.7 cm.)
Gift of the Samuel H. Kress Foundation, 60.17.26

Madonna and Child with Two Angels, c. 1500

Oil on panel, 34¾ x 22¼ in. (88.3 x 56.5 cm.)
Gift of the Samuel H. Kress Foundation, 60.17.39

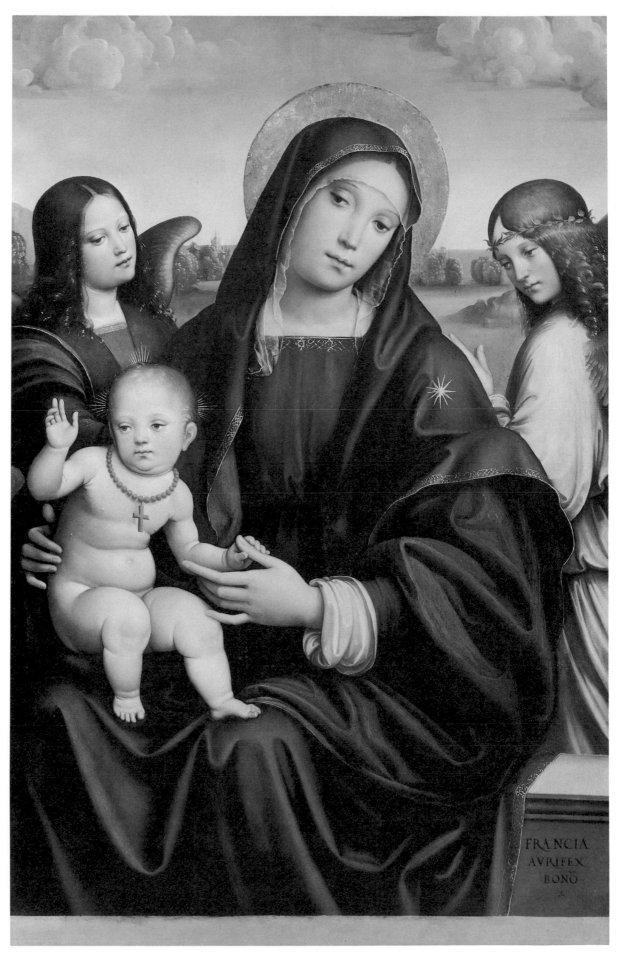

FRANCIA
AVRIFEX
BONÕ

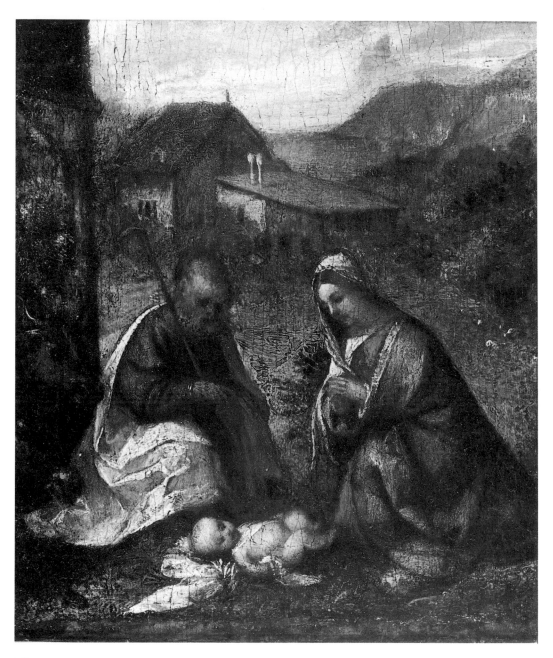

Titian (Tiziano Vecellio) attributed to
Italian, active before 1511–1576

The Adoration of the Child, c. 1507–8

Oil on panel, 7½ x 6⅜ in. (19 x 16.2 cm.)
Gift of the Samuel H. Kress Foundation, 60.17.41

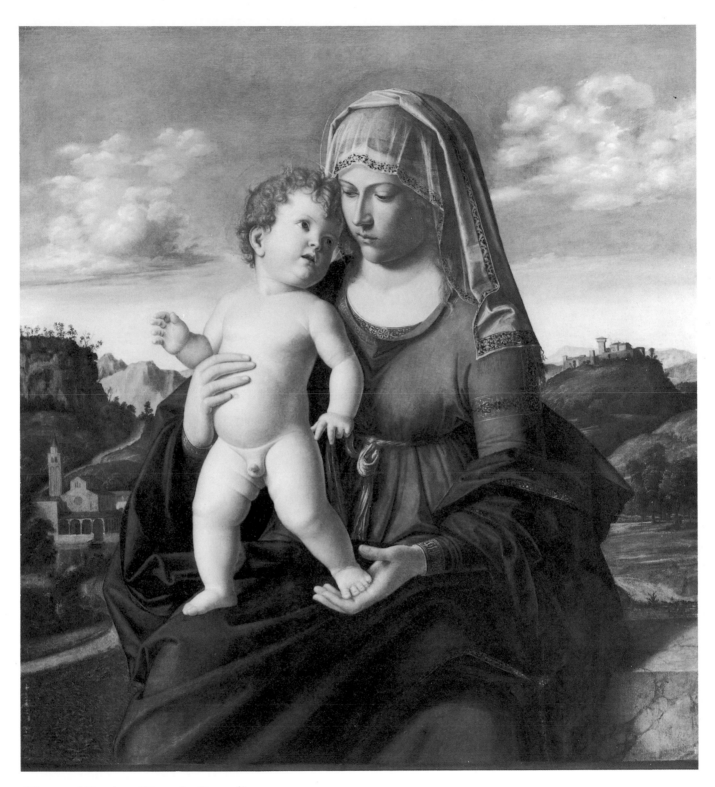

Giovanni Battista Cima da Conegliano
Italian, 1459/60–1517/18

Madonna and Child in a Landscape, c. 1496–99

Oil on panel transferred to canvas, 28 x 24¾ in. (71.1 x 62.9 cm.)
52.9.152

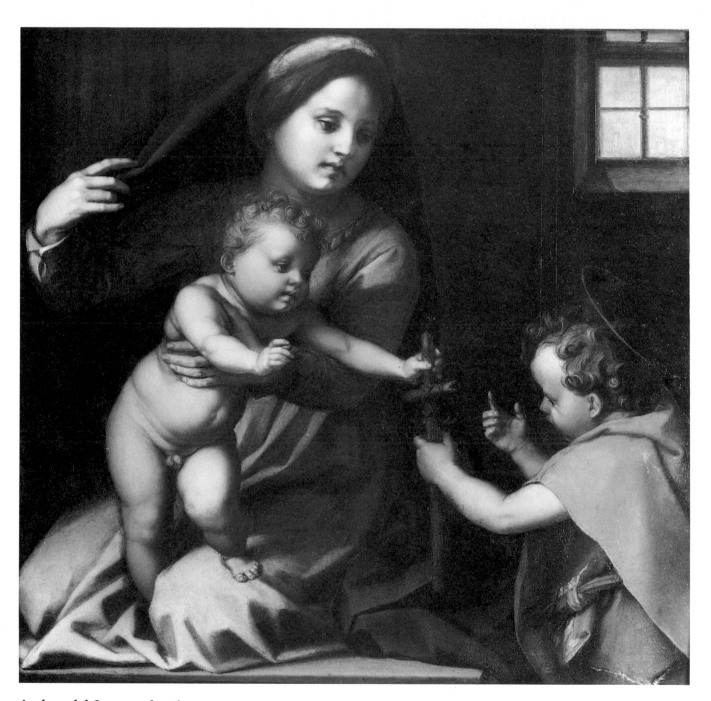

Andrea del Sarto and assistants
Italian, 1486–1530

Madonna and Child with St. John the Baptist, c. 1528

Oil on panel, 23 x 24½ in. (58.4 x 62.2 cm.)
52.9.167

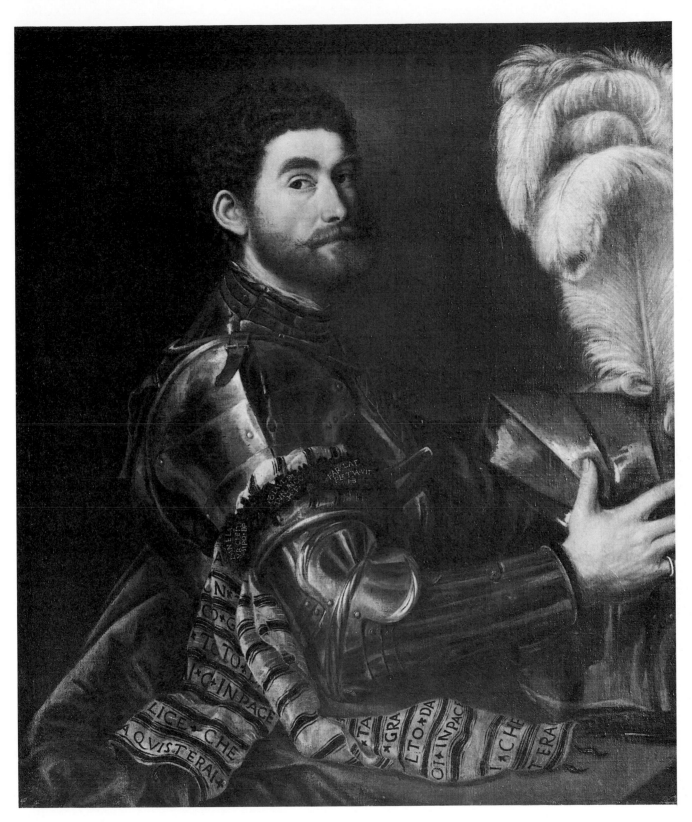

Paris Bordon
Italian, 1500–1571

Portrait of a Knight in Armor, c. 1535–40

Oil on canvas, 36 x 30 in. (91.4 x 76.2 cm.)
52.9.148

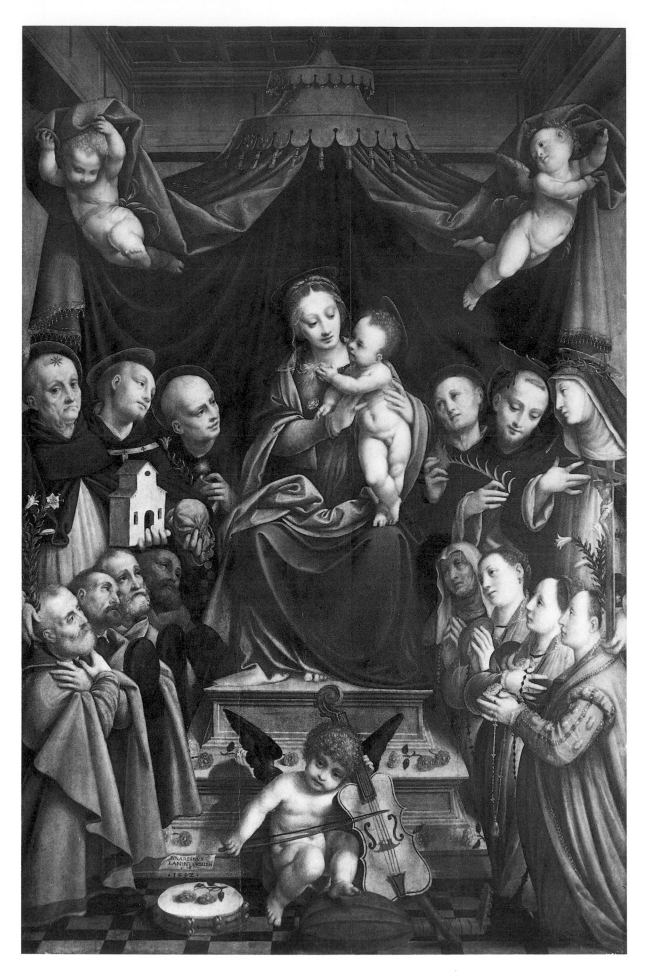

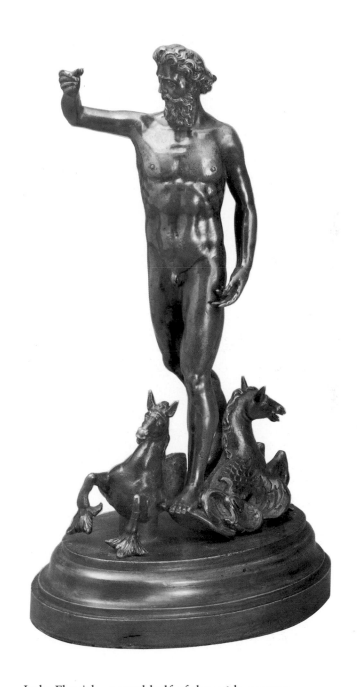

Bernardino Lanino
Italian, active c. 1530–1581/83

Italo-Flemish, second half of the 16th century

Madonna Enthroned with Saints and Donors, 1552

Neptune

Oil on panel, 92⅜ x 60½ in. (234.7 x 153.7 cm.)
Gift of the Samuel H. Kress Foundation, 60.17.45

Bronze, 9½ x 2¾ x 5½ in. (24.1 x 7 x 13.9 cm.)
Gift of Mr. and Mrs. Arthur W. Levy, Jr., 57.11.2

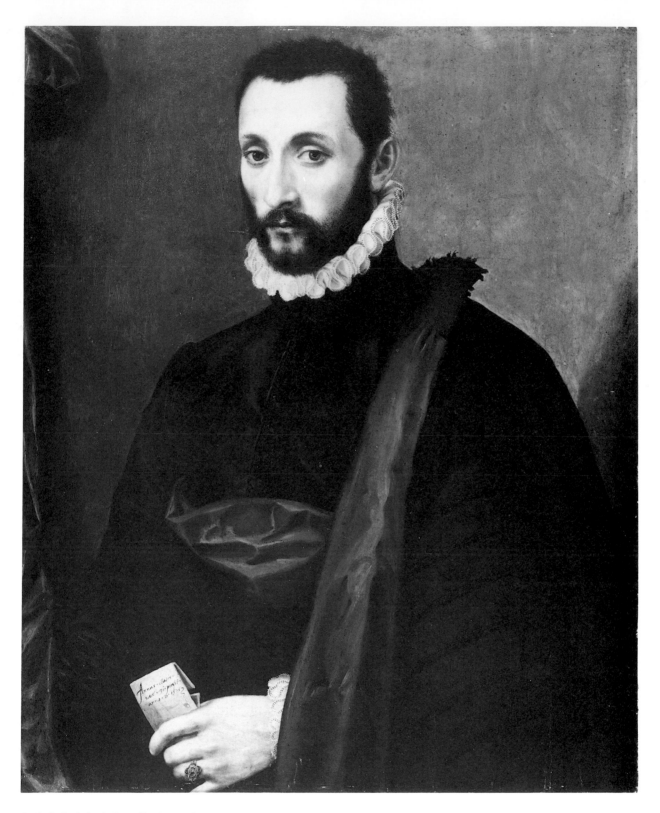

Michele Tosini, called Michele di Ridolfo del Ghirlandaio
Italian, 1503–1577

Portrait of a Gentleman, 1575

Oil on panel, 32½ x 26 in. (82.5 x 66.1 cm.)
Gift of Mr. and Mrs. Arthur Erlanger, 55.10.1

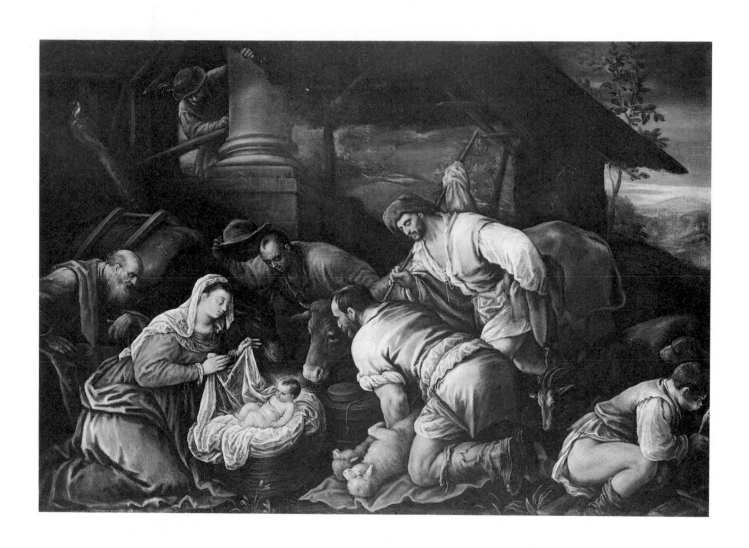

The Bassano Family
Italian, Venetian School, active second half of the 16th century

Adoration of the Shepherds, c. 1575–80

Oil on canvas, 45½ x 65¾ in. (115.5 x 167 cm.)
52.9.144

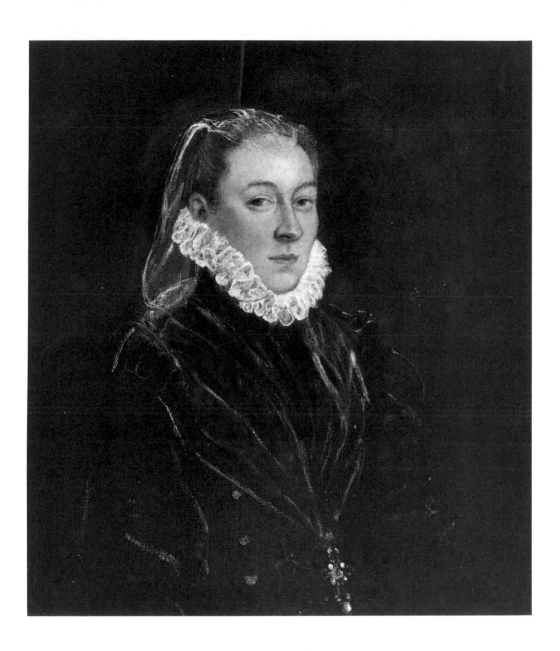

Jacopo Tintoretto attributed to
Italian, 1518–1594

Lodovico Carracci
Italian, 1555–1619

Portrait of a Lady, c. 1580

The Assumption of the Virgin, c. 1586–87

Oil on canvas, 28⅞ x 25½ in. (73.3 x 64.8 cm.)
Gift of the Samuel H. Kress Foundation, 60.17.48

Oil on canvas, 96½ x 53 in. (245 x 134.6 cm.)
Gift of Mrs. J. L. Dorminy
in memory of her husband, 57.21.1

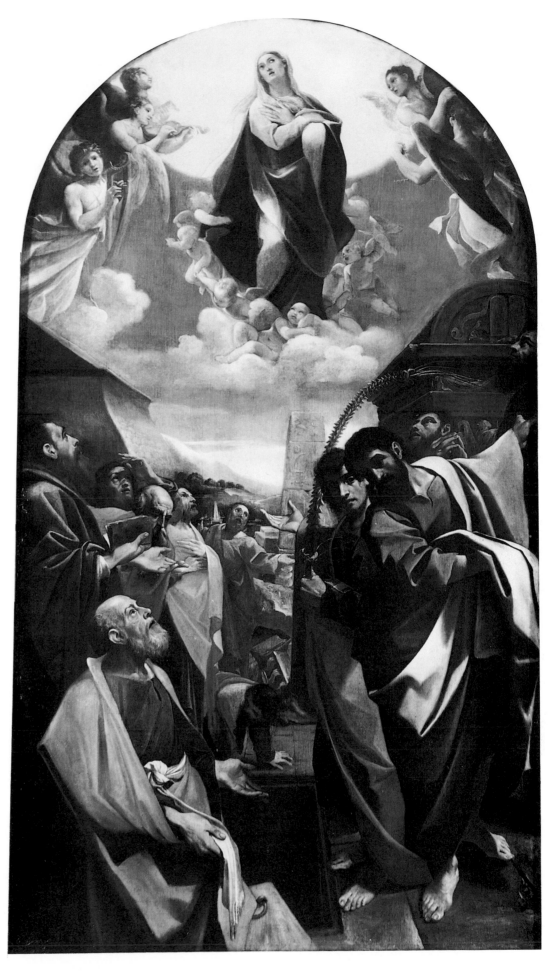

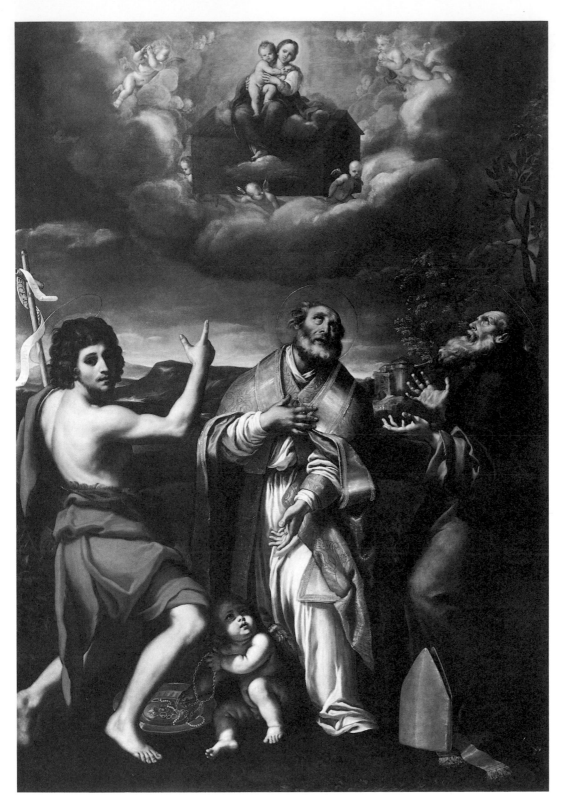

Domenico Zampieri, called Domenichino
Italian, 1581–1641

Massimo Stanzione
Italian, 1585–1656

The Madonna of Loreto Appearing to St. John the Baptist,
St. Paterniano, and St. Anthony Abbot, 1618–19

The Assumption of the Virgin, c. 1634–40

Oil on canvas, 108½ x 74⅝ in. (275.6 x 189.6 cm.)
Gift of the Samuel H. Kress Foundation, 60.17.52

Oil on canvas, 94⅞ x 67⅛ in. (241 x 170.5 cm.)
Gift of the Samuel H. Kress Foundation, 60.17.51

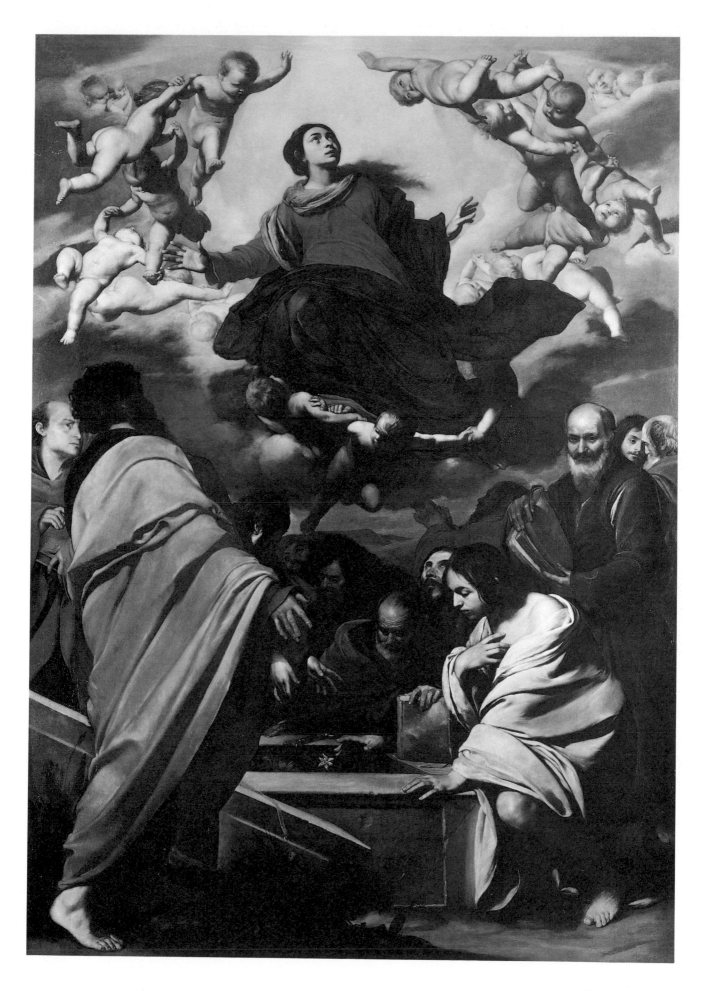

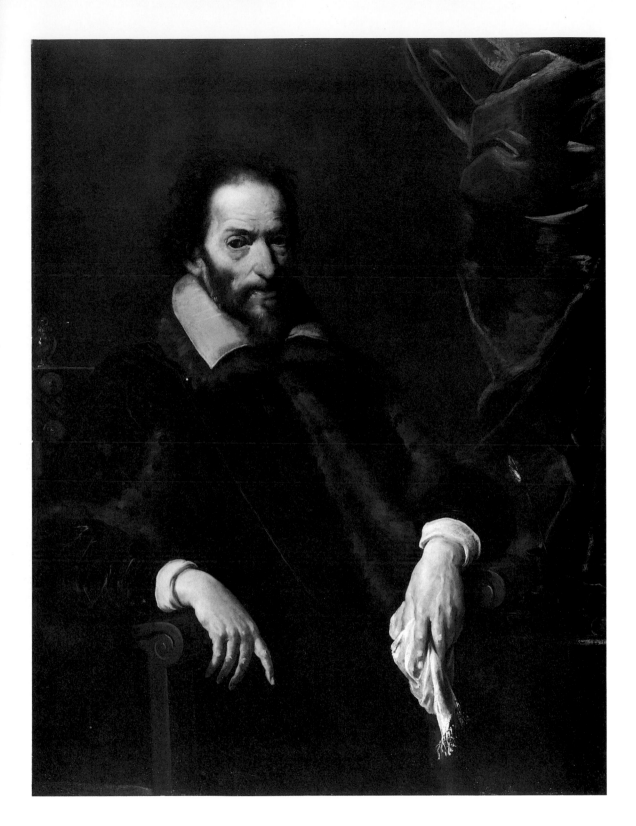

Bernardo Strozzi
Italian, 1581–1644

Portrait of a Gentleman, c. 1629

Oil on canvas, 46½ x 35½ in. (118 x 90.1 cm.)
Gift of R. J. and G. C. Maxwell in honor of their sister Rachel Maxwell Moore, 59.36.1

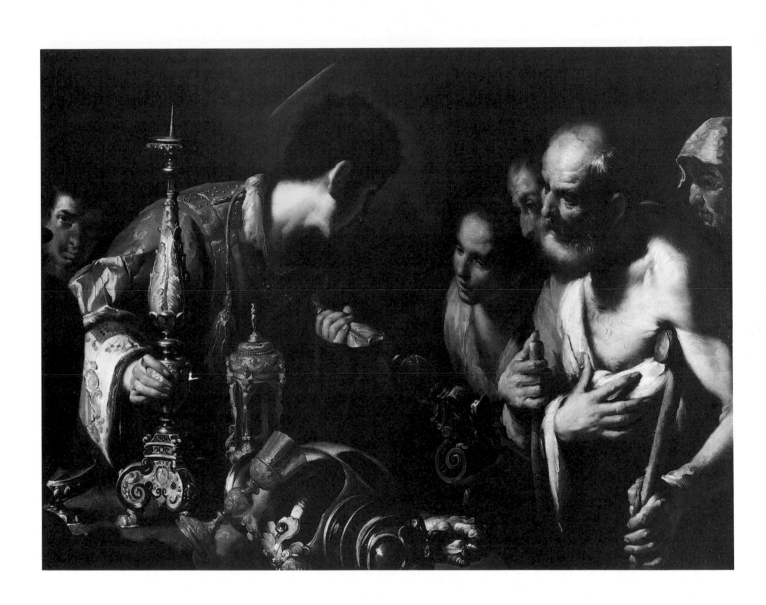

Bernardo Strozzi
Italian, 1581–1644

St. Lawrence Distributing the Goods of the Church, c. 1625

Oil on canvas, 46½ x 62 in. (118 x 157.2 cm.)
52.9.168

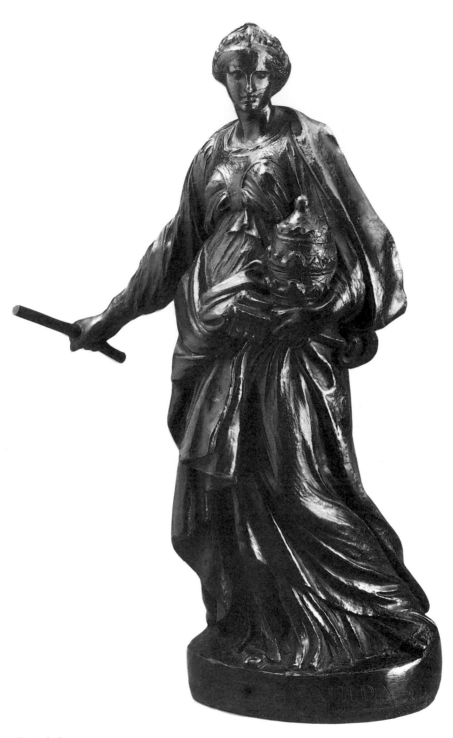

Gianlorenzo Bernini
Italian, 1598–1680

Countess Matilda of Tuscany (1064–1115), c. 1633–37

Bronze, h. 15¾ in. (40 cm.)
58.4.20

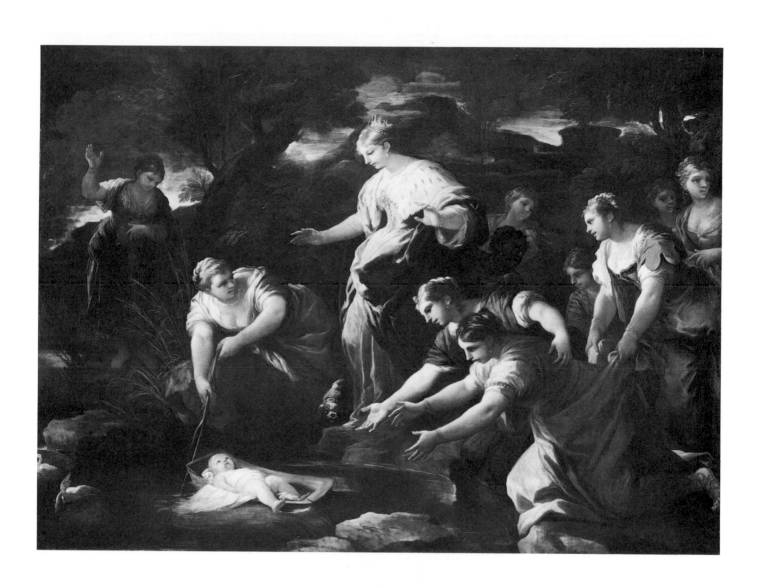

Luca Giordano
Italian, 1634–1705

The Finding of Moses, c. 1680

Oil on canvas, 60⅜ x 82⅜ in. (153.2 x 209.2 cm.)
52.9.158

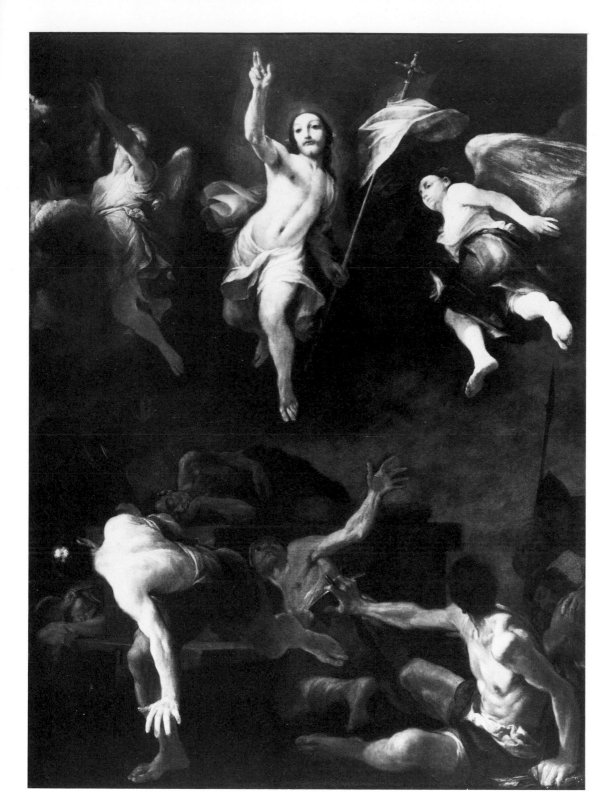

Giuseppe Maria Crespi, called Lo Spagnuolo
Italian, 1667–1747

The Resurrection of Christ, c. 1690

Oil on canvas, 56½ x 40 in. (143.5 x 101.6 cm.)
52.9.153

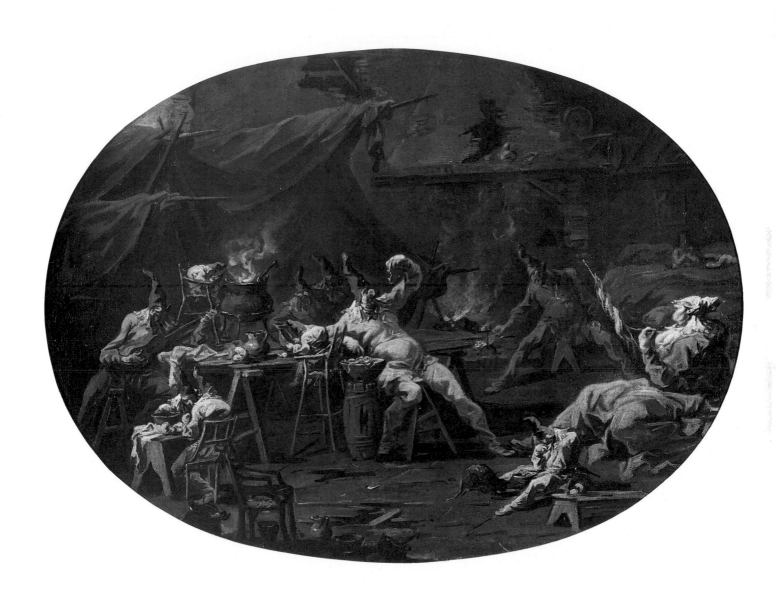

Alessandro Magnasco
Italian, 1667–1749

The Supper of Pulcinella and Colombina, c. 1710–20

Oil on canvas, 30¾ x 41⅜ in. (78.1 x 105.1 cm.)
Gift of the Samuel H. Kress Foundation, 60.17.56

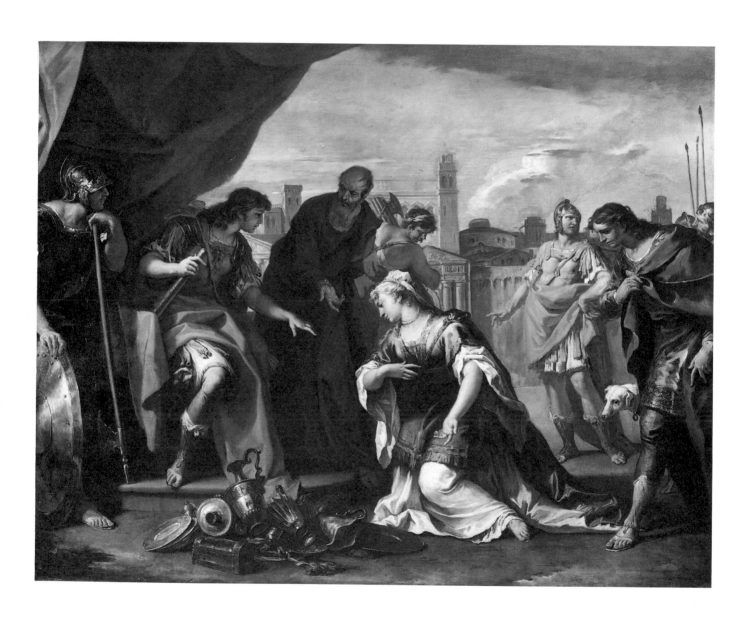

Sebastiano Ricci
Italian, 1659–1734

The Continence of Scipio, c. 1708–10

Oil on canvas, 76 x 96 in. (193 x 243.8 cm.)
52.9.164

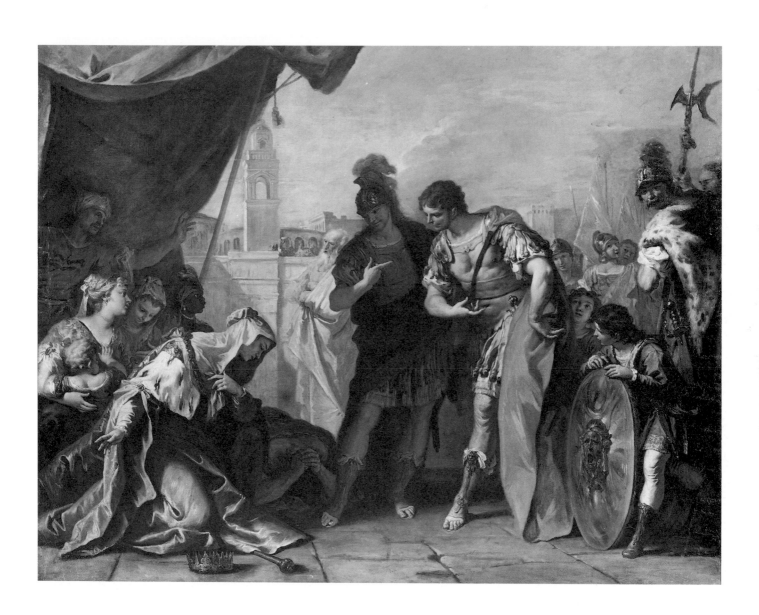

Sebastiano Ricci
Italian, 1659–1734

Alexander and the Family of Darius, c. 1708–10

Oil on canvas, 76 x 96 in. (193 x 243.8 cm.)
52.9.165

Pier Leone Ghezzi
Italian, 1674–1755

The Lateran Convention of 1725, c. 1725 (detail, facing page)

Oil on canvas, 100 x 122 in. (254 x 309.9 cm.)
52.9.157

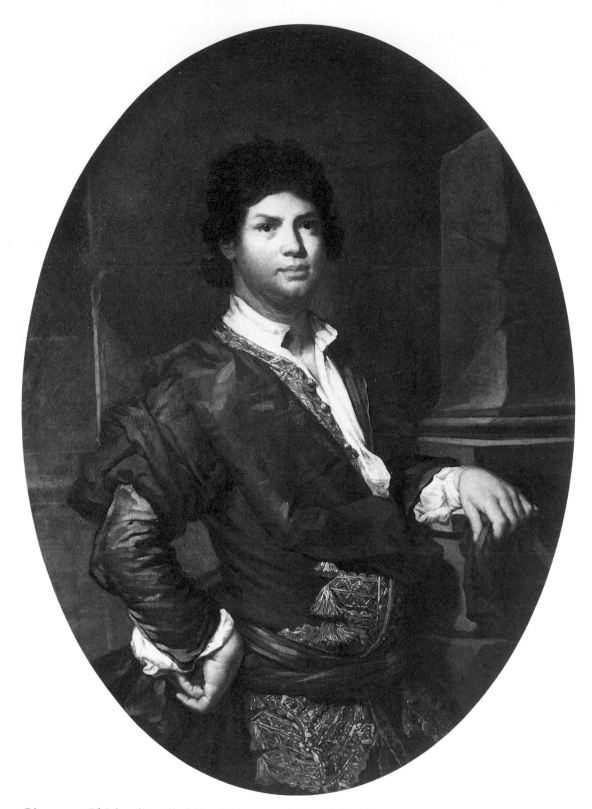

Giuseppe Ghislandi, called Fra Vittore and Fra Galgario
Italian, 1655–1743

Portrait of a Pupil as a Gentleman, c. 1730

Oil on canvas, 55 x 39¾ in. (139.7 x 101 cm.)
Gift of the Samuel H. Kress Foundation, 60.17.53

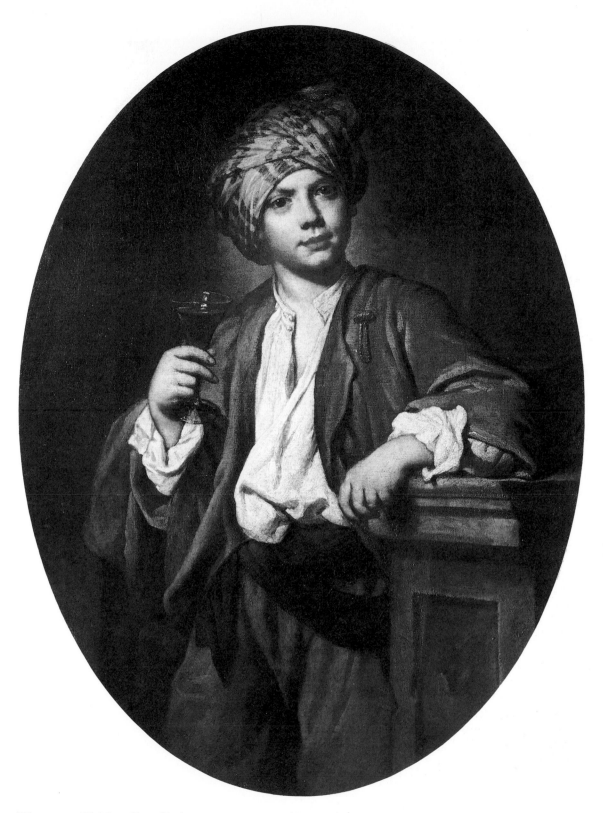

Giuseppe Ghislandi, called Fra Vittore and Fra Galgario
Italian, 1655–1743

Portrait of a Pupil with a Turban, c. 1730

Oil on canvas, 55 x 39¾ in. (139.7 x 101 cm.)
Gift of the Samuel H. Kress Foundation, 60.17.54

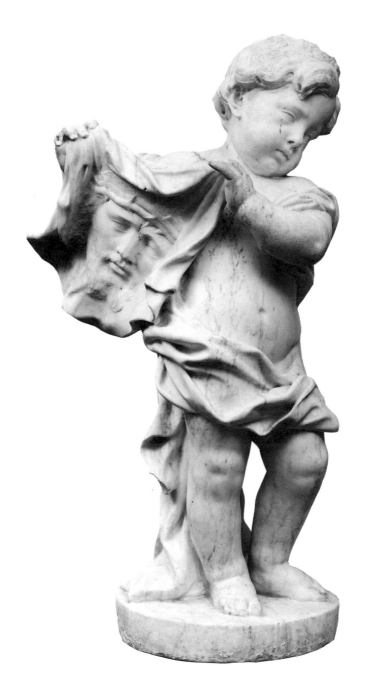

Agostino Cornacchini
Italian, 1685–1740

Angel with the Veil of Veronica, c. 1730–34

Marble, h. 42 in. (107 cm.)
Gift of Mrs. Garland S. Tucker, 57.12.1

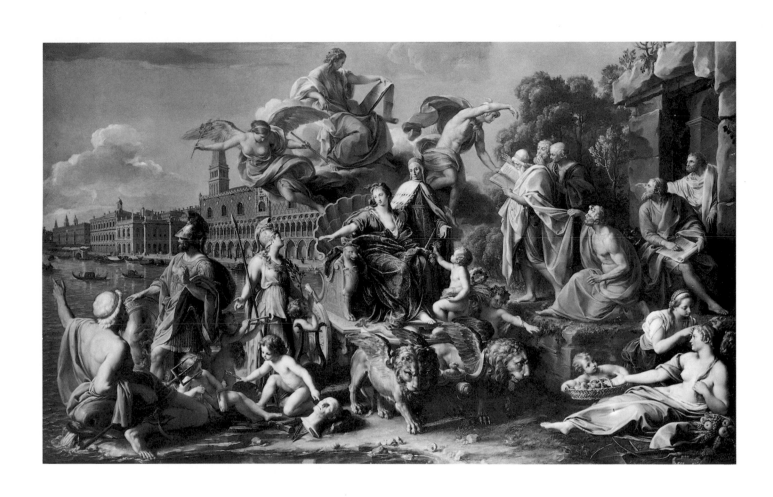

Pompeo Girolamo Batoni
Italian, 1708–1787

The Triumph of Venice, 1737

Oil on canvas, 68⅝ x 112⅝ in. (174.3 x 286.1 cm.)
Gift of the Samuel H. Kress Foundation, 60.17.60

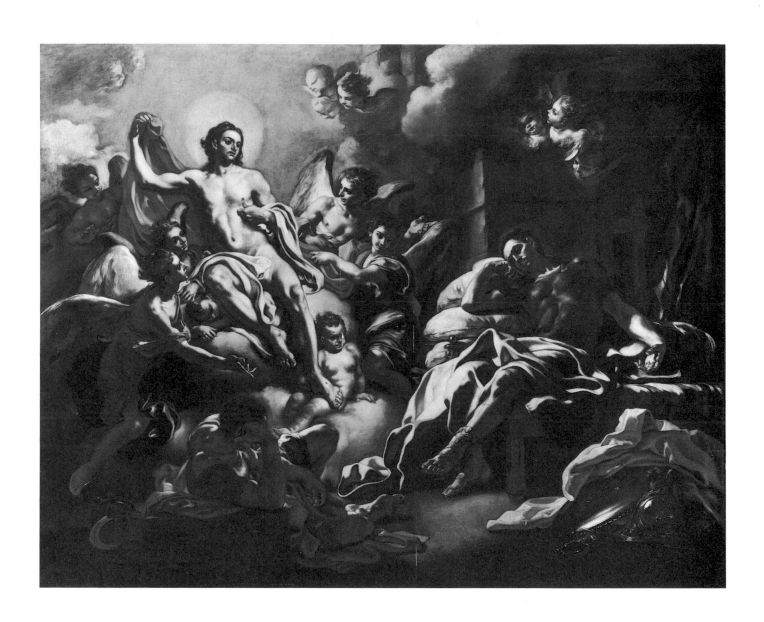

Francesco Solimena
Italian, 1657–1747

Christ Appearing in a Dream to St. Martin, c. 1733

Oil on canvas, 39½ x 49½ in. (100.3 x 125.7 cm.)
Gift of Mrs. Florence G. Montgomery, 59.2.1

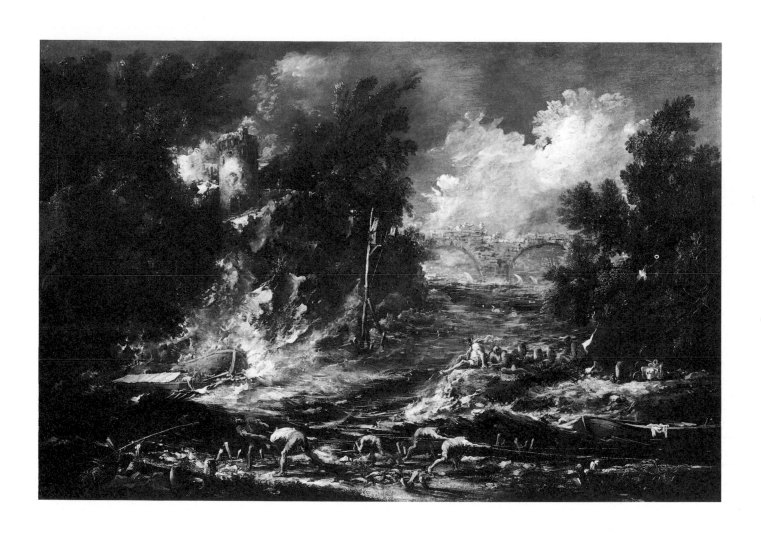

Alessandro Magnasco
Italian, 1667–1749

Bay with Shipwreck, after 1735

Oil on canvas, 45¼ x 68⅛ in. (114.9 x 173 cm.)
Gift of the Samuel H. Kress Foundation, 60.17.57

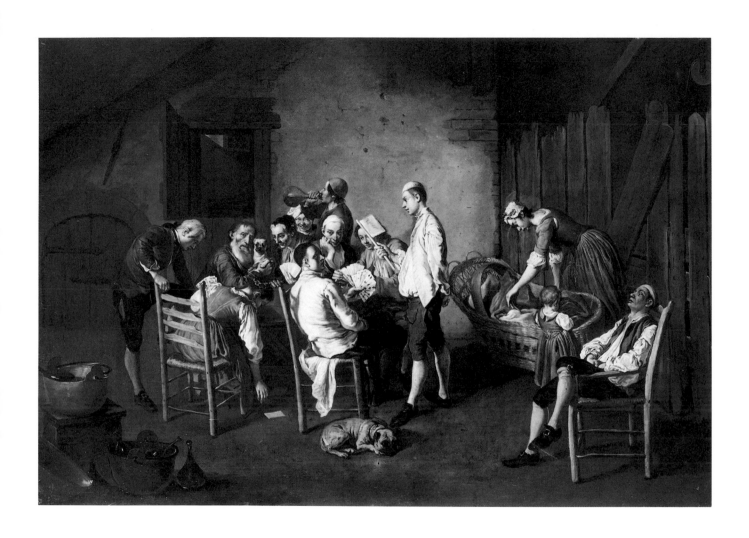

Giacomo Antonio Ceruti
Italian, 1698–1767

The Card Game, c. 1740–50

Oil on canvas, 28½ x 40¾ in. (72.4 x 103.5 cm.)
Gift of the Samuel H. Kress Foundation, 60.17.55

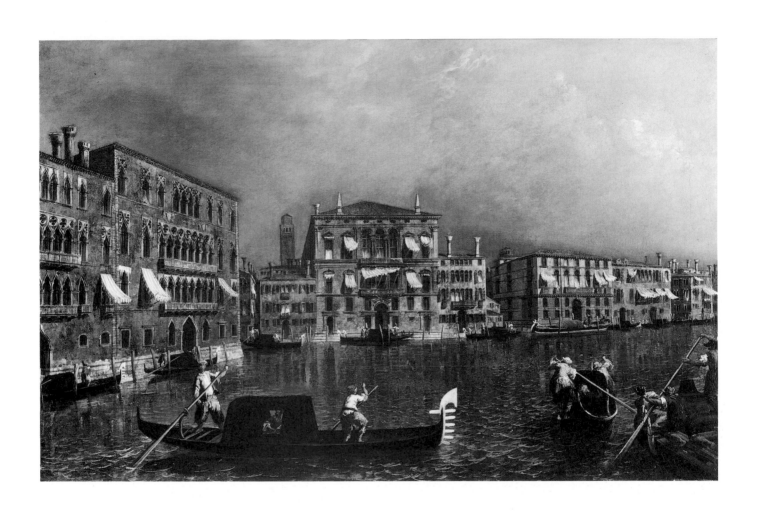

Michele Marieschi
Italian, 1710–1743

The Grand Canal at the Palazzo Foscari, c. 1740–43

Oil on canvas, 24¼ x 37⅞ in. (61.1 x 96.2 cm.)
Gift of the Samuel H. Kress Foundation, 60.17.59

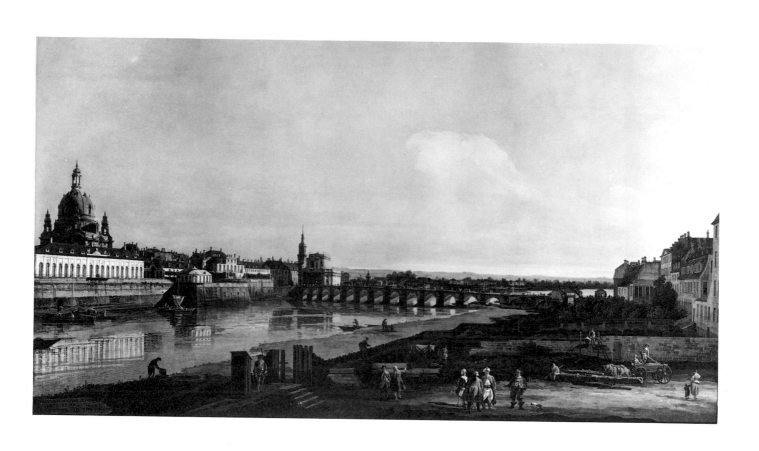

Bernardo Bellotto
Italian, 1720–1780

View of Dresden with the Frauenkirche at Left, 1747

Oil on canvas, 59 x 93 in. (149.9 x 236.2 cm.)
52.9.145

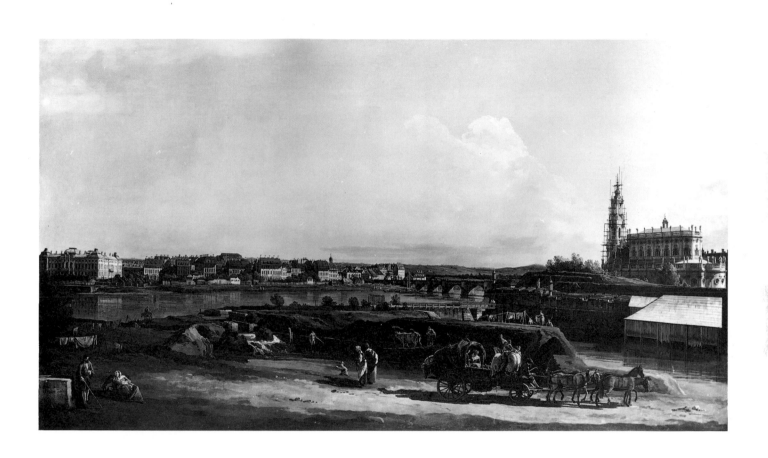

Bernardo Bellotto
Italian, 1720–1780

View of Dresden with the Hofkirche at Right, 1748

Oil on canvas, 59 x 93 in. (149.9 x 236.2 cm.)
52.9.146

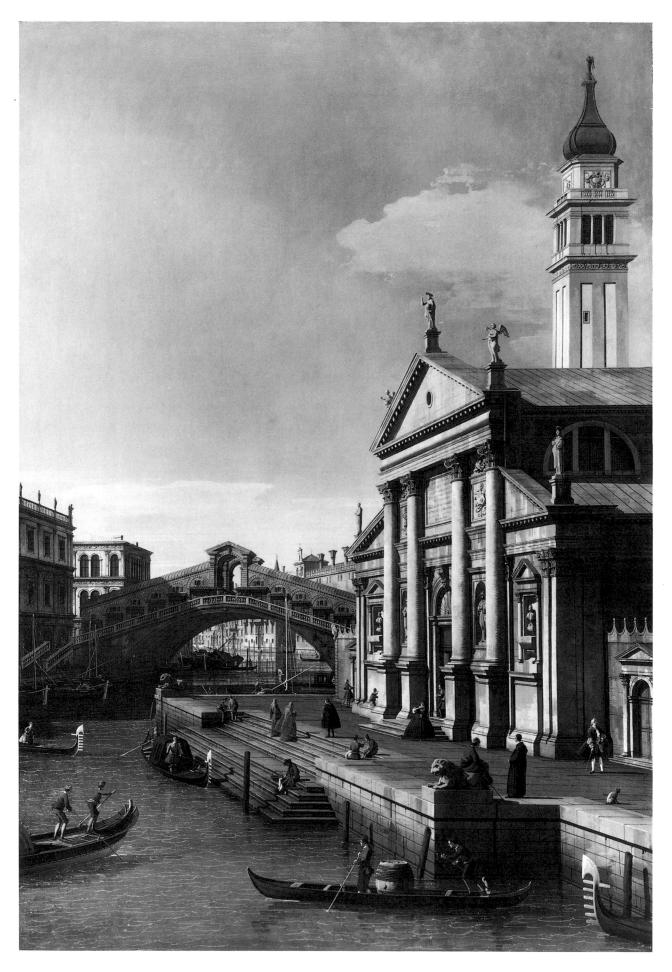

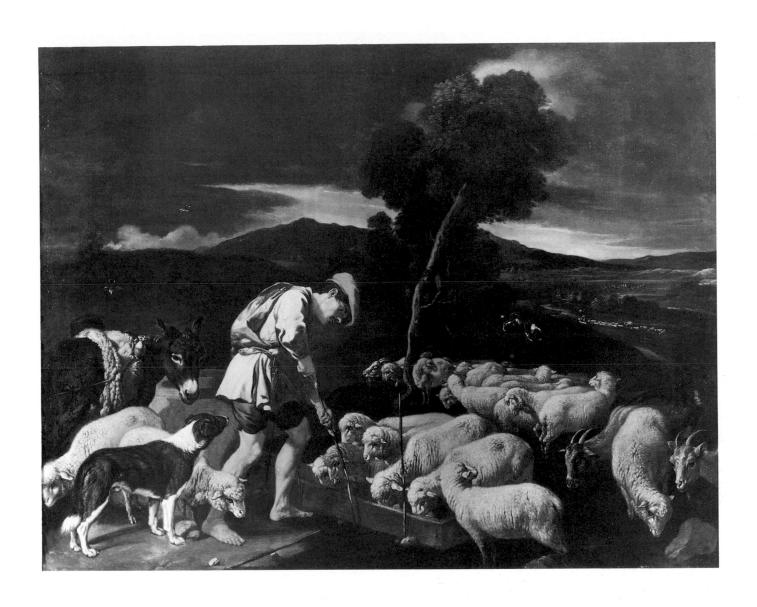

Canaletto (Giovanni Antonio Canale)
Italian, 1697–1768

Pedro Orrente
Spanish, c. 1570–1645

*Capriccio: The Rialto Bridge
and the Church of S. Giorgio Maggiore*, c. 1750

Jacob Conjuring Laban's Sheep

Oil on canvas, 66 x 45 in. (167.6 x 114.3 cm.)
52.9.149

Oil on canvas, 40 x 52⅝ in. (101.5 x 133.5 cm.)
52.9.181

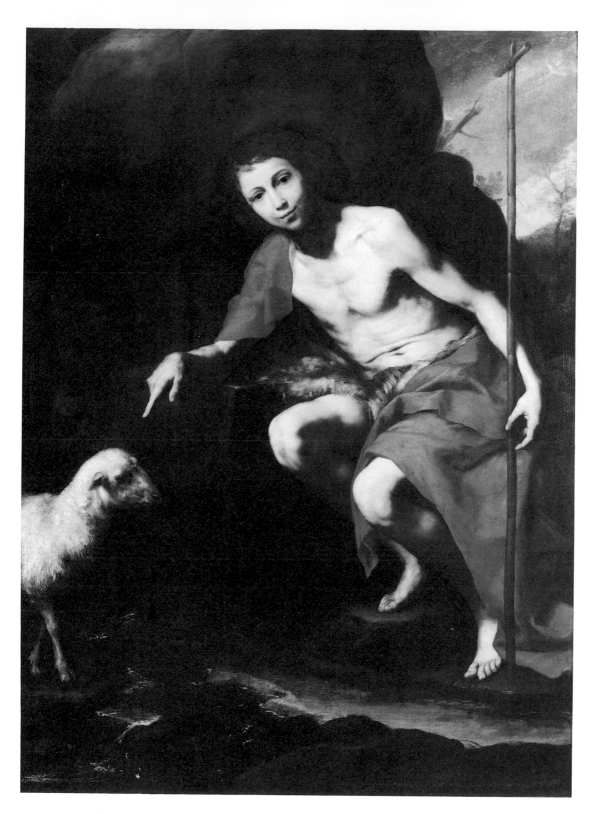

Jusepe de Ribera
Spanish, 1590–1652, active in Naples

St. John the Baptist, c. 1622–24

Oil on canvas, 70¾ x 50⅞ in. (179.7 x 129.2 cm.)
52.9.183

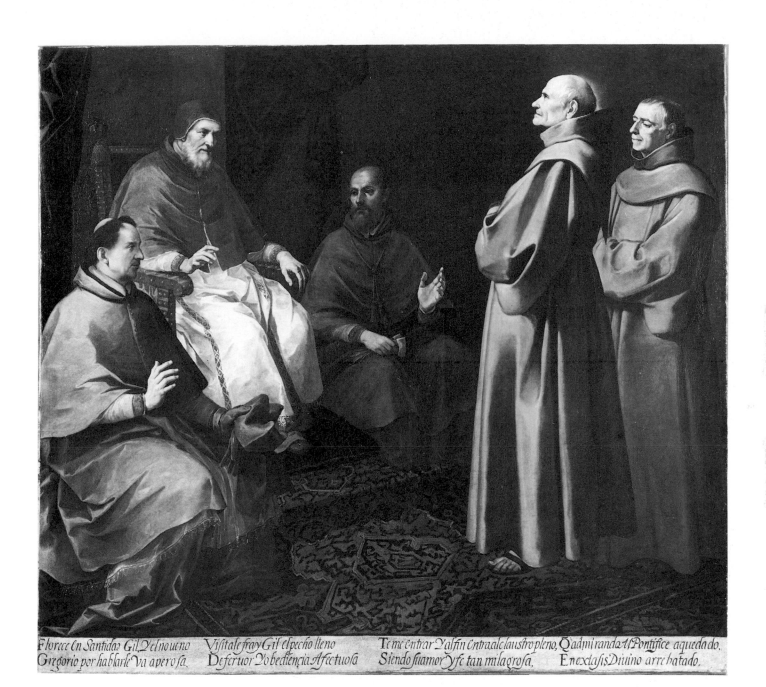

Florece en Santidad Gil, y el no ueno Visitale fray Gil el pecho lleno Te me entrar y alfin entra al claustro pleno, Q admirando u Pontifice aquedado,
Gregorio por hablarle Va aperosa. De feruor Yo bediencia Afectuosa Siendo suamor Yse tan milagrosa, En exctasis Diuino arre hatado.

Bartolomé Esteban Murillo
Spanish, 1617–1682

The Blessed Giles before Pope Gregory IX, 1645–46

Oil on canvas, 65½ x 73⅜ in. (166.3 x 186.4 cm.)
52.9.178

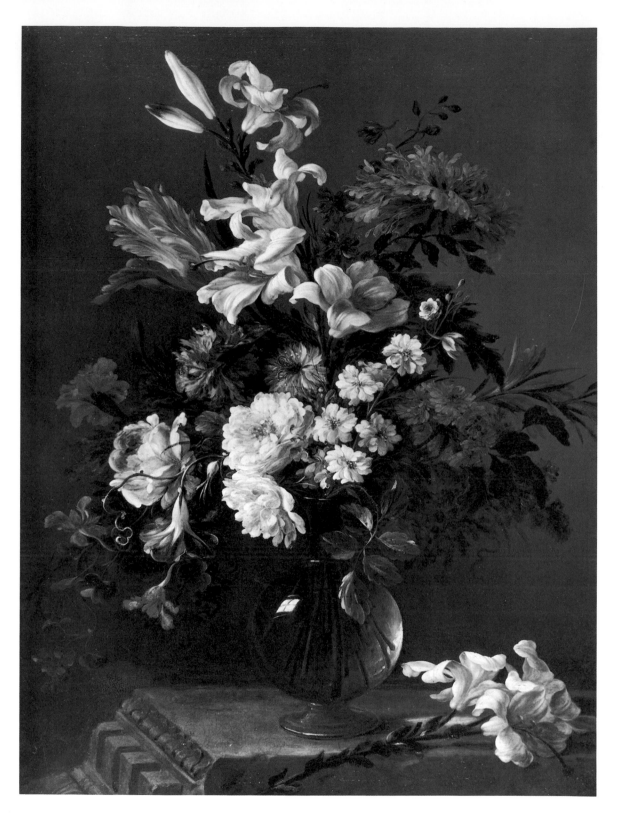

Bartolomé Pérez
Spanish, 1634–1693

A Vase of Flowers on a Pedestal, late 1660s

Oil on canvas, 25½ x 18½ in. (64.7 x 46.9 cm.)
Purchased with funds from the North Carolina Art Society (Robert F. Phifer Funds), 52.9.227

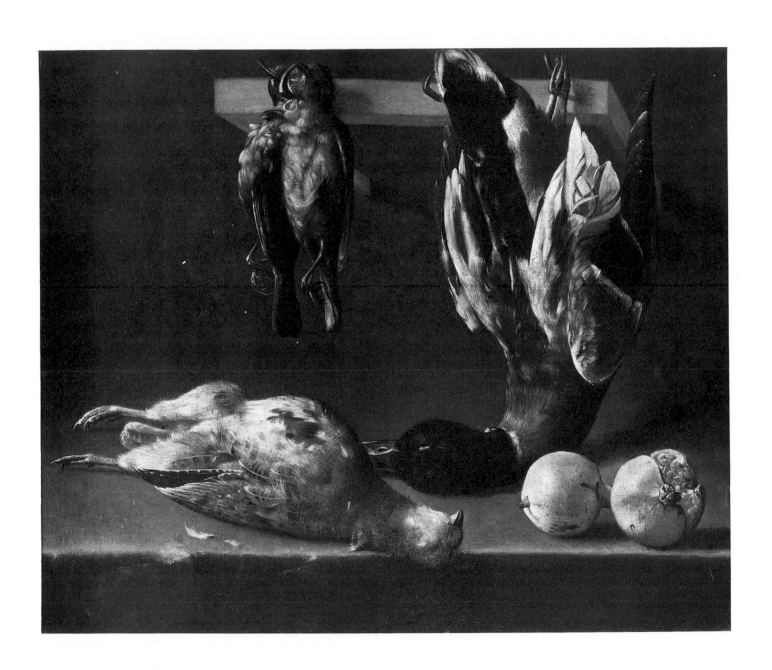

Alejandro de Loarte
Spanish, died 1626

Still Life with Dead Fowl

Oil on canvas, 18¹⁵/₁₆ x 23 in. (48 x 58.4 cm.)
64.6.1

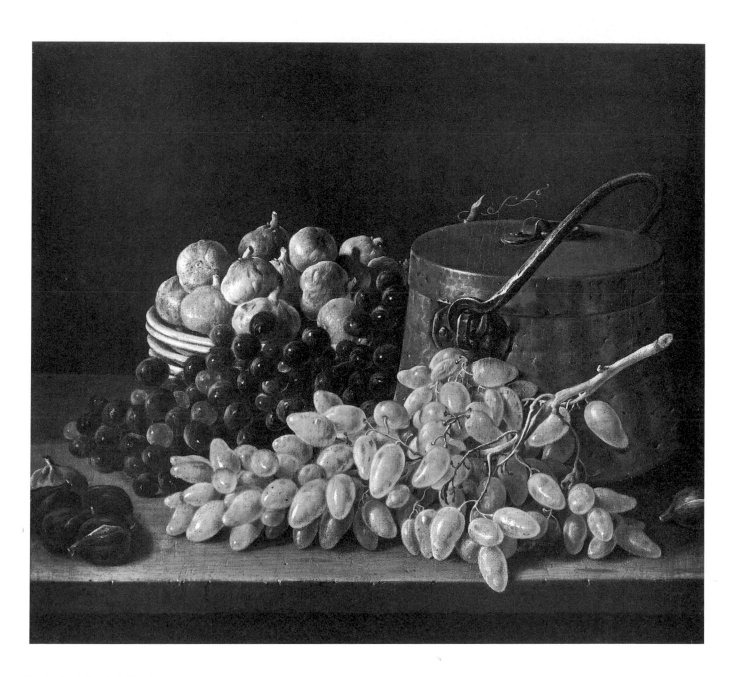

Luis Egidio Meléndez
Spanish, 1716–1780

Still Life with Grapes and Figs, c. 1765–75

Oil on canvas, 18⅝ x 21⅜ in. (47.2 x 54.3 cm.)
Original State Appropriation and funds from the North Carolina Art Society
(Robert F. Phifer Funds), 52.9.176

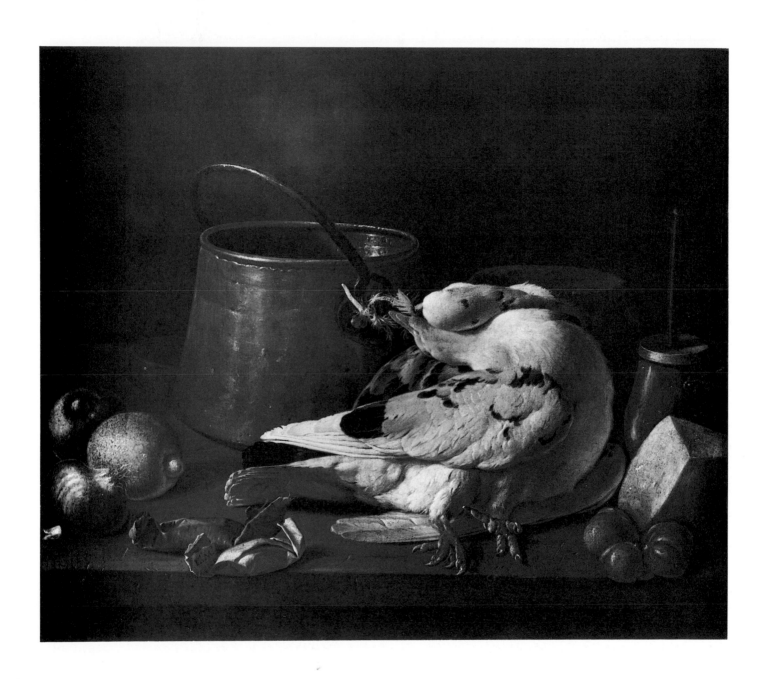

Luis Egidio Meléndez
Spanish, 1716–1780

Still Life with Pigeons, c. 1765–75

Oil on canvas, 18½ x 21¼ in. (47 x 54 cm.)
Original State Appropriation and funds from the North Carolina Art Society
(Robert F. Phifer Funds), 52.9.177

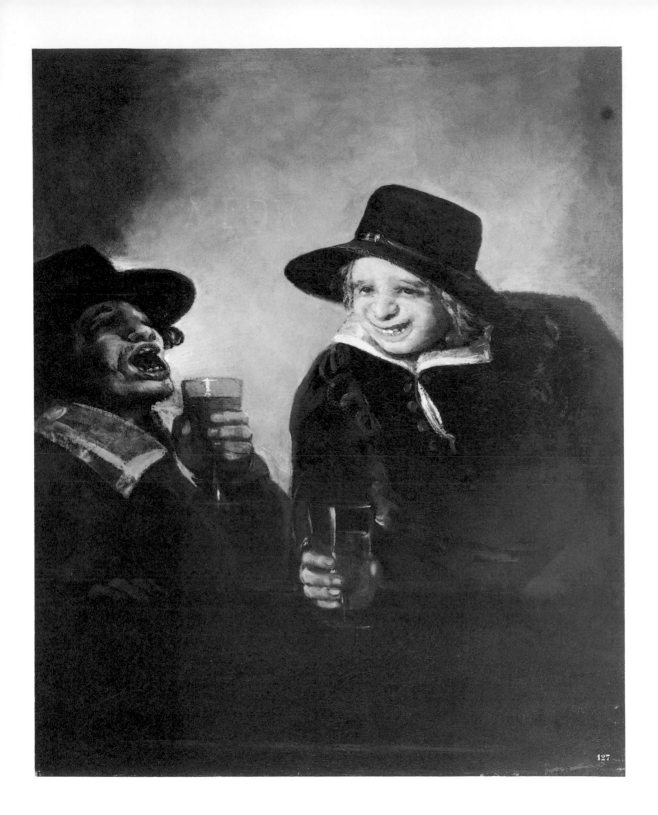

Goya y Lucientes, Francisco José de
Spanish, 1746–1828

The Topers, 1805–12

Oil on canvas, 39⁷/₈ x 31⁷/₁₆ in. (101.3 x 79.7 cm.)
Gift of the Mary Reynolds Babcock Foundation, 56.13.1

American Art

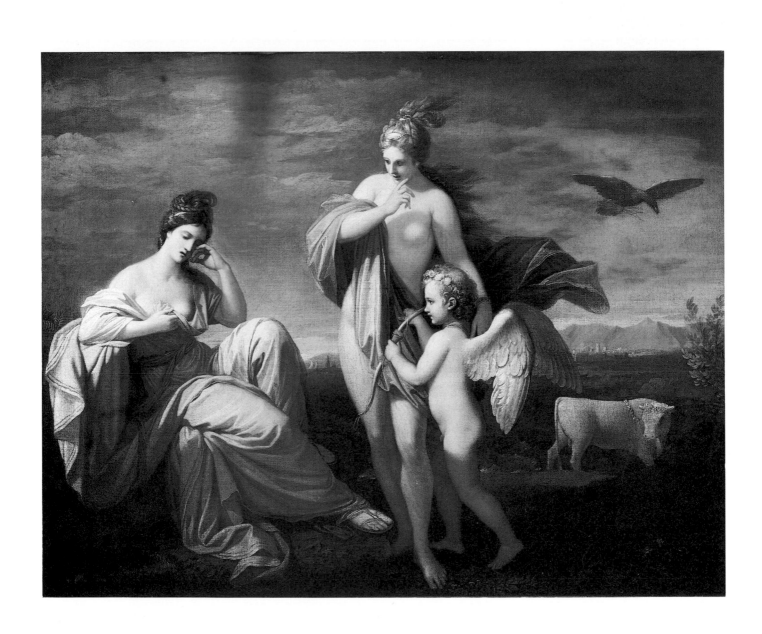

Benjamin West
American, 1738–1820

Venus and Europa, 1770

Oil on canvas, 28¼ x 36¼ (71.7 x 92.1 cm.)
Gift of the late Mr. L. Y. Ballentine and Mrs. Ballentine, 60.13.1

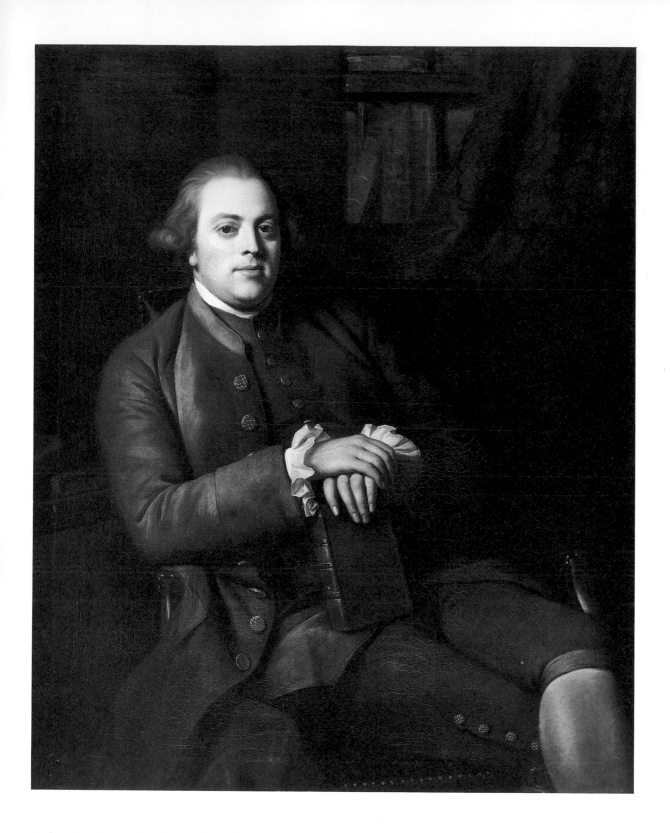

John Singleton Copley attributed to
American, 1738–1815

Portrait of a Man, c. 1770

Oil on canvas, 50 x 40⅛ in. (127 x 101.9 cm.)
Gift of Mr. and Mrs. R. Philip Hanes, Jr., in honor of Richard Thurmond Chatham, 63.14.1

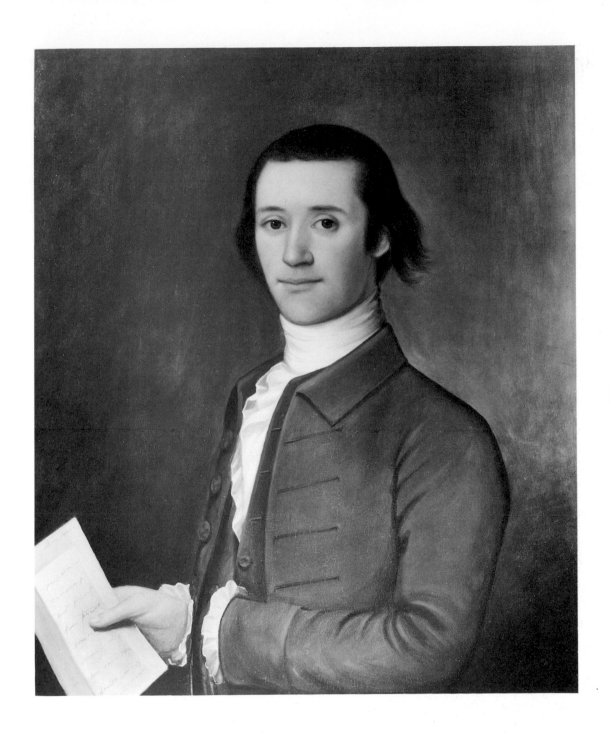

Adolf Ulrich Wertmuller
American, born Sweden, 1751–1811

Samuel Donaldson, c. 1795

Oil on panel, 30 x 24¾ in. (76.2 x 62.9 cm.)
52.9.196

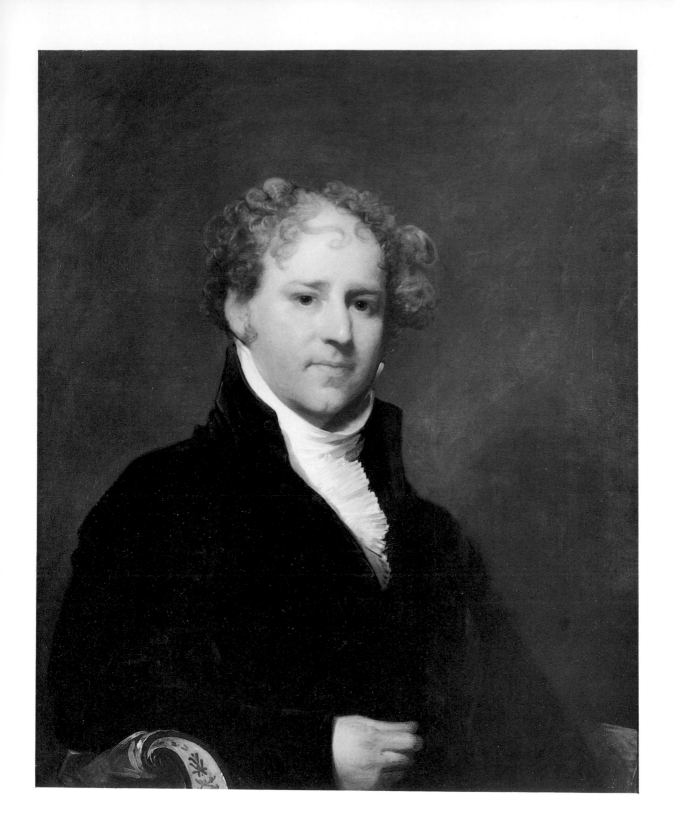

Gilbert Stuart
American, 1755–1828

Mr. Charles Davis (1777–1821), 1808

Oil on panel, 32¾ x 26⅜ in. (83.2 x 66.9 cm.)
52.9.31

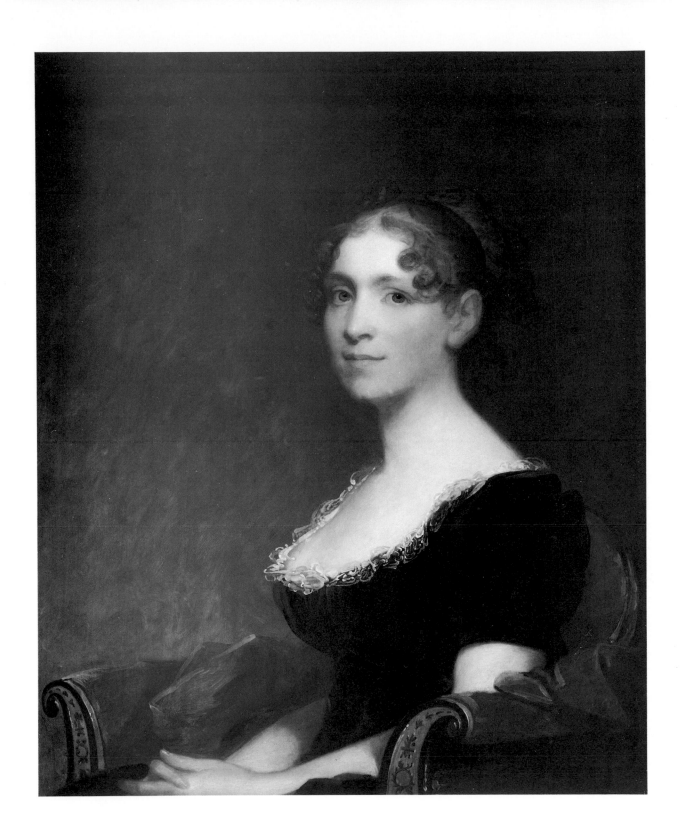

Gilbert Stuart
American, 1755–1828

Mrs. Charles Davis (1783–1841), 1808

Oil on panel, 32¾ x 26⁹⁄₁₆ in. (83.2 x 67.4 cm.)
52.9.32

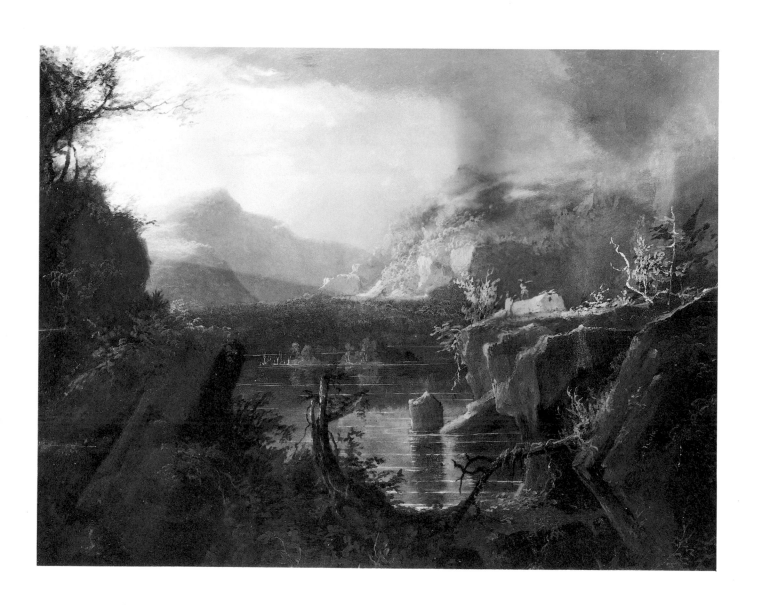

Thomas Cole
American, born England, 1801–1848

Romantic Landscape, 1826

Oil on panel, 16¹/₁₆ x 21¹⁵/₁₆ in. (40.7 x 55.8 cm.)
52.9.7

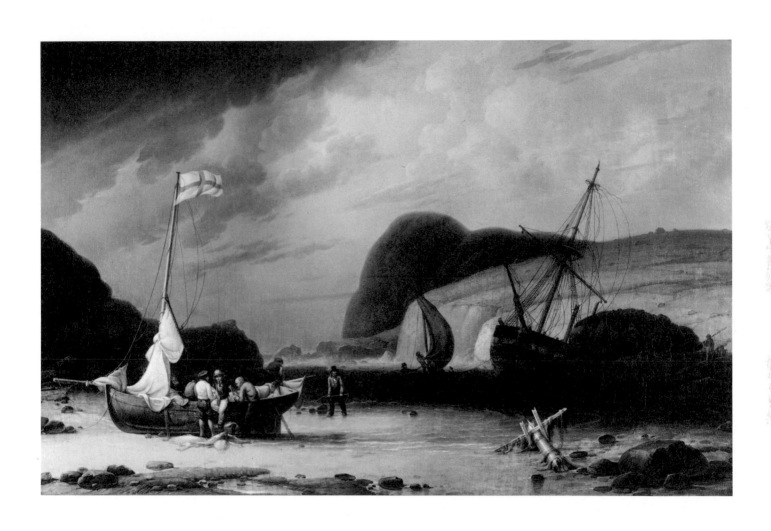

Robert Salmon
British, 1775–mid 1840s, active in United States 1828–1840

Great Ormes Head, near Liverpool, 1836

Oil on canvas, 50¾ x 77½ in. (128.9 x 196.8 cm.)
76.1.9

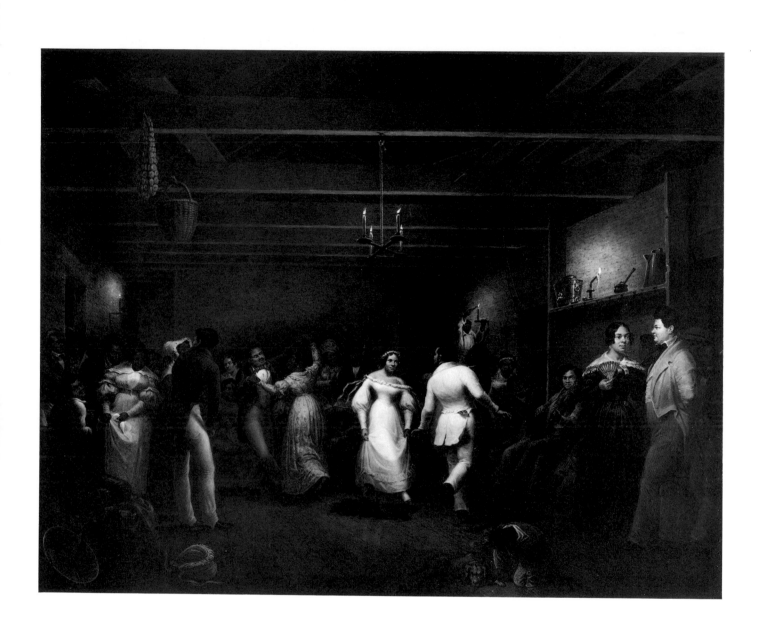

Christian Mayr
American, born Germany, c. 1805–1850

Kitchen Ball at White Sulphur Springs, 1838

Oil on canvas, 24 x 29½ in. (61 x 75 cm.)
52.9.23

Rembrandt Peale
American, 1778–1860

George Washington (1732–1799), after 1823

Oil on canvas, 35⅞ x 29 in. (91.2 x 73.7 cm.)
Gift of Mrs. Charles Lee Smith, Sr., William Oliver Smith, Charles Lee Smith, Jr.,
and Mrs. Joseph H. Hardison in memory of Dr. Charles Lee Smith, 56.4.1

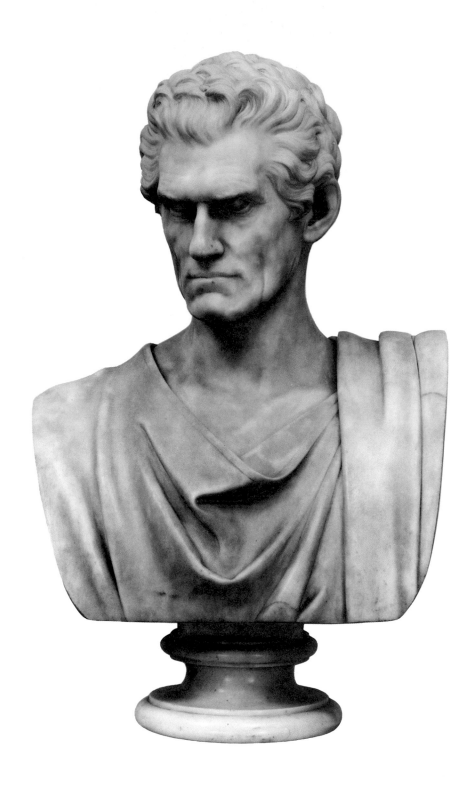

Hiram Powers
American, 1805–1873

John C. Calhoun (1782–1850), after 1848

Marble, 29½ in. (75.1 cm.)
Gift of the North Carolina Museum of History, 56.3.1

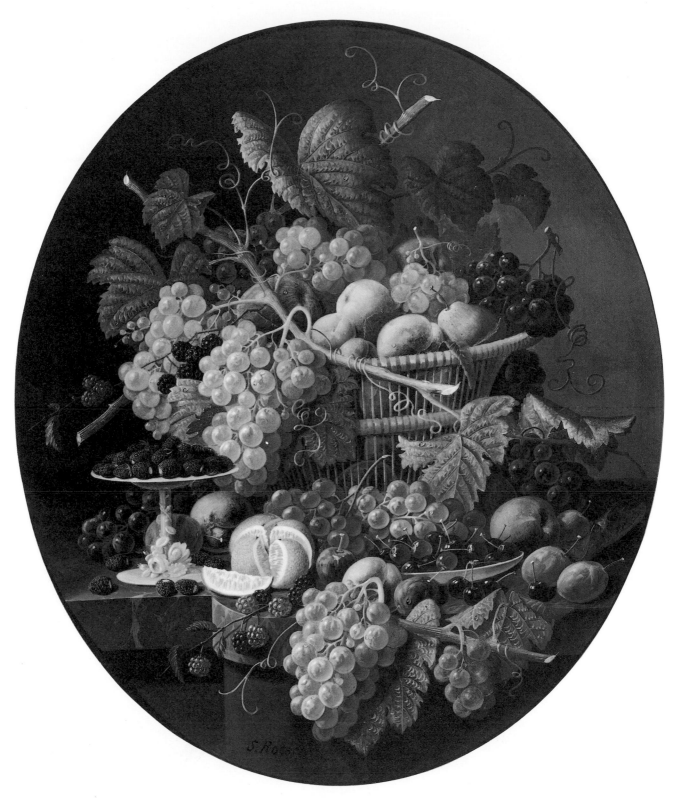

Severin Roesen
American, born Germany, c. 1815–c. 1872

Still Life with Fruit, after 1848

Oil on canvas, 30¼ x 25 in. (76.7 x 63.5 cm.)
Purchased with funds from the North Carolina Art Society (Robert F. Phifer Funds)
in honor of Mrs. Charles Lee Smith, Jr., and the late Mr. Charles Lee Smith, Jr., 77.8.1

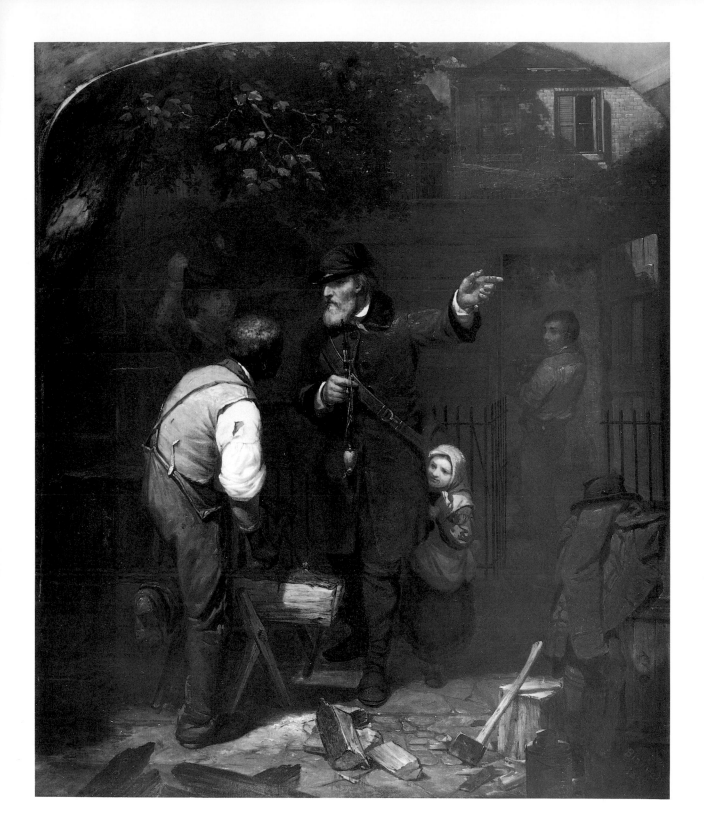

Charles Blauvelt
American, 1824–1900

A German Immigrant Inquiring His Way, 1855

Oil on canvas, 36⅛ x 29 in. (91.7 x 73.8 cm.)
52.9.2

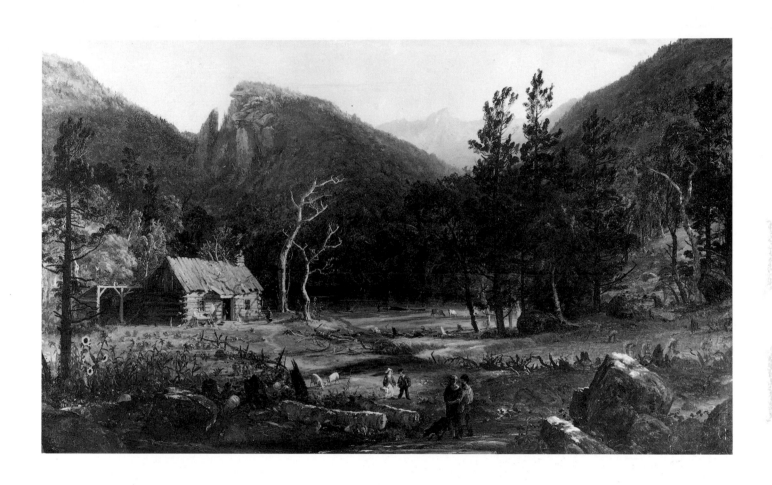

Jasper Francis Cropsey
American, 1823–1900

Eagle Cliff, Franconia Notch, New Hampshire, 1858

Oil on canvas, mounted on panel, 23¹⁵/₁₆ x 38⁷/₈ in. (60.8 x 98.8 cm.)
52.9.9

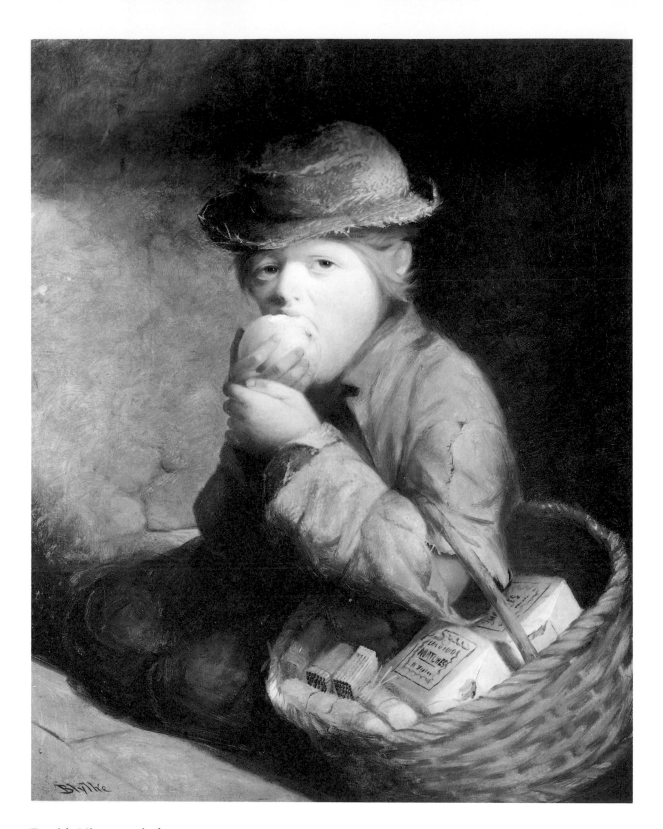

David Gilmour Blythe
American, 1815–1865

A Match Seller, c. 1859

Oil on canvas, 26¾ x 21⅞ in. (67.9 x 55.5 cm.)
52.9.3

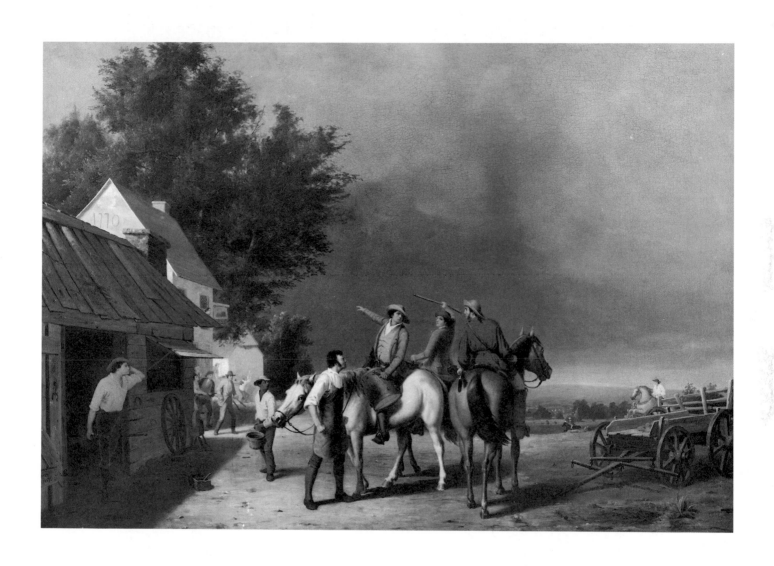

William Ranney
American, 1813–1857

First News of the Battle of Lexington, 1847

Oil on canvas, 44¹/₁₆ x 63⁵/₁₆ in. (111.9 x 160.8 cm.)
52.9.25

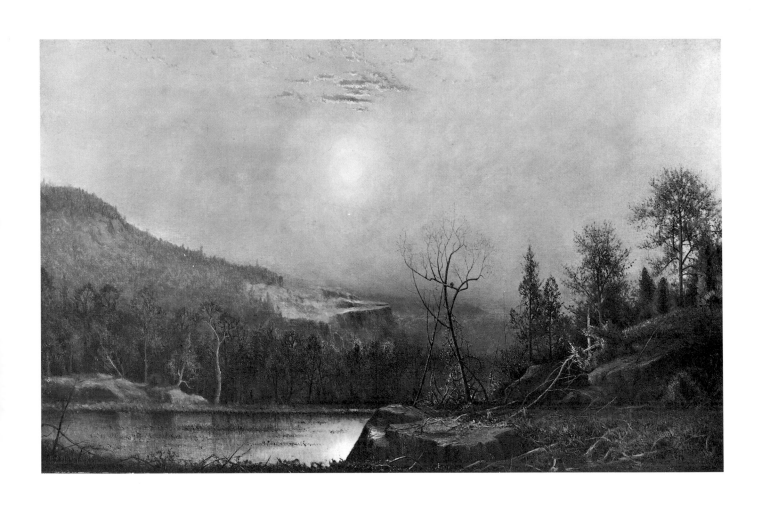

Ralph Blakelock
American, 1847–1919

Sunrise, 1868

Oil on canvas, 19¾ x 32¼ in. (50.2 x 81.9 cm.)
52.9.1

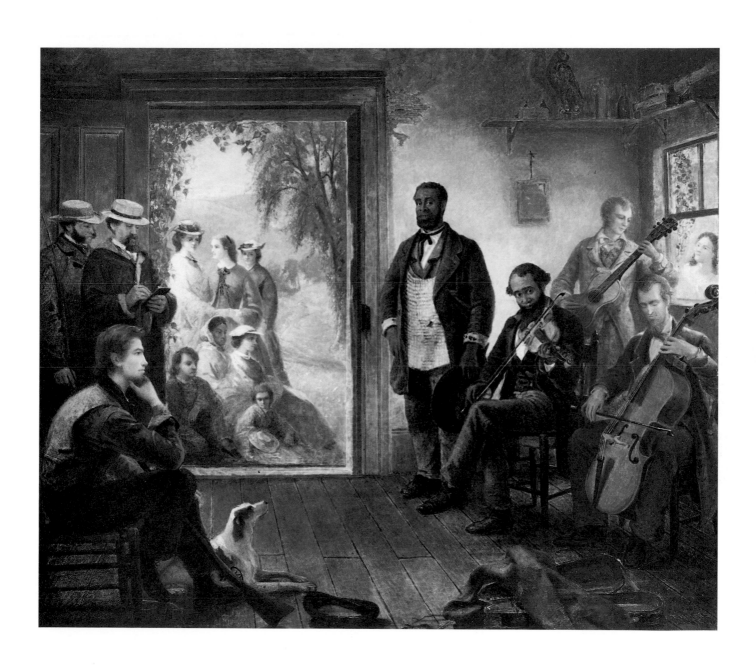

Thomas Hicks
American, 1823–1890

The Musicale, Barber Shop, Trenton Falls, New York, 1866

Oil on canvas, 25 x 30⅛ in. (63.5 x 76.3 cm.)
52.9.15

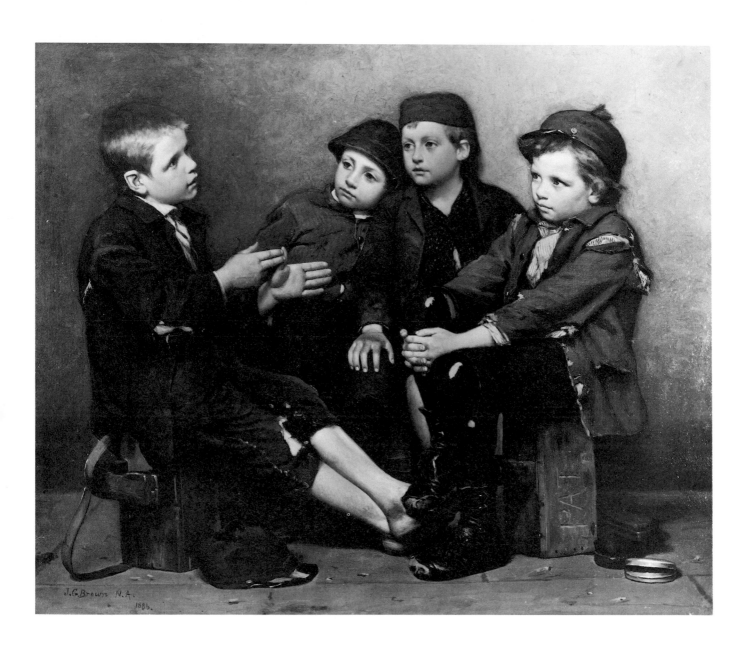

John G. Brown
American, born England, 1831–1913

Frank Duveneck
American, 1848–1919

A Tough Story, 1886

Oil on canvas, 25 x 30⅛ in. (63.5 x 76.3 cm.)
52.9.5

Mrs. Mary E. Goddard ("The Crimson Gown"), c. 1878–79

Oil on canvas, 58⁹/₁₆ x 31⁷/₁₆ in. (148.7 x 92.5 cm.)
52.9.11

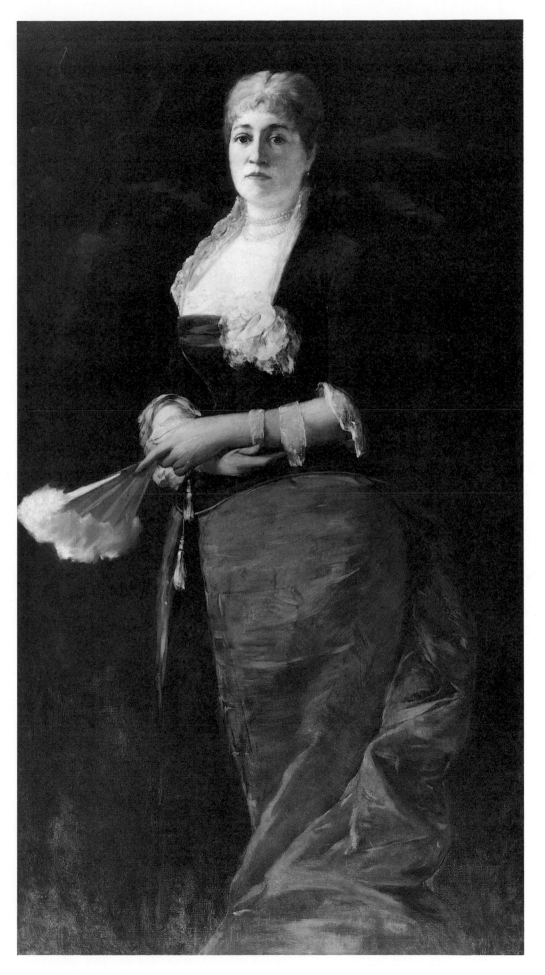

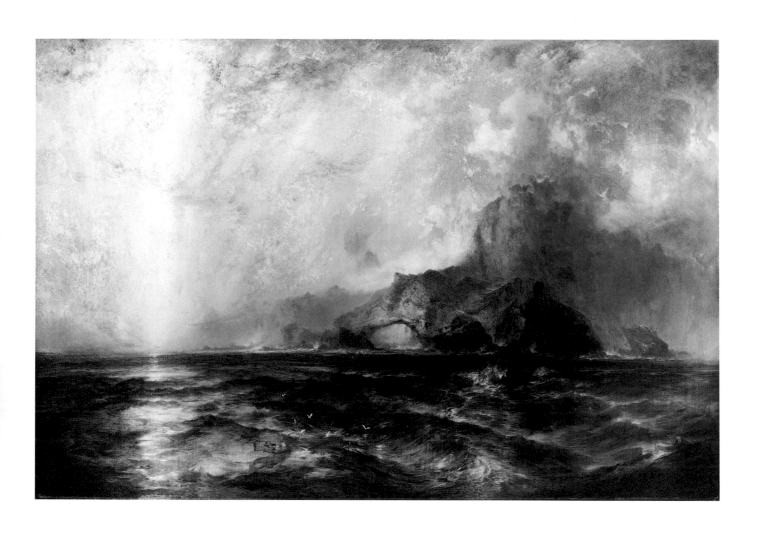

Thomas Moran
American, 1837–1926

"Fiercely the red sun descending / Burned his way across the heavens," c. 1875

Oil on canvas, 33³/₈ x 50¹/₁₆ in. (84.8 x 127.1 cm.)
Purchased with funds from the North Carolina Art Society (Robert F. Phifer Funds), 52.9.34

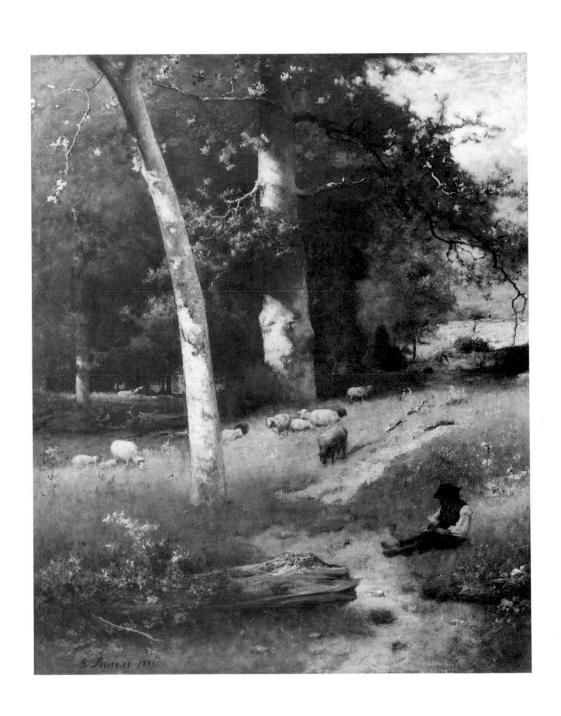

George Inness
American, 1825–1894

Under the Greenwood, 1881

Oil on canvas, 36⅛ x 29⅛ in. (91.7 x 74 cm.)
52.9.17

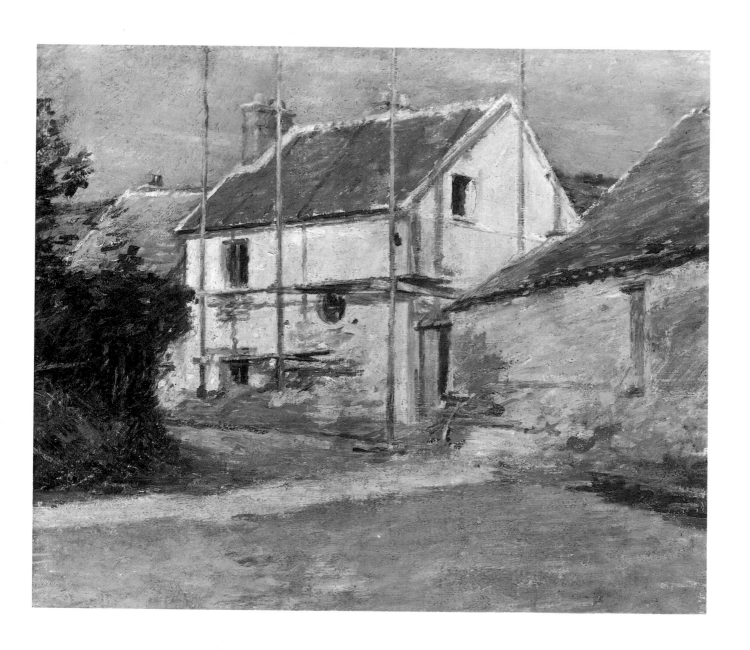

Theodore Robinson
American, 1852–1896

Sketch at Bercy, c. 1890

Oil on canvas, 18³/₁₆ x 22³/₁₆ in. (46.2 x 56.4 cm.)
Gift of Mrs. Jacques Busbee, 52.7.1

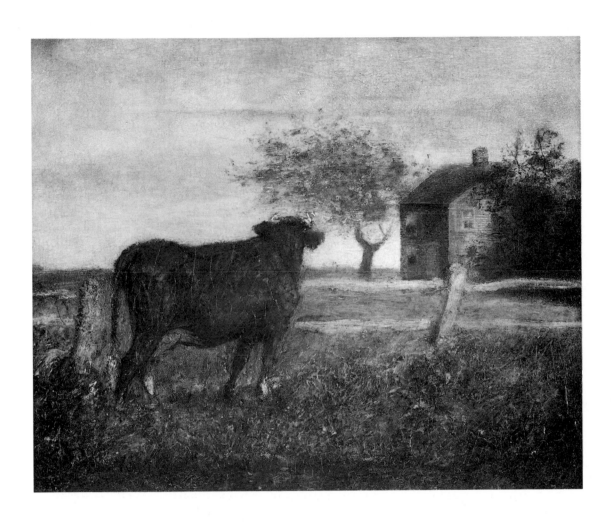

Albert Pinkham Ryder
American, 1847–1917

The Pasture, early 1880s

Oil on canvas, 12⅛ x 15¼ in. (30.8 x 38.7 cm.)
Purchased with funds from the North Carolina Art Society (Robert F. Phifer Funds), 52.9.26

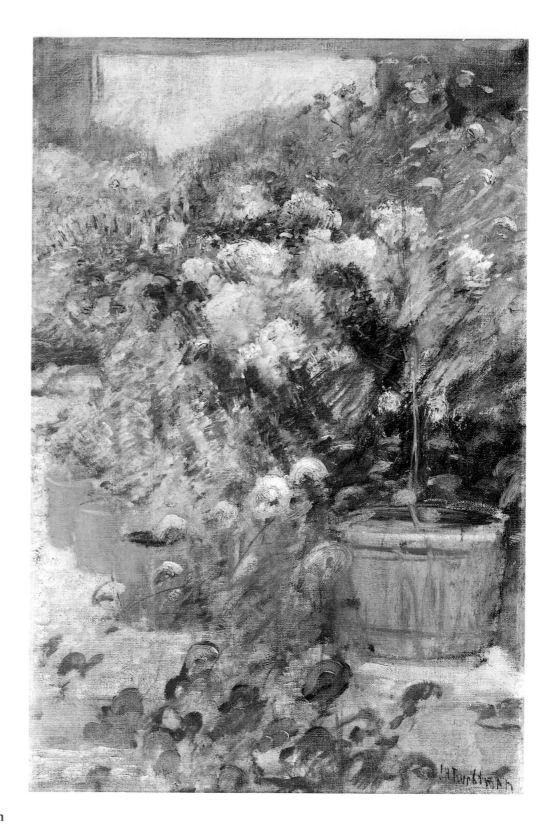

John Henry Twachtman
American, 1853–1902

In the Greenhouse, c. 1890–1902

Oil on canvas, 25⅛ x 16 in. (63.8 x 40.7 cm.)
73.1.3

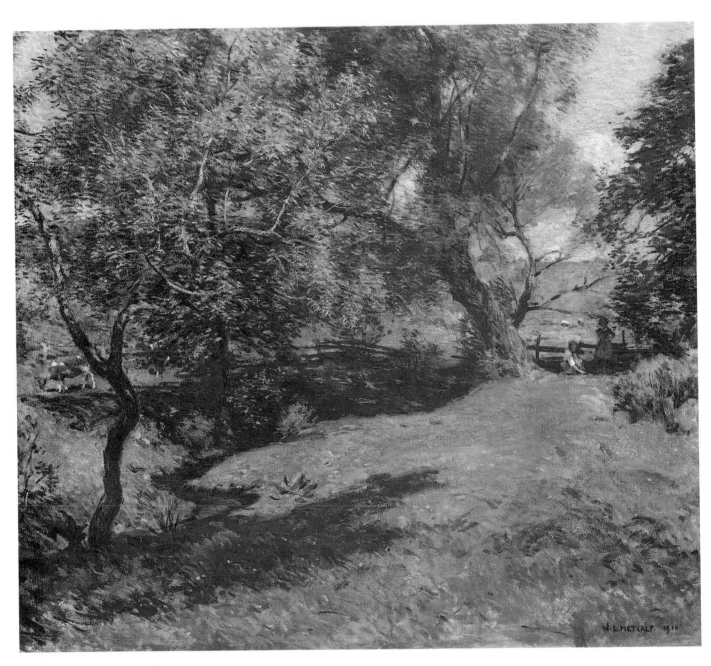

Willard Leroy Metcalf
American, 1858–1925

June Pastoral, 1910

Oil on canvas, 26¹/₁₆ x 29¹/₁₆ in. (66.3 x 73.8 cm.)
Gift of Charles M. Reeves, Jr., and family in honor of Mrs. Charles M. Reeves, Jr., 78.23.1

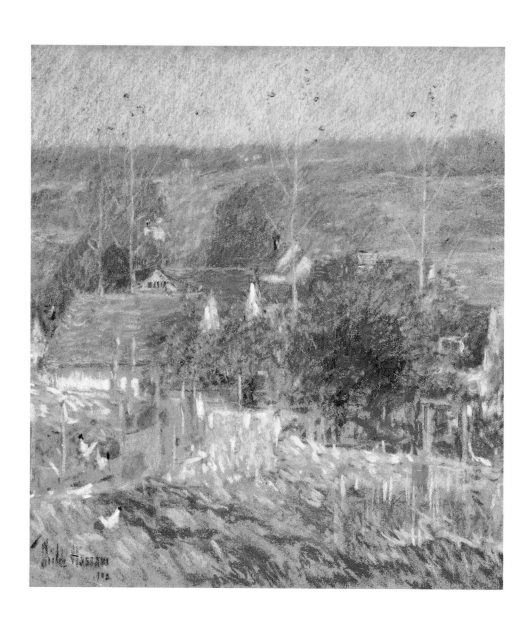

Childe Hassam
American, 1859–1935

Autumn, 1902

Pastel on paper, 11 x 9¾ in. (27.9 x 24.8 cm.)
Gift of Sylbert Pendleton in memory of Katherine Pendleton Arrington, 71.39.1

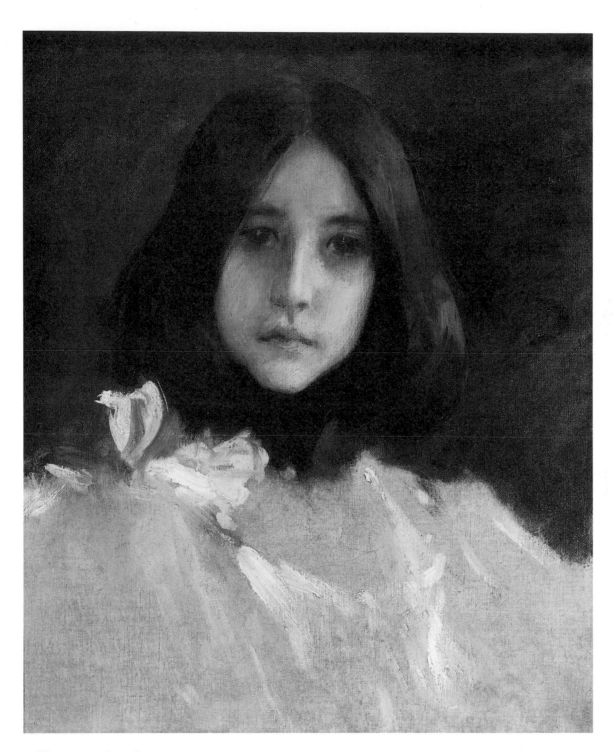

William Merritt Chase
American, 1849–1916

The Artist's Daughter, c. 1899

Oil on canvas, 19¼ x 15⅛ in. (48.9 x 38.5 cm.)
Gift of the North Carolina Art Society (Robert F. Phifer Bequest), 28.2.7

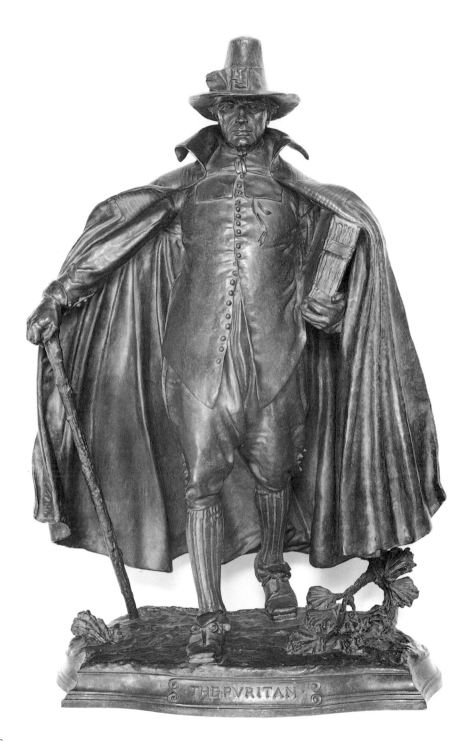

Augustus Saint-Gaudens
American, 1848–1907

The Puritan, 1899

Bronze, h. 31 in. (78.7 cm.)
Gift of Mr. and Mrs. Fabius B. Pendleton, 71.40.9

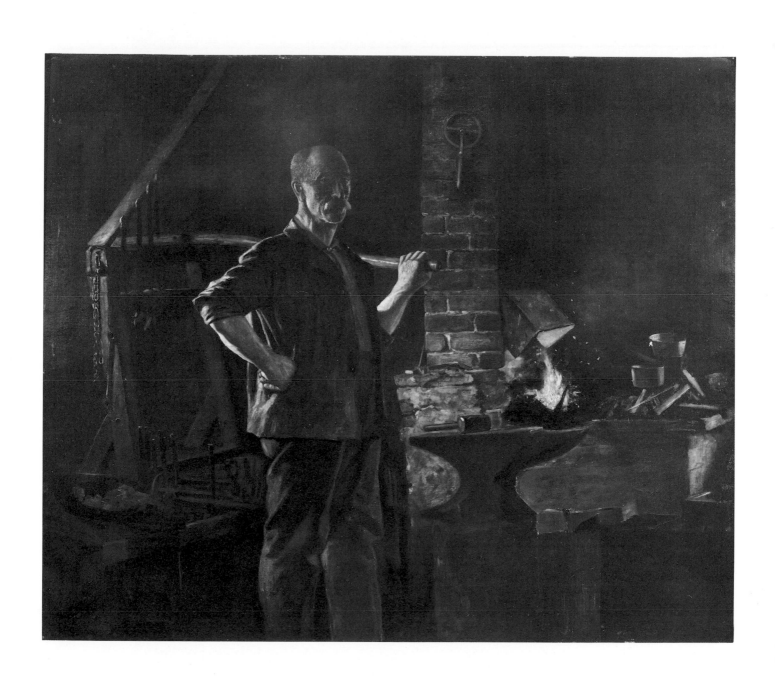

John G. Brown
American, born England, 1831–1913

The Blacksmith

Oil on canvas, 25¹/₁₆ x 30¹/₁₆ in. (63.7 x 76.4 cm.)
52.9.6

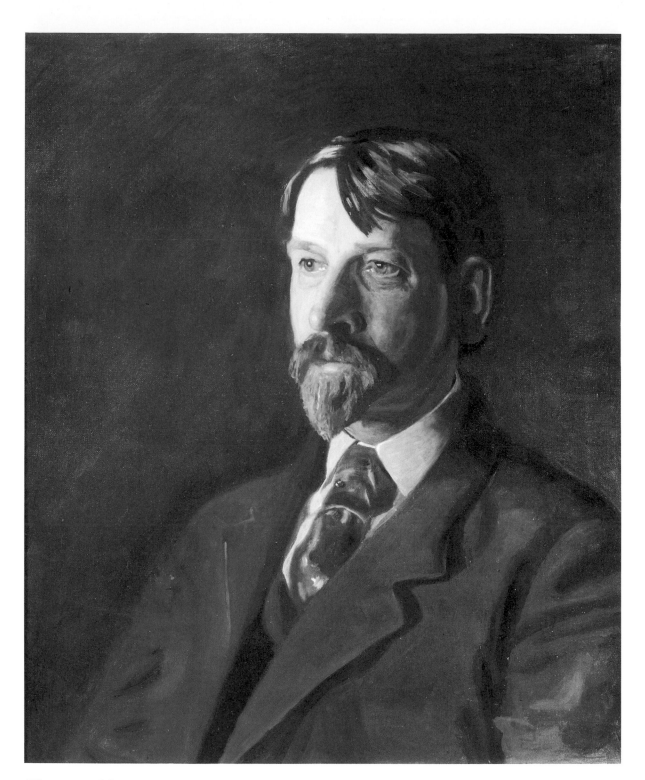

Thomas Eakins
American, 1844–1916

Dr. Albert C. Getchell (1857–1950), 1907

Oil on canvas, 24 x 20¹/₁₆ in. (61.1 x 51 cm.)
67.6.1

Twentieth-Century Art

Lyonel Feininger
American, 1871–1956

The Green Bridge II, 1916

Oil on canvas, 49⅜ x 39½ in. (125.4 x 100.4 cm.)
Gift of Mrs. Ferdinand Möller, 57.38.1

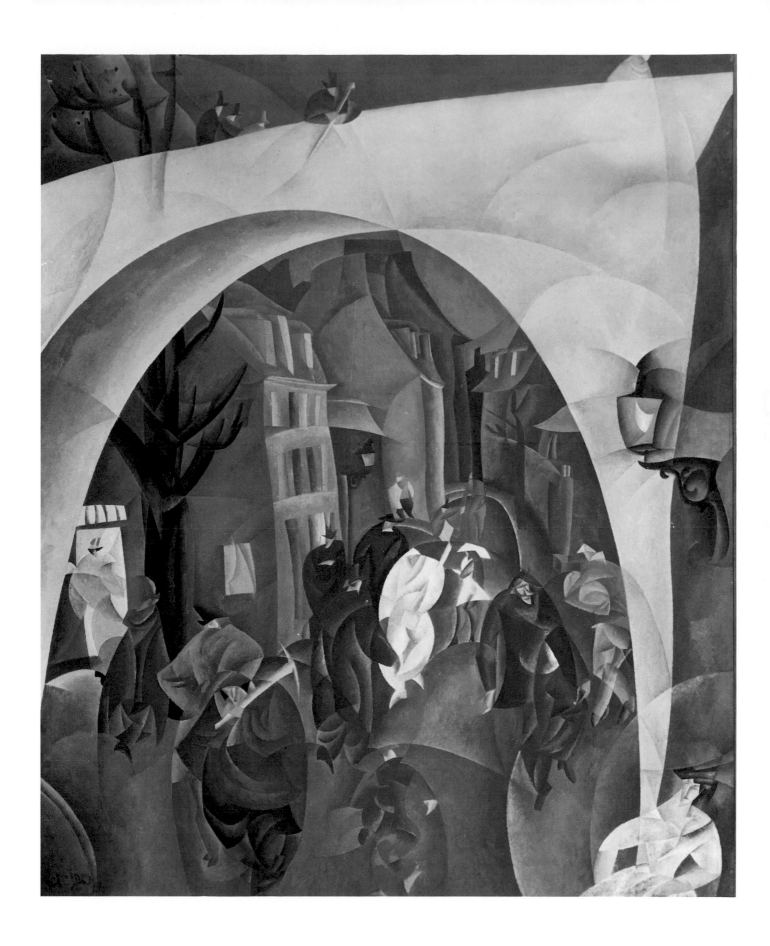

Otto Mueller
German, 1874–1930

Two Nude Figures, c. 1915

Oil on canvas, 47½ x 35⅝ in. (120.7 x 90.5 cm.)
Bequest of W. R. Valentiner, 65.10.48

262 Twentieth Century

Erich Heckel
German, 1883–1970

Berlin Landscape with Canal, 1920

Oil on canvas, 32⅞ x 38 in. (83.5 x 96.7 cm.)
Gift of Mr. and Mrs. S. J. Levin, 60.4.1

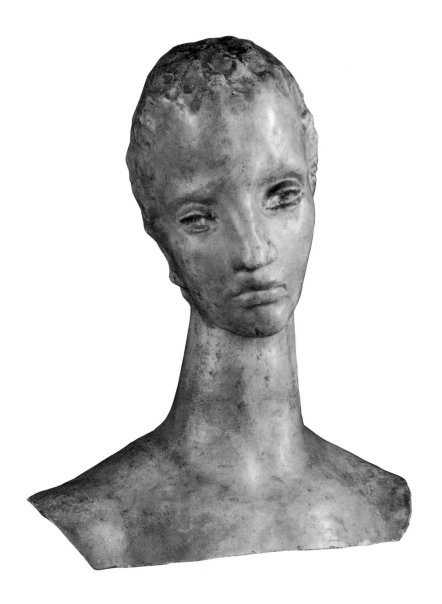

Wilhelm Lehmbruck
German, 1881–1919

Head of a Woman, c. 1913–14

Plaster, 17½ x 13½ x 9¾ in. (44.4 x 34.2 x 24.8 cm.)
Bequest of W. R. Valentiner, 65.10.42

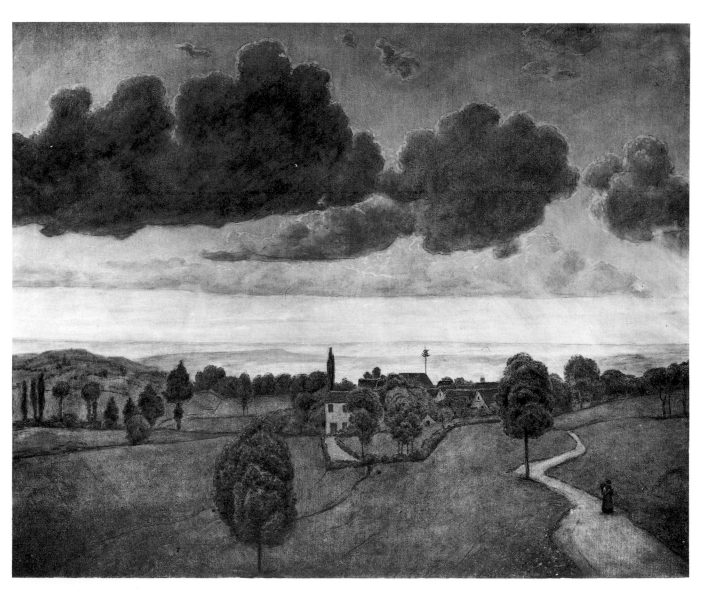

Hans Thoma
German, 1839–1924

Sunset, 1917

Oil on canvas, 31⅝ x 39½ in. (80.4 x 100.4 cm.)
Gift of Walter Lowry, 56.10.1

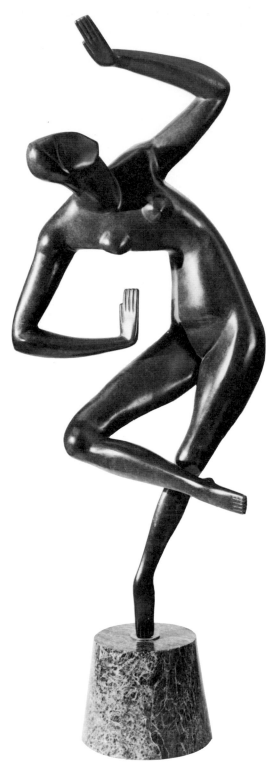

Alexander Archipenko
American, born Russia, 1887–1964

Blue Dancer, 1913

Bronze with blue patina, h. 41 in. (104.1 cm.) including base
76.1.8

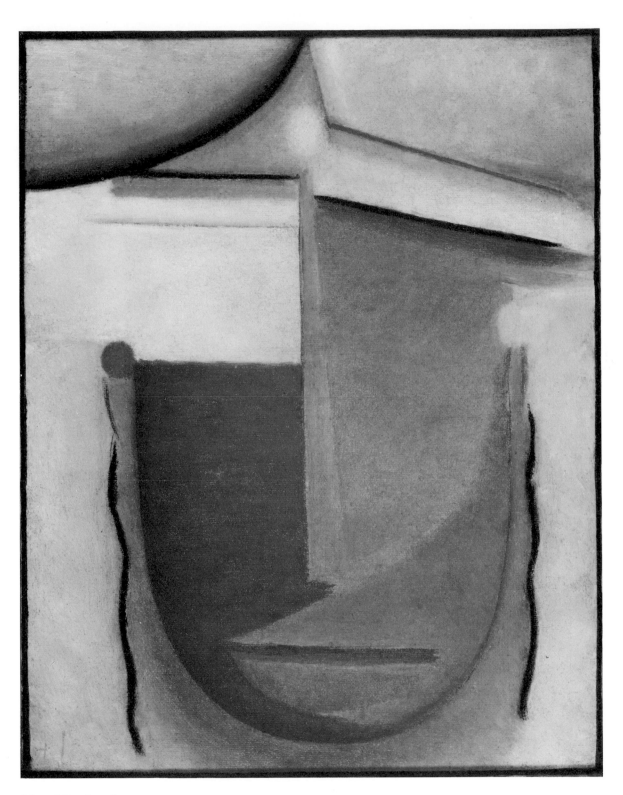

Alexej Jawlensky
Russian, 1864–1941

Head, c. 1929

Oil on canvas, 17¼ x 13¹⁵⁄₁₆ in. (43.9 x 35.4 cm.)
Bequest of Mrs. Consuelo Sides, 66.29.1

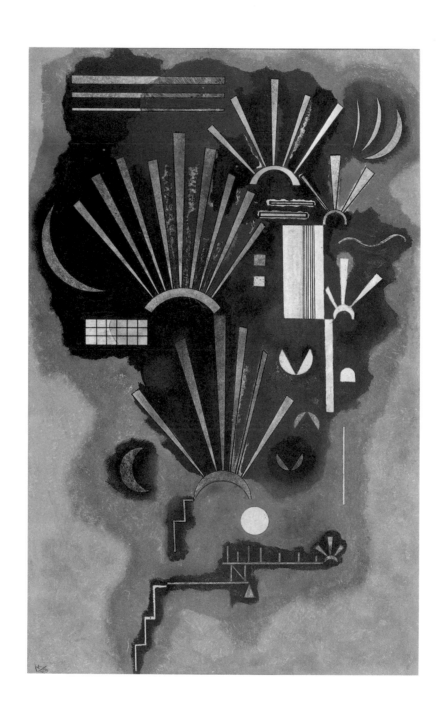

Wassily Kandinsky
Russian, 1866–1944

Zunehmen #520, 1933

Mixed media, 20¹/₁₆ x 12³/₈ in. (51 x 31.4 cm.)
Bequest of W. R. Valentiner, 65.10.29

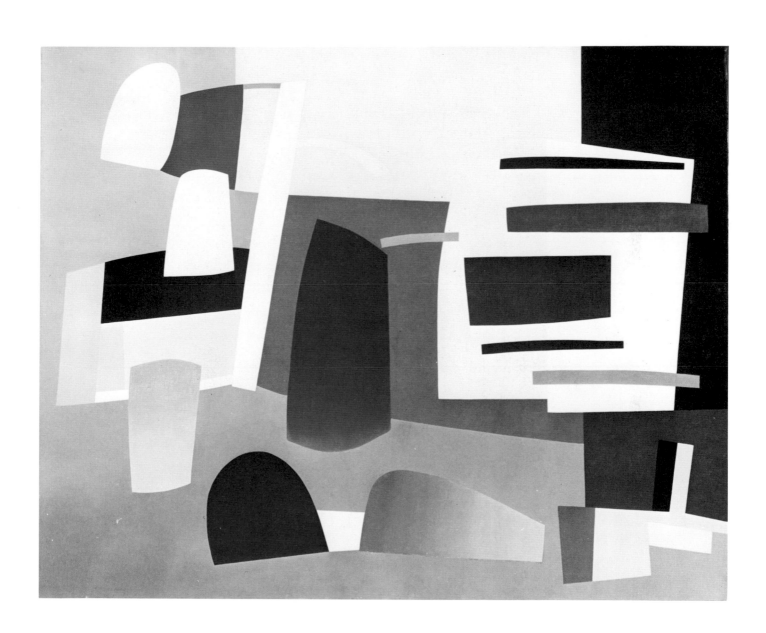

Jean Hélion
French, born 1904

Untitled, 1934
Oil on canvas, 50¹⁵/₁₆ x 63⁵/₈ in. (129.4 x 161.6 cm.)
Gift of Peggy Guggenheim, 57.40.1

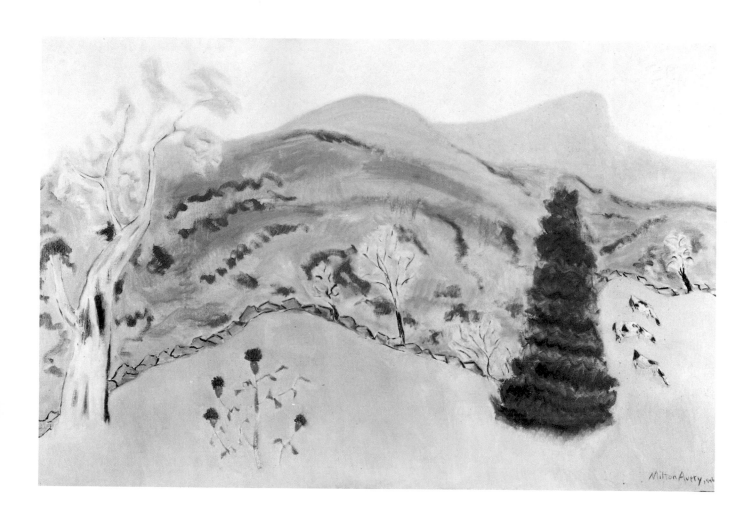

Milton Avery
American, 1893–1965

Blue Landscape, 1946

Oil on canvas, 34¼ x 53⅛ in. (87 x 135 cm.)
Gift of Roy Neuberger, 57.1.1

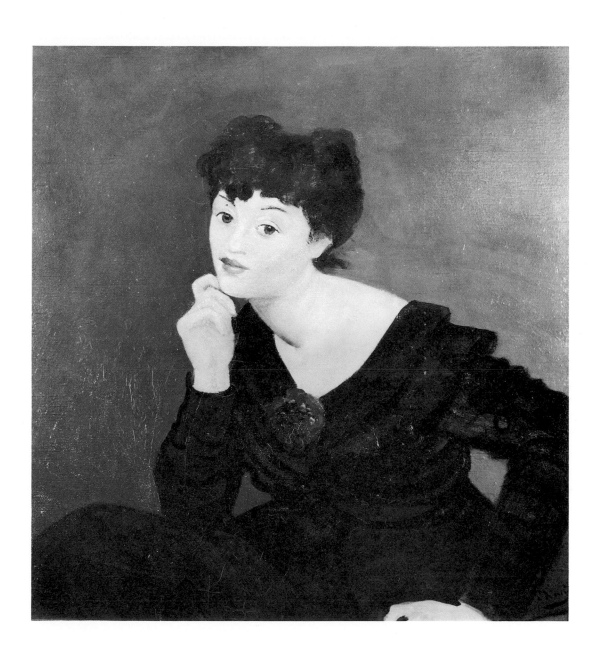

André Derain
French, 1880–1954

Isabel Lambert, 1930s

Oil on canvas, 30¾ x 29⅛ in. (78 x 73.9 cm.)
Gift of Mrs. James Forrestal, 55.9.1

Andrew Wyeth
American, born 1917

Winter, 1946

Tempera on composition board, 31⅜ x 48 in. (79.7 x 121.9 cm.)
72.1.1

Thomas Hart Benton
American, 1889–1975

Spring on the Missouri, 1945

Oil and tempera on masonite, 30¼ x 40¼ in. (76.7 x 102.2 cm.)
77.1.3

Robert Motherwell
American, born 1915

Young Girl, 1947

Oil on canvas, 48⅞ x 21⅝ in. (124.1 x 54.8 cm.)
Gift of the Olsen Foundation of New Haven, Connecticut, 58.21.1

Franz Kline
American, 1910–1962

Orange Outline, 1955

Oil on paperboard, mounted on canvas, 38 x 40 in. (96.5 x 101.6 cm.)
Gift of Mr. and Mrs. S. J. Levin, 58.8.8

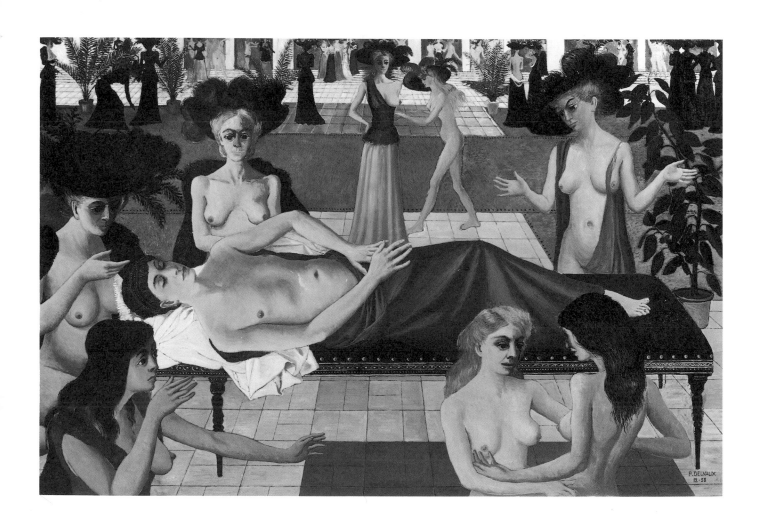

Paul Delvaux
Belgian, born 1897

Antinoüs, 1958

Oil on wood, 49⅛ x 75⅛ in. (124.8 x 190.8 cm.)
Gift of John L. Loeb, 62.22.3

Walter Murch
American, 1907–1967

Car Heater, 1957

Oil on canvas, 21½ x 16½ in. (54.6 x 41.9 cm.)
73.1.1

Robert Morris
American, born 1931

Untitled, 1964

Composition board, lead, steel, staples, screws, 33½ x 6 in. (85 x 15.2 cm.)
Gift of Rhett and Robert Delford Brown, 76.26.1

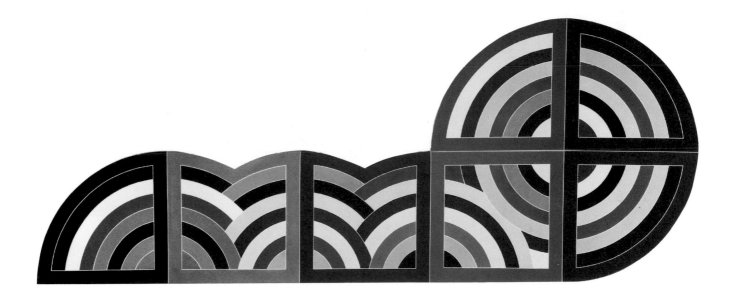

Frank Stella
American, born 1936

Raqqa II, 1970

Synthetic polymer on canvas, 120 x 300 in. (304.8 x 762 cm.)
Gift of Mr. and Mrs. Gordon Hanes, 82.16

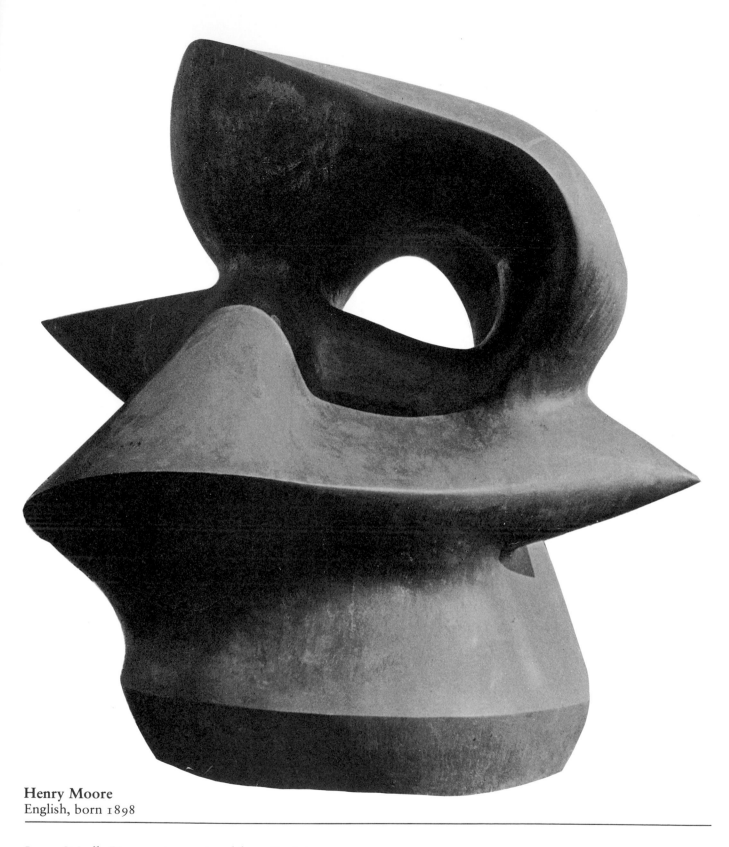

Henry Moore
English, born 1898

Large Spindle Piece, cast 1974 (model, 1968–69)

Bronze, 128 x 127 x 77¼ in. (325.1 x 322.6 x 196.2 cm.)
Gift of Mr. and Mrs. Gordon Hanes, 80.6.3

Neil Welliver
American, born 1929

Breached Beaver Dam, 1976

Oil on canvas, 95 15/16 x 96 1/8 in. (243.6 x 244.3 cm.)
Gift of Lee and Dona Bronson in honor of Edwin Gill, 77.7.2

Louise Nevelson
American, born 1900

Black Zag CC, 1971–77

Painted wood, 48 x 59 x 9 in. (121.9 x 149.9 x 22.9 cm.)
Purchased with funds from the National Endowment for the Arts and the North Carolina Art Society
(Robert F. Phifer Funds), 78.2.2

North Carolina Art

Jacob Marling
American, 1774–1833

Portrait of a Boy, c. 1820

Oil on canvas, 26 x 22 in. (66 x 55.9 cm.)
61.1.8

William Charles Anthony Frerichs
American, 1829–1905

The Falls of Tamahaka, Cherokee County, North Carolina, c. 1860–70

Oil on canvas, 30 x 48 in. (76.2 x 121.9 cm.)
Gift of Mr. and Mrs. George Finch, 65.24.1

Elliott Daingerfield
American, 1859–1932

The Grand Canyon, c. 1912

Oil on canvas, 36¼ x 38¼ in. (92 x 97.1 cm.)
52.9.202

Francis Speight
American, born 1896

Spring, 1930

Oil on canvas, 39⅝ x 50⁵/₁₆ in. (100.7 x 127.7 cm.)
Gift of Mr. and Mrs. Warner L. Atkins, 81.12.1

Hobson Pittman
American, 1900–1972

Studio in Charleston, c. 1946

Oil on canvas, 19½ x 32⅜ in. (49.6 x 82.2 cm.)
Gift of Mr. and Mrs. Sam Clark, Miss Nan Clark, Mr. D. Russell Clark, 55.22.1

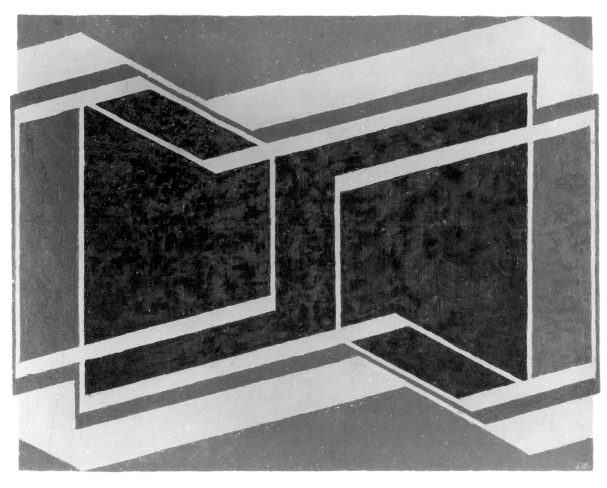

Josef Albers
American, 1888–1976

Kinetic V, 1945

Oil on masonite, 21¾ x 27¾ in. (55.2 x 70.5 cm.)
Anonymous gift, 63.2.1

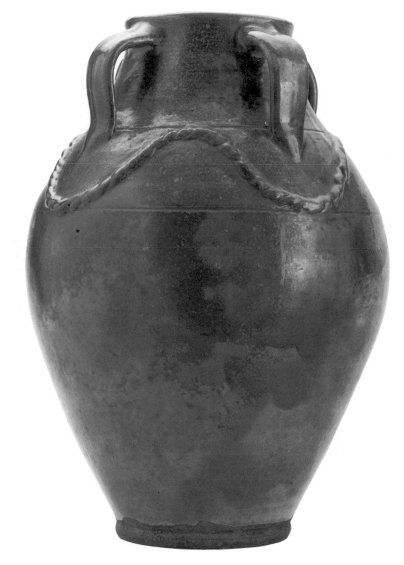

American, North Carolina, Jugtown
Busbee Period, 1917–1947

———————————————————————————————

Persian Style Jar

Ceramic with "Chinese blue" glaze, h. 13½ in. (34.2 cm.)
Gift of the North Carolina Art Society (Jacques Busbee Memorial Committee Funds), 50.19.162

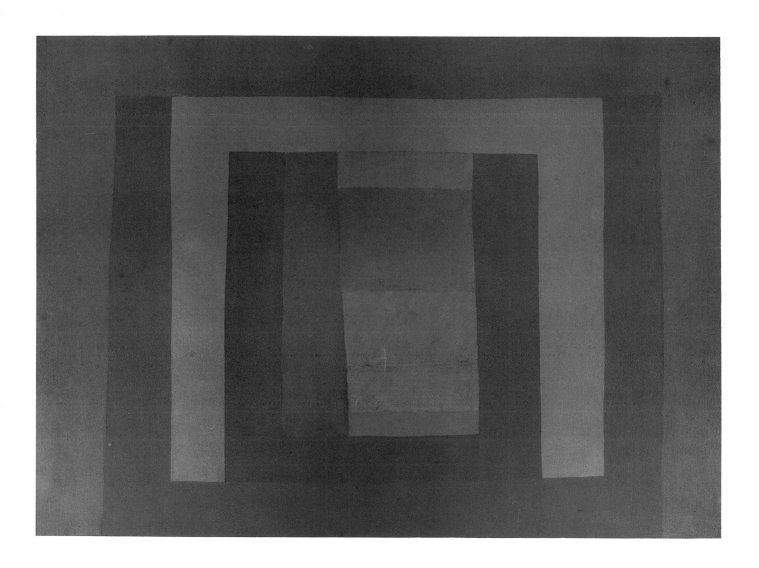

George Bireline
American, born 1923

Jan. III, 1966

Acrylic on canvas, 52 x 72 in. (132.1 x 182.8 cm.)
Gift of the North Carolina Art Society, 66.33.1

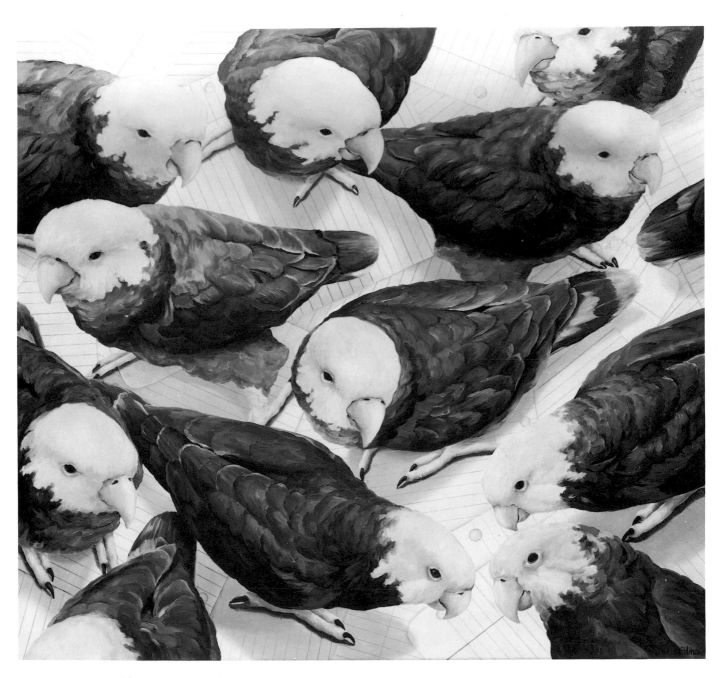

Gina Gilmour
American, born 1948

Love Letter to Lévi-Strauss, 1976

Oil on canvas, 62½ x 69 in. (158.7 x 175.3 cm.)
Purchased with funds from the North Carolina Art Society (Robert F. Phifer Funds), 76.24.1

Index of Artists